BASICS FILMMAKING

Robert Edgar

The Language of Film

Second Edition

Fairchild Books An imprint of Bloomsbury Publishing PLC

B L O O M S B U R Y LONDON • NEW DELHI • NEW YORK • SYDNEY Fairchild Books An imprint of Bloomsbury Publishing Plc

50 Bedford Square 138 London New WC1B 3DP NY UK US

1385 Broadway New York NY 10018 USA

www.bloomsbury.com

FAIRCHILD BOOKS, BLOOMSBURY and the Diana Logo are trademarks of Bloomsbury Publishing Plc

First published in 2010 © Bloomsbury Publishing Plc, 2015

All rights reserved. No part of this publication may be reproduced or transmitted in any form or by any means, electronic or mechanical, including photocopying, recording, or any information storage or retrieval system, without prior permission in writing from the publishers.

Robert Edgar, John Marland, and Steven Rawle have asserted their rights under the Copyright, Designs and Patents Act, 1988, to be identified as authors of this work.

No responsibility for loss caused to any individual or organization acting on or refraining from action as a result of the material in this publication can be accepted by Bloomsbury or the authors.

British Library Cataloguing-in-Publication Data

A catalogue record for this book is available from the British Library.

ISBN: PB: 978-1-4725-7524-1 ePDF: 978-1-4725-7525-8 ePUB: 978-1-4742-4922-5

Library of Congress Cataloging-in-Publication Data

Edgar, Robert. The language of film / Robert Edgar, John Marland, Steven Rawle. — Second edition. pages cm Includes bibliographical references and index. ISBN 978-1-4725-7524-1 (paperback) 1. Motion pictures—Semiotics. 2. Motion pictures—Production and direction. 3. Cinematography. I. Marland, John. II. Rawle, Steven. III. Title. PN1995.E345 2015 791.43014—dc23 2014041192

Typeset by Saxon Graphics Ltd, Derby Printed and bound in China

Pan's Labyrinth 2006

director

Guillermo del Toro

Pan's Labyrinth combines fantasy with social commentary and political debate. Part of the power of cinema is to engage us in the spectacle while intellectually challenging us. This is part of the language of film and is one of the reasons why this language is so specific to cinema.

4 Table of Contents

Introduction

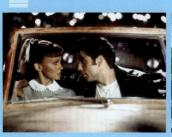

6

Semiotics	10
Images	12
The Visual Mind	14
Reading the Signs	16
Making Meaning	22
Codes and Filters	26
Case Study: Seven	30
Chapter Summary	36

Narrative	
Theories of Storytelling	40
Structuralism	42
Theories of Structure	48
Genette's Narrative Discourse	56
Music	60
Short Film and Narrative	62
Case Study: The Secret Life of	
Walter Mitty	64
Chapter Summary	70

Intertextuality	72
Text	74
Quotation	78
Allusion	82
Cult Film	84
Genre	88
Case Study: Citizen Kane	92
Chapter Summary	98

Frames and Images

Sound

Ideology	100
Ideological Analysis	102
Realism	108
Ideology and Genre	116
Case Study: Dead Man's Shoes	118
Chapter Summary	124

Constructing Meaning	182
Continuity Editing	184
Discontinuity Editing	190
Montage	194
Pacing	198
Case Study: Psycho	200
Chapter Summary	206

The Shot	128
Distance, Height and Framing	130
Shot Distances	132
Mise en Scène	136
The Mobile Camera Frame	142
Time and the Long Take	144
Case Study: Hero	148
Chapter Summary	154

Film: An Audiovisual	
Medium	158
Sound Properties	160
Diegetic and Non-diegetic	
Sound	164
Offscreen Space and Audio	166
The Voice	170
Music	172
Case Study: Berberian Sound	d
Studio	174
Chapter Summary	180

Conclusion	208
Film Language Glossary	209
Index	213
Picture Credits /	
Acknowledgements	216

As the title of this book suggests, film has a distinctive language all of its own.

When we are watching a movie in the cinema or at home we seldom have any difficulty understanding this language. Even though most films are a mosaic of fractured images and fragmented narratives, we have little problem piecing them together into something complete, pleasing, and meaningful (so much so that we seldom experience them as fractured or fragmented in the first place). We are capable of following the most labyrinthine plots, feeling genuine emotion for the most improbable characters, and believing that their worlds continue to exist even after the film has ended. We don't know how we do it (or that we are *doing* anything at all) but we are.

We never had to learn "film." We are like people who had no need to learn the grammar of their "mother tongue" because it has come so naturally to them, merely by being exposed to it. However, becoming a filmmaker involves being deliberately mindful of the structures and conventions that allow film to communicate so effectively to a global audience. An effective filmmaker needs to know how this language works, how the screen communicates to people, how meaning is gradually built up of tiny elements, and how to control an audience's thoughts and feeling.

It isn't enough to be able to "read" the screen, you need to be able to "write" on it. The *implicit* knowledge we have as spectators has to be converted into the *explicit* knowledge of the practitioner who can *make* these things happen for *someone else*—who can create narrative complexity, stimulate feelings toward fictional characters, and generally suspend the disbelief of an entire movie theater. In other words, filmmakers need to learn how to create the experiences that audiences crave—and harness the power of illusion that makes film such a uniquely popular medium.

This book attempts to help you to make the transition from consumer to practitioner—from someone who just responds to the language of film, to someone who actively *uses* it.

Film is one of three universal languages, the other two: mathematics and music. Frank Capra, director

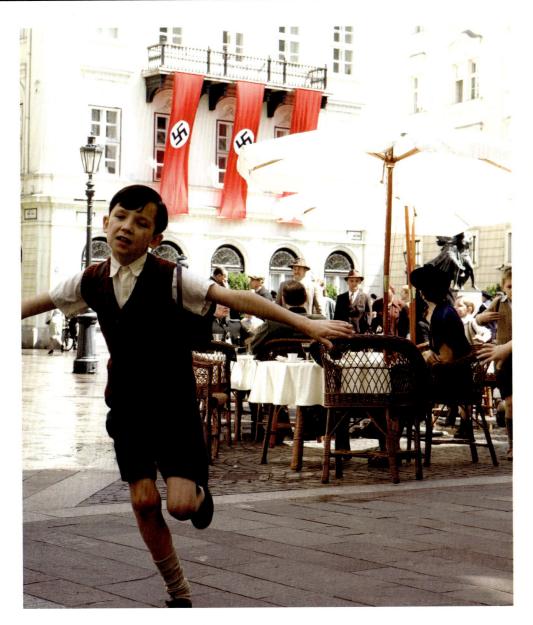

The Boy in the Striped Pajamas 2006

director

Mark Herman

The Boy in the Striped Pajamas takes the audience on an emotional journey into history and imagination. The flickering lights (which all film is made from) convey a story of great power in personalizing the horrors of the Holocaust.

7

Starting Again

Ironically, the ease with which we consume film presents us with a problem. The very immediacy of film, its spectacle, and the directness of its impact on us, make it difficult to unpick and examine. We have to "unlearn" a lot of what we think we know, and start again. For this reason we will go back to the basic first principles from which all films grow.

Our familiarity with the form actually makes it more difficult to think about film constructively. This is what is most valuable about film theory, and why we will be referring to some key theoretical thinkers—they have the happy knack of making us look again at what we take for granted.

One such film theorist, Christian Metz, famously said that: "Film is hard to explain, because it is so easy to understand." Here Metz is making the crucial distinction between knowing what a thing means and knowing how it comes to have that meaning, between "tacit" knowing and the sort of knowledge that can be readily articulated to others. Filmmakers—be they directors, cinematographers, designers, or actors—need to be able to talk to one another about what they are doing, about the "meaning" they are trying to create. Only then can they really be said to be working collaboratively in this most collaborative of art forms.

Film Languages

Film language is actually made up of many different languages all subsumed into one medium. Film can co-opt into itself all the other arts—photography, painting, theater, music, architecture, dance, and, of course, the spoken word. Everything can find its way into a movie—large or small, natural or fantastic, beautiful or grotesque. Not that film is without limitations. There are things that cinema struggles to do. The very fact that it is a predominantly visual medium makes invisible things (the stuff of the mind and the heart) impossible to convey except indirectly. Unlike a novel, a film cannot take us into the unconscious thoughts or secret longings of a character. We can only know of these things indirectly—by interpreting what we see of their external behavior.

This is a limitation indeed, but the same one we experience in real life.

Chapter by Chapter

Chapter 1: Semiotics

Film, like any "language," is composed of signs. Film semiotics is the study of how these visual and auditory units function to construct the meaning we attribute to cinematic texts. Filmmakers and audiences share an understanding of the sign systems (the codes and conventions) that allow film to communicate meanings beyond what is seen or heard. Chapter 1 seeks to investigate and outline these codes and conventions.

Chapter 2: Narrative

The consideration of narrative is the consideration of how an audience derives meaning from a film—it is about comprehension. In Chapter 2, we'll see how films are limited by time, and by their own language, and thus why their structure has to be very precise. Generally, the more successful a film is the more hidden its structure will be. It is your job to uncover that structure.

Chapter 3: Intertextuality

Texts are not produced or consumed in a vacuum, but in the context of other textual activity. Films relate to each other. Textual production occurs against a dense background of expectations, established by tradition and perpetuated by generic conventions. Textual "meaning" arises as the result of a process of recognition, comparison, and contrast to which all texts are subject. In Chapter 3, this "intertextuality" is examined to suggest some of the various ways film begets film begets film.

Chapter 4: Ideology

Chapter 4 examines the question of what films mean. The interpretations people give to films are many and varied but what is without doubt is that film always carries a message or messages. This chapter seeks to determine that all film and all aspects of film are ideological and the choices an audience has as to the meaning are actually very limited. They are limited by context, by expectation, and by the maker(s) of the film

Chapter 5: Frames and images

In Chapter 5 we'll look at how the "seen" aspects of cinema relate to the ways in which the camera gives us a perspective on what we see and how we comprehend the many possible uses of the image. The various visual uses of the film image will be examined through the vocabulary of the moving image and a series of case studies, to show how the film camera shapes and distorts our perspective of cinematic objects and spaces.

Chapter 6: Sound

The visual has long obscured the craft and understanding of sound in cinema. Most audiences will forgive weaker visuals, but will never forgive poor audio, and many sound practitioners will tell you that professional films are defined by their attention to the crafting, recording, editing, and creative uses of sound. Chapter 6 examines how sound contributes to narrative, space and the unique properties of audiovisual media like cinema to tell stories, create imaginary worlds and shape the realist (and often non-realist) effect of cinema.

Chapter 7: Constructing Meaning

In addition to the visual and aural aesthetics of the camera, cinema has other techniques relating to the ways in which images are joined together to form plausible space and narrative sequences. Space, time, narrative, and style are all constructed by the use of editing techniques to manipulate the individual images into a coherent (or deliberately incoherent) whole. In Chapter 7, we'll consider these "invisible" effects to see how editing adds another dimension to the visual image.

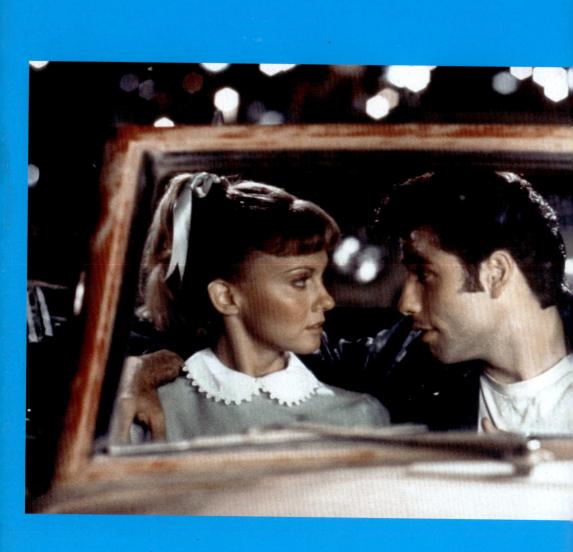

SEMICTICS

Grease 1978

director

Randal Kleiser

Every picture tells a story. It's remarkable what can be read from a single image. Even if we haven't seen the complete film we already "know" a great deal about Danny and Sandy from the information contained in this one frame. Semiotics investigates how this is possible. Basically, filmmaking is telling a story in pictures.

This sounds pretty straightforward. Simply let the camera roll, record the actors speaking their lines, and your film will be "in the can" in no time. Capture enough footage and you can always pull it into the desired shape later on. Right?

Wrong! Holidaymakers can afford to do this, proper filmmakers can't. Leaving the story to play itself out in front of a camera is wasteful of both time and money, and will almost always result in something as awkward, slow, drab and stagey as the average wedding video. The camera is not responsible for the pictures on the screen—you are.

Real movie-making begins with carefully choosing the precise images you need for the particular story you want to tell. This selection process is done in the best equipped editing room in the world—your imagination.

This leads inevitably to the study of semiotics. This is essentially the study of "signs": It is the analysis of communication and can be applied to any form of communication. Film has its own language and therefore there is a branch of semiotics that concerns itself with film. Filmmakers have the biggest canvas and the fullest paint box imaginable. With it they can fashion images that speak to virtually anyone who sees them.

Visual Culture

One look at the still from *Grease* on pages 10–11, and we feel we understand exactly what is going on. This is because everything has been arranged to ensure we do so.

The shot is framed to emphasize the way Danny (John Travolta) is "making advances" toward Sandy (Olivia Newton-John)-invading her space. It is obviously his car-and a red one at that. The white T-shirt and black leather jacket, regulation wear for a young rock'n'roller, conform to the stereotype of disaffected youth created by actors such as Marlon Brando. His thick glossy jet-black quiff and sideburns are the signatures of his manhood, dangerous and wild. This is who he is, or rather who we are meant to think he is. Sandy is also instantly recognizable. Her cardigan, highbuttoned blouse, and lace collar put her at the opposite end of conformity and respectability. The costume makes her a "good girl" in contrast to his "bad boy." Her hairstyle is as virginal as his isn't. The film goes on to have fun with these notions. Danny isn't really so "bad" but has to keep up the pretense in front of his friends. The all-singing, all-dancing finale has them swap personas-sacrificing their "reputations" to prove their true feelings for each other. So Danny turns up at the "School's Out" celebrations dressed like a college kid, while Sandy is transformed into a leather-clad vamp complete with cascading curls, red lipstick, and chewing gum.

She even stubs out a cigarette in *dangerously* high heels. For the transformation to work, the images must be clear and precise, and we must be able to "read" them.

In fact, we seem to pick up these signals quite effortlessly. This is because we belong to a visual culture adept at the transmission and reception of visual information. Filmmakers in particular need to be experts in this process.

Seeing comes before words. John Berger, art critic, novelist, painter

12

Precision

Film images are *never* vague. They are stubbornly "concrete." You may casually envisage a scene in terms of *a* man, *a* car, and *a* landscape. However, the camera will slavishly record *this* man, in *this* car, in *this* landscape—in all their specificity. The image will immediately convey a huge number of impressions (such as period and location) and suggest a host of ideas (such as romantic journeys, the open road, or the vastness of nature).

Are these the thoughts you want the audience to have? If you show Danny in his car the audience will think of 1950s America, "free spirit" and "trouble ahead." Successful filmmaking depends on having a firm command of your material—exercising maximum control over what the viewers see and hear.

It is often the little things that count the most: for example, in a wedding scene it might be the gleam in the bride's eye or the rather proud way she holds her head; the way the groom fiddles with his tie or fires a glance at another woman in the congregation; the stilted walk of the bride's father and the tear on the mother's cheek; the fidgeting children at the back and the panicky expression on the man's face as he checks his pockets for the ring.

All these are wedding-scene **clichés**, but if they are chosen and arranged with sufficient care, then the tension for the audience in the cinema is as great as it would be for the guests in the church. The excitement and trepidation pours from the screen into the auditorium.

With all the above in place you can be sure your audience will jump when the bride calmly lifts her veil, slowly withdraws a knife from beneath her bouquet and stabs the bridegroom straight through the heart. Now there's a wedding scene! And what of the final image: the flower in its buttonhole, slowly turning from white to red? Not subtle, but indelible—and worth a thousand words.

Recommended Reading

Roland Barthes's *Mythologies* is a collection of articles written between 1954 and 1956 for the left-wing French magazine *Les lettres nouvelles*. The articles show how even seemingly trivial aspects of everyday life can be filled with meaning and are wonderfully playful about "the little things"—including the meaning of Marlon Brando's hairstyle in the film *Julius Caesar* (dir. Joseph L. Mankiewicz 1953).

Clichés: Overused, stale and out-worn expressions, mostly to be avoided. But they are overused for a reason—they tend to work, especially when given a slight "tweak."

Recommended Viewing

Watch the end of Hitchcock's *Rear Window* (1954) and spot the numerous ways he finds to make us frightened for Jimmy Stewart and Grace Kelly. Draw a simple graph charting the rise and fall of anxiety and empathy in the audience.

Auteur: A director whose individual vision is the sole or dominant driving force behind an entire body of work. We can all think of film images that have stamped themselves indelibly on our memory. Once seen, never forgotten. As a filmmaker your minimum aim should be to create something that is memorable and rewards repeated viewing. But before your film will stick in anyone else's mind, it has to first live in your own.

A Vivid Imagination

Alfred Hitchcock seems to have found directing rather tedious. As far as he was concerned all the essential creative work had been done well before he stepped on set. The film was already made—*in his head*.

This reveals Hitchcock as the quintessential **auteur**, and central to this is his ability to vividly imagine his films—to construct them in his mind's eye, detail by detail, and frame by frame. This is not only an indication of his having a good "inner camera." Not only did he "see" the images in advance, he also knew how his audience would interpret them. He was a master manipulator who combined great craftsmanship with a shrewd understanding of what made his audience tick.

Look, for example, at *Psycho* (1960) and the cunning way Hitchcock gets us to "collude" with Norman Bates even as he is covering up the evidence of a murder. When he is attempting to hide the car carrying the innocent woman's body, and it gets stuck only half submerged in the waters of the lake, almost everyone in the audience thinks, "Oh no!"

Once the screenplay is finished, I'd just as soon not make the film at all... I have a strong visual mind. I visualise a picture right down to the final cuts. I write all this out in the greatest possible detail in the script, and then I don't look at the script while I'm shooting. I know it off by heart...

Alfred Hitchcock, filmmaker and producer

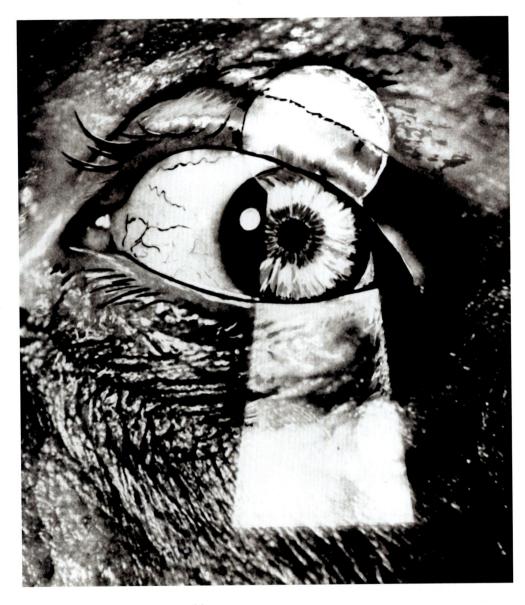

Peeping Tom 1960

director

Michael Powell

Cinema embodies a way of seeing that is inherently voyeuristic indulging the guilty pleasure we get from secretly watching other people. Directors such as Alfred Hitchcock and Michael Powell know how to exploit film's potential to arrest and disturb us by using the camera as an instrument to expose our darkest fears and desires. A movie is a highly complex act of communication, and no act of communication is effective unless it takes into account how the recipient will receive it. If a film is to have the desired effect, the filmmaker needs to know exactly how the screen communicates. They need to know how the images produced will be understood by the audience and work upon their imaginations moment by moment. This is where **semiotics** is useful.

Units of Meaning

When we talk about movies we typically refer to characters, action, and dialogue. In fact each of these elements is made up of much smaller units. Characters, for instance, are built from tiny fragments of information (such as physical features, bodily gestures, and spoken words), each selected and juxtaposed to create the illusion of a real-life threedimensional human being.

Film theorists refer to a detail of this sort as a **sign**. Film semiotics, the study of cinematic signs, breaks film down into its constituent parts to identify the atomic building blocks from which the complexity of narrative is constructed. Signs are the most fundamental units of meaning—the atoms from which films are formed.

A sign is anything we can see or hear or feel that refers to something we can't—usually something absent or abstract. For example, the sign we commonly see by the roadside instructing us to STOP is there to warn us of potential hazards not yet visible.

In the specific context of cinema a "sign" is anything, large or small, which we find ourselves responding to. Put another way, something becomes a sign when we single it out for special attention. For instance, we may take no real notice of anything outside the car as we watch the family having a violent argument, but once we hear the sound of a pneumatic drill and spot the workmen with their shovels these become "danger signs."

Semiotics: The study of signs. It has its origins in the work of Ferdinand de Saussure, a Swiss linguist who was the first to identify some of the basic principles that apply to any sign-based system.

Sign: An object, quality, or event whose presence or occurrence indicates the probable presence or occurrence of something else.

Visual Abbreviation

Imagine a Western. The ringing of a church bell is an ominous sign. A crowd gathered around a body lying in the middle of Main Street is a sign that there has been a gunfight. The badge on his shirt indicates that he was the sheriff—it's a sign of his status. The sight of another man removing it and pinning it on himself is yet another sign, either that the sheriff's deputy is taking over the job or that a gunman is taking control of the town.

Anything the eye or ear picks up on, whatever we single out for attention and draw a specific meaning from, is functioning as a sign. It stands for something that contributes to our overall understanding. The sheriff's gray beard may be a sign that he was too old for the job. The gun still in his holster is a sign he was hopelessly outclassed, taken by surprise or shot in the back. Amid this field of implicit signs is a single *explicit* one—a crumpled poster carrying the gunman's picture and the word "Wanted."

A sign is not always so clear-cut. A scar on the deputy's face might indicate that he too is a victim of violence. On the gunman it would signal that he habitually *deals* in violence—he is a villain. Context determines the exact meaning we derive from a sign, and this context is made up of other signs. A smile on the gunman's lips would tell us how to read the scar on his cheek.

Film is the art of visual abbreviation. Filmmakers use smiles and scars, badges and beards, to tell the audience more than they can be explicitly shown or told. The audience sees meaning in them because it is a movie—and they have been deliberately placed there for a reason. A movie is a matrix of interrelated signs erected by the filmmaker to guide the audience on their journey.

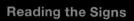

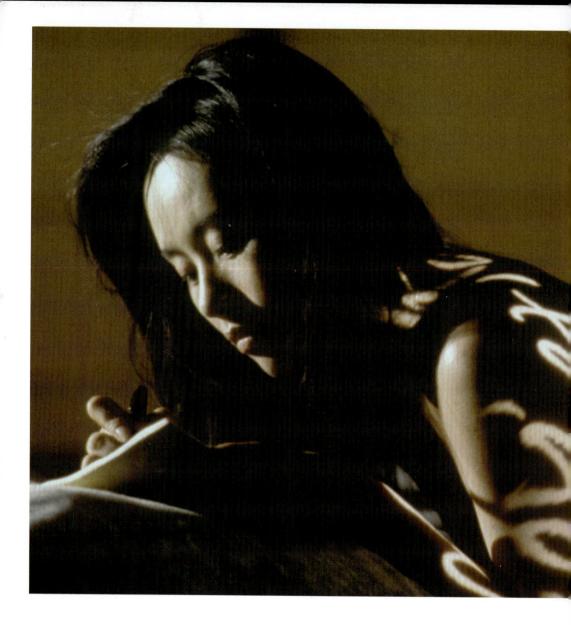

The Pillow Book 1996

director

Peter Greenaway

It has been said that filmmaking is "painting with light." Well, here the words projected onto a woman's body create an unusual connection between the subject and the viewer. She is reading signs and so are we. Greenaway knows that overlaying images not only creates aesthetic depth, but intellectual complexity.

A Compound of Signs

The still from *The Pillow Book* on pages 18–19 is an unusually intricate image. In a sense, the reclining figure is itself a compound of signs from which we gather an impression of luxuriant sexuality and cultural sophistication. Although we probably don't notice it directly, we are also affected by the dark, rich earth colors in the background—adding to the sense of warmth, seclusion, and erotic intimacy. These too are signs that inform our reading.

Most striking (because "unnatural") is the fact that the woman's nakedness is "clothed" in light—words (more signs) projected onto her skin. The fact that she is also in the act of writing, creates a dialogue between the two things that gives the image a complex meaning alluded to in the phrases used to promote the film: "The word is made flesh" and "Treat me like the page of a book."

It is disturbing whenever a person is depersonalized, treated like a thing—in this case a canvas or a screen. As an audience, it makes us self-conscious of the fact that she is an object for us.

It is the interaction of signs—the juxtaposition of "nature" and "artifice," which prompts this sort of interpretation. In a sense, the image *represents* the rather abstract thoughts Greenaway is aiming to stimulate in us. This level of intellectual suggestion is difficult to achieve in film—and rare.

The most important point here, however, is that just looking at the image and responding to it, we are already doing semiotics—constructing meaning through interaction with the signs.

EXERCISE: INTERPRETING SIGNS

Choose a moment from a favorite movie—one compound image that sums up your experience of the entire film. Write down ten words that describe the thoughts and feelings it evokes. Now attach each word to a particular aspect of the image and reflect on the impact the smallest details can have.

The Flow of Signs

Technically speaking, a "motion picture" is in fact a sequence of individual pictures, but it is *experienced* quite differently as a steady stream of sensations. A movie is a vast outpouring of signs.

The filmmaker's task is to control and channel this flow of information in order to create the desired illusion and shape the audience's experience of it. It is a game of consequences—if I show them this, they will think or feel *that*. The way in which you craft and organize your film's signs will determine the reality and meaning an audience will attribute to them.

Changing any one aspect of Peter Greenaway's "reclining woman" will alter the way the audience perceives her at that moment. If she turns the page they become aware of her as a writer; if she closes her eyes they see her as someone resting or dreaming, if the light moves over her skin they see her as a strange canvas—an aesthetic "object." These implications are already there of course, but are reemphasized by slight changes in the play of signs around her. And changing one thing can change *everything*. Just imagine what an accompanying soundtrack of sleazy music would do to the scene.

An audience may not be able to dwell on every single frame of a film but it is extraordinary just how much and how quickly they can process what you give them. Having said this, cinematic images are extraordinarily fleeting. A crucial plot point may occur in a split second. If you overload your audience with too much information, or it comes too quickly, they may single out and concentrate on the wrong thing—miss a crucial element of characterization or miss a necessary stage in the narrative.

Successful filmmaking involves keeping the audience "on-track" and pointing them in the right direction throughout -steering their perception and focusing their attention, without seeming to do so. There are some crucial conceptual distinctions that underpin semiotics in its attempt to describe how information is transmitted and received at the most basic level—how meaning is made possible by the "play of signs" between filmmaker and audience.

Two Sides of the Sign

The first basic insight of semiotics is that a sign has two parts: the physical and the psychological.

- The physical part is the "sign-as-object," the tangible *thing* we see or hear, such as a metal road sign, the tear in the heroine's eye, or the words "Go for your gun." This is called "the signifier"—the external stimulus.
- The psychological part is the "sign-as-concept," the *reaction* to the object, the mental picture or idea it provokes in the mind. This is called "the signified"—the internal response to the signifier.

The signifier is what we *perceive* of the sign, while the signified is the actual *meaning* the sign has for us. This distinction between the thing used to communicate (tears) and the thing communicated (sadness), has important implications for filmmakers who are trying to effect a precise response in their audience. It is crucial to find the perfect stimulus for the state you want to create *in the viewer*.

The difficulty lies in the fact that the sign has one signifier, but *many* potential signifieds. The signifier is "out there," fixed and publically shared, whereas the signified is a unique response determined by a range of personal factors. We all interpret things differently according to experience or mood.

What is more, tears *can* be a sign of many things—sorrow, fear, frustration, relief, gratitude, happiness, or a mixture of these. It follows that the relation between signifier and signified is arbitrary. There is no natural bond between the sign-as-perceived and the sign-as-understood. If one character hands another a single red rose the meaning is clear. Yet there is no inherent connection between a garden shrub and romantic love. The link is entirely due to convention—creating an efficient shorthand for quite complex notions that would otherwise require an awful lot of words. In fact, by bypassing language the image creates an emotional attachment to the screen.

Metaphor and Metonymy

Metaphor and metonymy are different ways of transmitting meaning. Metaphoric meaning establishes a relationship between two things based on a *resemblance*, sharing a common property, which encourages a *comparison*: "as quick as a shot," "as light as a feather," "my love is like a red, red rose." Metaphors point to a connection and invite us to elaborate upon it—often imagining something immaterial as if it could be seen or felt.

Metonymic meaning establishes a relationship based on *association*—instead of asserting a resemblance, a metonym *substitutes* one thing with another—"the bottle" for drink, "hands" for workers, "the press" for journalists, "the crown" for the monarchy, "the Oval Office" for the US president. As a figure of speech, a metonym replaces numerous changeable things with one single vivid and fixed image (for example "the pen is mightier than the sword"—meaning words are more effective tools for change than physical violence).

The significance of this for filmmakers is that visual texts (unlike literary ones) are characteristically metonymic. In other words, what is seen replaces or substitutes what cannot be seen. Films have difficulty conveying the *experience* of power, wealth, or love, but they are good at conveying the trappings and rituals that surround them.

This relationship of part to whole is also very important for film. The technical term for this is **synecdoche**. Our sheriff *is* his badge, our gunslinger *is* his gun. Our heroine *is* a rose—beautiful, but easily crushed. Julia Roberts's character is *"that* smile." Clint Eastwood's spaghetti Western antihero is *that* cigar—smoldering, hard bitten, and enduring.

A flag is a metonym—standing for a country or a cause. When D. W. Griffith (*The Birth of a Nation*, 1915) shows a Southern Confederate soldier during the American Civil War ramming a Confederate flag into an enemy cannon, the flag is the Confederacy—a brave, romantic, but ultimately futile attempt to resist the mechanized might of the Union army. **Synecdoche**: Where some portion of a thing stands for the whole.

Denotation and Connotation

A further important distinction exists between two dimensions of meaning—two "levels of signification":

- Denotation: the primary direct "given" meaning the sign has e.g., a military uniform and insignia will denote a particular class or rank (soldier, sergeant, captain, general, and so on).
- Connotation: the secondary indirect meaning derived from what the sign "suggests"—for example, military uniforms may connote valor, manliness, oppression, conformity, and so on as the result of collective cultural attitudes or unique personal associations.

Both levels of meaning clearly operate in the still from *The Birth of a Nation* (opposite). Everyone will recognize a hectic battlefield scene and many will recognize the uniform of an officer in the Southern Confederate army during the American Civil War. This is the factually based denotative meaning.

However, the connotations it has, the ideas it evokes, will vary enormously according to the viewer's attitudes to war in general and that war in particular. This leads to another central insight of film semiotics: meaning does not reside in the film like some buried treasure awaiting discovery. Meaning is the result of the interaction between the film and the audience—it is a fluctuating process only partially at the filmmaker's command. Nevertheless, it is his or her task to exert maximum possible control—to anticipate the range of likely connotations and nudge the audience in the desired direction.

A film is never really good unless the camera is an eye in the head of a poet.

Orson Welles, director, writer, actor and producer

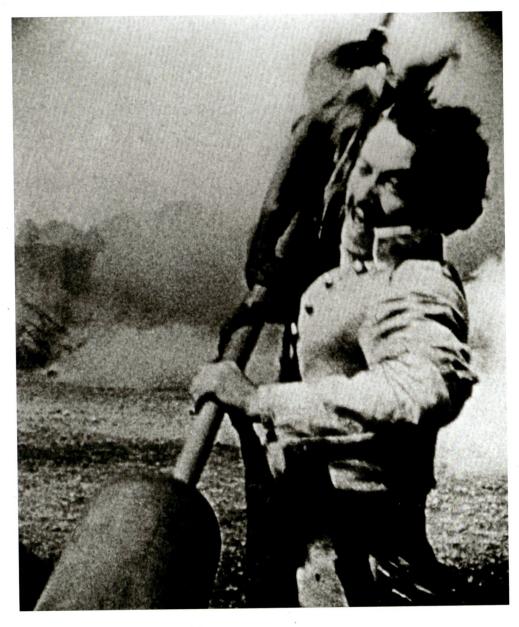

The Birth of a Nation 1915

director

D. W. Griffith

This image of battle sticks in the memory. Whether attacking a cannon with a flag appears courageous, cavalier, or just plain crazy depends, in part, on the way we interpret his ecstatic expression.

Roland Barthes: A French semiotician whose major work, published 1950–1970, sought to locate the universal structure and narrative conventions from which the impression of meaning is created in realist texts. Barthes published a range of material in journals and in book form. Among the most notable works are *Mythologies* (1957), *The Essentials of Semiology* (1964), and *S/Z* (1970). In his attempt to discover the essential underlying structure beneath any and all narratives, the French literary theorist **Roland Barthes** identified five separate signifying systems or frameworks through which texts communicate. As we'll explore further in Chapter 2, his analysis is just as relevant and revealing about film, and can help clarify some of the issues of communication that are central to successful filmmaking.

Five Systems of Meaning

These systems are referred to as "codes." However, this term can be rather misleading and confusing. Barthes doesn't mean that filmmakers and others are deliberately *adopting* a "code," which then needs to be *cracked* by some special act of intelligence. What he *is* saying is that narrative artists generate meanings by employing preexisting structures.

The filmmaker doesn't *elect* to use these systems; he or she just decides how to deploy them in a particular situation. They are structures that inevitably come into play the instant anyone starts to organize signs into narrative coherence. Taken together they are to narrative what grammar is to language. They have to be in place for anything to make sense.

Audiences use these conventional systems to construct meaning from texts. None of us need formal training to either encode or decode narrative information in this way any more than we learned our native language by being told a set of rules or procedures. In both cases, we subconsciously learn as we are immersed in a language-world full of signs and stories.

It may be helpful to reimagine these "codes" as five different types of grid, mesh, or net in which the signs that make up the text are captured, sifted, and meaningfully related one to another. Each net catches different kinds of material; and taken together they constitute a kind of network through which signs are filtered and our perception organized. Barthes's five codes, or "systems of meaning," are as follows:

1 The enigma code

This is the principal structuring device that sparks the audience's interest and drives a movie forward. All films deliberately set puzzles, pose problems, hint at secrets to be divulged, mysteries to be unraveled, and hopes fulfilled. This is what ignites curiosity, holds attention, and creates suspense and surprise. By withholding and strategically delaying the release of narrative information, filmmakers control the audience.

The audience's experience of a movie can be expressed in terms of the almost endless string of questions it prompts us to ask; some implicit, some explicit. Barthes identifies ten types of question—from the initial posing of general questions (What is this going to be about? What's going to happen next?) to the final disclosure at the end (Who did it? Will he get the girl?). He also identified no fewer than eight different ways to keep the riddle from being solved, including giving partial and multiple answers. In *Psycho* (1960) Alfred Hitchcock, the great master of enigma, uses them all.

2 The connotative code

This refers to the signs that imbue characters and settings with meaning, for instance the innumerable sensory signs (speech, clothing, movement, or gestures) from which we draw inferences about the characters. These inferences can be complex and subtle, but they all derive from bits of information mentally composed into the illusion of real people having real experiences in a real world.

In watching a movie we note certain connotations (of word or image), which we then organize into themes. For example, as can be seen on page 31, in *Falling Down* Michael Douglas's crew cut, necktie, and briefcase constellate into a theme—call it "responsibility" or "traditional values"—which places him in a certain relationship with the decayed environment around him.

3 The action (or proairetic) code

This refers to signs belonging to the pattern of actions, large or small, that make up the narrative. The most interesting examples tend to show the audience one thing in order to reveal something else. As we've already seen, inner events must be signaled by outer ones if the story is to have human depth. For example, when a cowboy tightens his gun belt he isn't adjusting his clothing, he is making a life or death decision. When the hero and heroine kiss at the end it is more than a kiss! These actions do not mean what they mean by virtue of our experience of reality, but our exposure to other films. Antitheses: Things or ideas that are opposed to one another.

4 The symbolic code

This relates to the way an audience's reception of texts is determined by organizing all experience into a pattern of **antitheses**. These antitheses might include: good/bad; hero/ villain; true/false; or life/death. The list is endless, but it is only through this patterning of contrasts that the audience can "read" the text conceptually, know what it "means," over and above what merely "happens."

Language itself is structured around these binary oppositions and our entire cultural map of beliefs and values is derived from them: right/wrong; rich/poor; master/slave. Not that the pairings are ever strictly equal. In any given context one of the pair of terms is favored or "privileged" over the other, reflecting a hierarchy of value. For example, in so far as we sympathize with the central character in *Falling Down* the "traditional values" he represents are supported and endorsed.

5 The cultural (or referential) code

This encompasses the text's references to things already "known" and codified by a particular culture. This includes the body of shared assumptions relating to society, such as psychology, morality, and politics, without which the world of the text would be unfathomable.

Without a common currency of ideas about the law, marriage, and social responsibility we wouldn't understand what *Falling Down* was all about. We don't have to *personally* agree with these ideas, but they operate as a given frame of reference for the struggles the film enacts.

EXERCISE: READING SIGNS

You don't need to "take up" semiotics, but Barthes's theory is a useful tool to examine the "sign-writing" process of movie-making. Now select a favorite scene and use his five-part categorization to differentiate the signs and your reading of them.

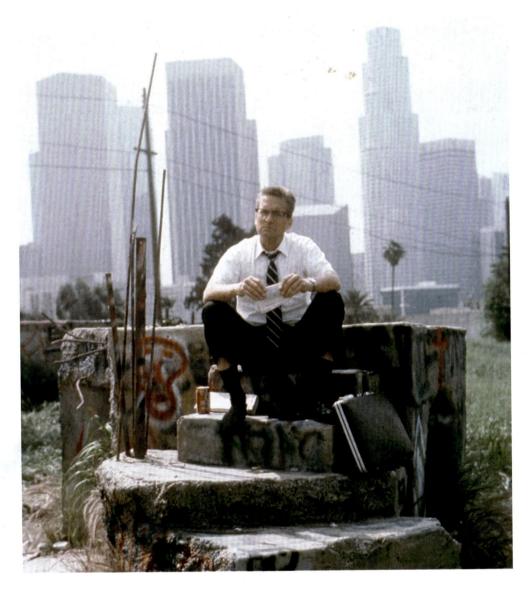

Falling Down 1993

director

Joel Schumacher

We can use Barthes's five "codes" to examine Michael Douglas's character: (1) raising questions about how he finds himself in these alien surroundings, (2) defining him by his business-like appearance, (3) interpreting whether sitting there is an act of fatigue or defiance, (4) exploring the contrast between skyscrapers and demolition sites, and (5) reflecting on the cultural values represented by both.

Case Study: Seven (1995)

	Seven New Line Cinema
Director	David Fincher
Screenwriter	Andrew Kevin Walker
Cast including	Morgan Freeman (Detective William Somerset) Brad Pitt (Detective David Mills) Kevin Spacey (John Doe) Gwyneth Paltrow (Tracy Mills)
Crew including	Darius Khondji (cinematography) Richard Francis-Bruce (editing) Arthur Max (production design) Gary Wissner (art director)
Tagline	Seven deadly sins, seven ways to die.

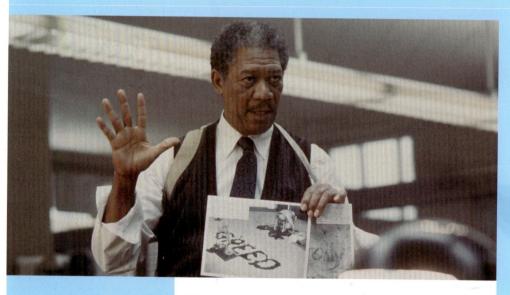

1.5

Somerset counts off the Seven Deadly Sins, and holds up a message from the killer which carries the signature "idea" behind these apparently motiveless crimes. It is delivered in the form of a sign which only Somerset can "read" and truly understand.

30

Synopsis

Police Detective Somerset is counting down the last seven days before his retirement. Called to investigate a suspicious death he detects the work of a serial killer who chooses victims to represent the Seven Deadly Sins. Knowing it will be a long-running investigation, Somerset is reluctant to be involved. However, he is equally sure that Mills, a young cop new to the city's homicide unit, is not yet ready for this kind of job.

Roland Barthes's five codes are clearly in operation in every part of David Fincher's *Seven*. Like any film—but perhaps more than most—this taut pitch-black thriller is a swirling sea of signs. The central conceit of the movie invites a semiotic analysis, as it seems to hinge on the ability to decipher a cryptic message. Even the title itself plays with systems of meaning. A great deal of the film's publicity refers to it as *Se7en*.

Key Connotations

The moment it begins the movie sets us to work, dealing out bits of information that the viewer can sort into appropriate patterns of understanding. Our senses are on maximum alert for the "road signs" that signal the kind of experience the film is going to give us.

The "world" of the film is created with great economy. Before anything appears on the screen we hear distant wailing sirens summoning up associations of danger and rescue, criminality and law enforcement. The almost constant rain adds an element of claustrophobia to the background hostility and menace of the soundtrack.

This external environment contrasts with the first visual images we see, as we follow Somerset (Morgan Freeman) moving slowly around the hushed and dimly lit interior of his apartment, getting prepared to face the city streets. His calm and methodical manner conveys an inner stillness, which will be his hallmark.

Assembly

In these early scenes, Somerset is being "assembled" for us from a series of carefully chosen outward signs that inform the audience who he is and what to expect from him. He tidies his kitchen, and one by one collects the personal effects neatly lined up on his dressing table. He carefully places a fountain pen in the pocket of his crisp white shirt, and plucks fluff from his suits.

When we next see him he looks like the stereotypical American detective complete with trench coat and trilby—a costume that adds to his air of authority, but singles him out as a figure slightly displaced in time.

The chess set in the foreground of the opening shot suggests intellectual combat and a struggle between black and white — good and evil. The switchblade he later throws with such shocking force and deadly accuracy into a dartboard presents mental sharpness, directness, and efficiency.

Other objects associated with Somerset represent extensions of his personality. When we see him in his cramped office pecking away at an old-fashioned manual typewriter we are seeing someone comfortably self-contained in his working habits, but "out of step" with modern ways. He says as much: "I don't understand this place anymore."

Most striking of all is the metronome that he keeps beside his bed. Its regular motion reflects the order he craves and drowns out the chaos that encroaches from the street outside. These noises—emergency vehicles and angry voices—are the world he lives in and wishes to escape.

All these signs point to Somerset's psychology—to the qualities of intelligence and calculation, maturity and independence, moderation and self-control, which equip him for the task ahead. They are visible external-signifiers of the invisible-internal-signified—his *mind*. These signs give the illusion of human depth and complexity that makes him "real" to us, and allow us to attribute to him beliefs and desires that can go unstated. Creating a coherent character profile encourages the audience to feel that they recognize and understand him. Attaching to him they attach to the film.

Working the Enigmas

Being a detective thriller the whole movie is explicitly structured around the need to solve a mystery. We are already alert to the overriding question the film asks. Who is behind these murders? Why "seven"? Where are the clues that will lead them to him? These question marks take us further and further into the heart of the film. One of the audacious things about this movie is the explicit way it foregrounds the "breadcrumb" procedure of clues and quesswork, which is the staple of the detective story.

Not only do we have the implicit countdown through the seven days of the week, but we see Somerset being seduced into investigating the case. Although he is determined to avoid involvement, his boss cunningly piques his interest—putting evidence on his desk (thin slithers of linoleum taken from the gluttony victim's stomach), and quietly mentioning over his shoulder as he leaves: "They were fed to him." Somerset is also being fed a line—and he bites. Somerset's curiosity gets the better of him. He's hooked, and so are we.

This trail of breadcrumbs orients the audience toward closure and the ultimate satisfaction of "order restored." Nevertheless, the big punch line delivered at the end of *Seven*, and the sudden change of direction implied by the words "I'll be around" leave us with something both shocking and thought-provoking.

Actions Speak Louder than Words

We experience something strangely familiar when we follow Somerset back to the crime scene. Hearing a strange throbbing coming from the refrigerator, he turns to find not only where the plastic came from but the note from the murderer that confirms his worst fears. Somerset here exhibits the powers of observation and intuition we associate with a master sleuth. He is on the villain's wavelength, with special insight into his deranged mind, and a methodical approach that cuts out all extraneous or superfluous influences. When he flatly refuses the coffee that his new partner Mills offers him on the way to the victim's apartment, it shows him to be intent only on the job at hand.

Recommended Viewing

Watch the opening of Steven Spielberg's *Schindler's List* (1993) for another example of a character "getting dressed" for the benefit of the audience.

Tip

When introducing a central character find an excuse to linger on them doing something indicative of who and what they are.

Things to look out for

Somerset in the library. What semiotics attach to poker, books and Bach?

The Clash of Opposites

Barthes's symbolic code offers the richest vein for analysis. The "cut" from the sound of Somerset's metronome to the edgy credit sequence juxtaposes order and chaos, method and madness in a way that perfectly captures the conceptual polarity around which the entire film turns.

Somerset and Mills embody a pattern of oppositions too numerous to mention. They belong to the time-honored tradition of the buddy movie—chalk and cheese, brains and brawn, the ever-steady and the unstable—a relationship beginning in hostility, but ending in mutual respect. We read each according to the other.

Their sharpest opposition appears in the cross-cutting between the library where Somerset has gone to do research on the Seven Deadly Sins and damnation, while Mills sits at home fruitlessly studying the files. The engraved illustrations depicting Hell in the copies of Dante's *Purgatorio* and Milton's *Paradise Lost* not only resemble the twisted corpses in the crime photographs, but reflect Mills's tortured incomprehension. Lacking the "culture" Somerset and John Doe share, Mills simply cannot read the signs.

When we see his wife looking on through a veil curtain, her role as angelic witness is clear. She is also the bridge that will bring the two men together.

Cultural Code

In order to understand even the first few minutes of the movie (including the edgy relationship between Somerset and Mills, their interview with the Captain, Mills's wife's reference to "tracker poles," and so on) the audience needs to understand a host of commonly held assumptions relating to personal ambition, seniority of status, professional advancement, career structures, hierarchies of responsibility, the authority of experience, and more. In other words, the audience needs to recognize (if not necessarily share) the values that dominate the modern world. An entire social structure is implied.

And of course, to understand the central **motif** of the film the audience must be able to recognize a host of moral and religious ideas based on a distinction between "crimes" that break the law of man—and acts that offend Almighty God. In a culture where such a distinction did not exist, the film would not only lack the frisson of Hell and eternal damnation—we would hardly understand it at all.

Motif: A dominant idea or concept, a recurring formal element, color or design feature. Repeated use of a particular **shot distance** can be developed into a motif through repetition and variation.

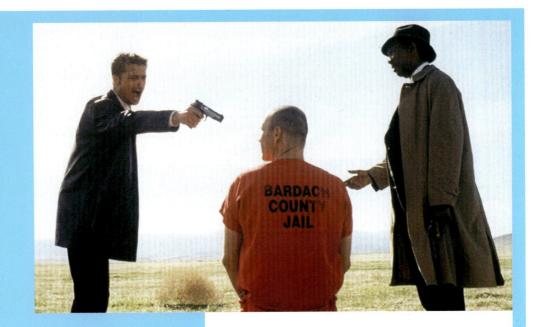

Seven takes us into moral and philosophical territory, and conducts a debate about human nature and social responsibility—it is the movie's innumerable signs that lead us there.

DISCUSSION QUESTIONS

Seven is an amalgam of signs and uses the familiar "myth" of the Seven Deadly Sins as the backbone of the story. What other signs are in operation to let you know you are watching a thriller?

Seven asks a number of questions (enigmas); consider what they are for you and where they appear in the film.

Unusually, Seven ends with an enigma. Do you think Mills shoots the killer?

Tip

Never neglect the details. When imagining a scene in your film it should be completely there in your head-the decor, the props, the clothes, the hairstylesvivid and exact in every particular. Always have regard for the way your audience is reading things at any given moment. Keep asking questions. What impression does this make? What impact is this having? Remember: Nothing escapes noticenothing is "silent"-on the screen.

We have looked in this chapter at signs—the basic units of cinematic meaning—and how they operate through association, combination, and interaction. Audiences are hypervigilant and (consciously or not) take in every minute detail of setting, costume, and performance. Everything on the screen contributes to characterizing the fictional world and the figures that inhabit it. Everything does a specific job and plays its part in the overall effect. Everything has meaning.

Hence the importance of planning and precision in choosing and arranging your material. You need to know each element will send the right bit of information, convey your intended meaning, and have the desired effect on the audience. Only then will their thoughts and feelings be exactly what you want them to be. It is so important to recognize the distinction between what is seen on the screen (the *signifier*) and what is understood (the *signified*). Good filmmaking is a matter of ensuring a firm relationship between the two. It is a matter of "the right images in the right order."

EXERCISE: REFRESHING CLICHÉS

Experiment with clichés. Take an over-familiar scene—someone preparing themselves for a romantic night out, an armed gang readying themselves to rob a bank, a cop trying to persuade someone not to throw themselves off a roof into the street. What elements seem "necessary" and why? What happens if you change any one of them?

EXERCISE: CHANGING THE IMAGE

Analyze a still taken from any part of this book. What thoughts or feelings does it provoke in you? Single out particular signs that contribute to this impression. For instance, look at page 29 and ask yourself why Joel Schumacher has given Michael Douglas an executive briefcase, a can of Coke, and a neat crew cut. How do these contribute to the image as a whole? Now imagine significant changes to the image (a suitcase, a bottle of whisky, longer unkempt hair), and assess the effect these would make to our assumptions about the character and his situation. Finally, watch the movie and see just how important these details are to the thematic meaning of the film as a whole!

Recommended Reading

Introductory Reading

Barthes, R. (1972) Mythologies, trans. A. Lavers. London: Jonathan Cape, 1972.

- Bignell, J. (2002) *Media Semiotics*. 2nd ed. Manchester and New York: Manchester University Press, 2002.
- Braudy, L. and Cohen, M. (eds.). *Film Theory and Criticism: Introductory Readings*, 7th ed. New York: Oxford University Press, 2009.
- Chandler, D. (2007) Semiotics: The Basics. 2nd ed. Abingdon: Routledge, 2007.

Hayward, S. Key Concepts in Cinema Studies. Abingdon: Routledge, 2006.

Monaco, J. How to Read a Film. New York: Oxford University Press, 2000.

Rose, G. (2006) Visual Methodologies: An Introduction to the Interpretation of Visual Materials. 2nd ed. London: Sage, 2006.

Silverman, K. (1985) The Subject of Semiotics. New York: Oxford University Press, 1985.

Stam, R. (1992) New Vocabularies in Film Semiotics. London: Routledge, 1992.

Advanced Reading

Barthes, R. S/Z: An Essay. New York: Hill and Wang, 1972.

Buckland, W. *The Cognitive Semiotics of Film*. Cambridge: Cambridge University Press, 2007. Metz, C. *Film Language: A Semiotics of the Cinema*. Chicago: University of Chicago Press, 1990. Mitry, J. *Semiotics and the Analysis of Film*. Bloomington: Indiana University Press, 2000. Wollen, P. *Signs and Meanings in the Cinema*, 4th ed. London: BFI, 1998.

NARRATIVE

The first thing to be considered in film analysis and production is the complexity of the overarching narrative structure. This implies that narrative is about stories. On one level it is, but narrative analysis is about much more than that. Narrative analysis is the study of the specifics of communication as it relates to structure—the details of the language that film uses.

As if that didn't sound complex enough, narrative is further complicated by its relationship to the real world. Film has its own specific language and as such is unconnected to reality in the way we might assume it is. However, as an audience, we have to believe that what we are seeing is real. It is the complexity of the relationship of narrative elements to narrative wholes and the relationship of both of these to the "real world" that makes narrative so fiendish for analysis and complex for filmmakers. Either way, you need to understand your medium.

2.0

Zardoz 1973

director

John Boorman

Zardoz is an interesting film depicting a society based around myth and legend—and therefore based around narratives. In the end, it is a copy of *The Wizard of Oz* that leads Zed to understand the world he inhabits. It is also both interesting and terrifying because of Sean Connery's costume. It was Frank S. Mottershaw's A Daring Daylight Burglary in 1903 that heralded a new vision for the moving picture as he introduced fictional storytelling to the medium. As part of the Sheffield Photo Company in England, Mottershaw pioneered a number of what would now be referred to as action films. The techniques that these films established quickly spread across the world and were further developed, most notably in Hollywood.

The Filmmaker as Theorist

This new form of storytelling included numerous scenes, cameras were placed carefully, and editing, particularly cutting on action, was introduced. From these techniques genres were established. This early foray into narrative-based cinema began to define the language of film. This is now as familiar to us as any spoken or written language. Like other languages it appears natural, but the language film uses is as carefully constructed and contextually driven as any other.

Film theory has its esoteric elements, which are often highly divorced from the practice of cinema, but on the whole it interrogates meaning, communication, and audience reaction. The vocabulary adopted by film theory may sometimes seem distant from the practice of making a film—the ideas certainly are not. Many great filmmakers are often the best (informal) students of their own medium and can talk eloquently about their own art and the work of filmmakers they admire. They are aware of the tools of meaning and communication and employ them as second nature.

For the new filmmaker, a sound knowledge of theory can lift your craft and turn it into art. It can also speed up a process, aid effective communication with a crew, and improve precision.

The Theorist as Filmmaker

The worst kind of theorist is one who takes no account of the context of film production; who sees film as nothing more than literature or history with moving pictures. To ignore the context in which a film is made and received is to disregard one of the things that makes film so special.

A working knowledge of the process of producing film is therefore helpful for the film theorist. Knowledge of shot types, how sound is recorded, how a crew really work together, the realities of having to use available footage in post-production, and so on, is essential information. This doesn't mean that every film theorist should leap out of their chair and grab a camera; much of this can be gleaned from observation or from reading about the experiences of directors. One thing that digital technology does afford the theorist is the opportunity to begin to engage in the process of production. Testing out ideas, shot types, and so on is both enjoyable and informative, even if you have no ambition to ever make a film.

EXERCISE: THE AUDIENCE

The majority of film theory, and a great deal of this book, is about the audience. Too often audiences are forgotten when film is treated as film, as an entity that exists almost divorced from any point of reception. Film is nothing without an audience. Like theater, film is designed for an audience; it is meaningless without them. Film theory forces the audience back into the equation. Audiences are varied and contingent, but it is important that we at least acknowledge they exist.

Structuralism: A term

applied to a body of thought that examines patterns of communication and meaning.

Text: A verbal, written, or visual artifact. Film is a medium that combines all these elements and thus the complexity of analysis is increased.

Recommended Reading

Aristotle's *Poetics* (c.335_{BCE}) is the foundation of all narrative analysis; it is thought provoking and surprisingly accessible. Roland Barthes's "An Introduction to the Structural Analysis of Narrative" (1966) will help you put the specific filmic theories on narrative into a broader context. **Structuralism** is an umbrella term for many different movements that share approaches to the analysis of the world. In structuralism's terms, everything in the world is available as "**text**" and can be analyzed in the same terms. Text thus means everything is available for analysis by the same set of broad principles. A text such as *Mythologies* (Roland Barthes, 1957) exemplifies this where Barthes uses the rules of structuralism and semiotics to analyze wrestling, red wine, and print media all in the same terms. This is the basis of film analysis.

Structuralism for Filmmakers

Structuralism developed out of the linguistic analysis of Ferdinand de Saussure (1857–1913) and in particular his book *Course in General Linguistics* (published posthumously in 1916). His principles were taken, developed, and applied to all aspects of human interaction to become the movement we understand today as structuralism. Film has its own specific language and as such the theories of a movement based in the study of language are particularly pertinent.

The benefits of a working knowledge of structuralism and its branches of semiotics and narratology are evident for film theorists. The advantages for the filmmaker are less obvious, but no less vital. Most filmmakers are hugely knowledgeable about the form they work in, be it the cinema history of Martin Scorsese or the avant-garde artistic expression of Derek Jarman. Filmmakers tend not to use the vocabulary of structuralism, but they implicitly use the approaches. When you are starting out you should endeavor to use both. Structuralism, as the name suggests, is about structure, and the smallest elements that go together to make up structure; this means that it can be used to ensure precision.

There have been many developments from structuralism such as post-structuralism and deconstruction, which challenge the assumptions made in the original theory. However, it is important to note two things:

- 1 Without knowledge of structuralist principles it is impossible to engage in subsequent debates.
- 2 Film language does not evolve in the same way as spoken language—it is a highly structured form.

The Foundation of Narrative Analysis

The study of narrative in film has been examined in a great deal of depth by a wide range of theorists and practitioners in a variety of different academic fields. Film narrative has been studied, appropriated, and used by sociologists, psychologists, cultural theorists, anthropologists, and semioticians as well as by literary theorists. However, by far the most plentiful source of narrative analysis has come from academics with a literary background who often work under the assumption that all narratives operate in the same way.

Much of the narrative analysis that film theory purports to have developed comes via the structuralist revolution of the 1960s; a theoretical system that still maintains much of its base in Aristotle's Poetics, which essentially deals with drama rather than literature or film.

If you string together a set of speeches expressive of character, and well finished in point and diction and thought, you will not produce the essential tragic effect nearly so well as with a play which, however deficient in these respects, yet has a plot and artistically constructed incidents.

Aristotle, Poetics

EXERCISE: UNDERSTANDING THE AUDIENCE

The issue of audience analysis is one that is a perpetual problem for film criticism. There is nothing wrong with looking at the construction of a film and analyzing how an audience may read and interpret what is appearing on the screen. However there are other methods of addressing this thorny issue; this is where ethnographic research methods meet film analysis. Consider what questions you may wish to ask of an audience, then show them a short film.

- What kind of responses are you getting?
- How representative of an audience do you think the group you have are?
- What demographic do they represent and how does this impact on the film?
- What impact does the size of the group have?
- Do you think that speaking in front of each other has had an impact on how they responded?

This kind of research can be very helpful but has to be treated with caution.

Structural Analysis

In his "An Introduction to the Structural Analysis of Narrative" (1966), Roland Barthes made many clear and compelling connections between narrative and the real world. Four of the key points to remember are:

- 1 Narratives appear in many forms: written, verbal, and visual all of which form part of the complex language of cinema.
- 2 Narratives are constructed, they don't just appear; they are selected and ordered. This is true of real life, but we do this on a subconscious level. In film it is deliberate.
- 3 Narratives apply to all human and cultural interaction—narrative discourse operates throughout all culture and throughout all time. This in itself makes the relationship between the real world and a film world even more complex for analysis, but it also allows the maker a great deal of freedom.
- 4 Narratives are "transhistorical"—they have always existed and by implication always will. This implies that narrative is primordial. In these terms film is now part of the real world film language is yet another language that we engage with on a regular basis.

This is the basis of narrative analysis in cinema—that there are comparisons between day-to-day communication and film language. However, film has its own specific modes of communication. It is the intersection between everyday life and film form that creates meaning for an audience. This suggests something fundamental.

Narrative is not the same as story: that is too simplistic. Narrative is about comprehension. Narrative is a fundamental facet of human communication.

Narrative may incorporate articulated language, spoken or written; pictures, still or moving; gestures and the ordered arrangement of all of these ingredients. It is present in myth, legend, fable, short story, epic, history, tragedy, comedy, pantomime, painting, stained glass windows, cinema, comic strips, journalism, conversation ... narrative is present at all times, in all places, in all societies; the history of the narrative begins with the history of mankind.... The narrative scorns division into categories of good and bad literature: narrative is international, transhistorical, transcultural: it is simply there like life itself.

Roland Barthes, "An Introduction to the Structural Analysis of Narrative," 1966

Narratology

Narratology is the name given to the study of narrative and narrative structure. In looking for patterns and trends in all texts it is part of the structuralist movement. This grouping of thinkers is informed by Saussure, but also by Claude Lévi-Strauss who (as a structural anthropologist) looked at repetitive narrative structures across different countries and cultures. In these terms, film narratology is concerned with both language (as in film's specific codes and conventions) and context and often the relationship between the two.

Story and Plot

We have established that narrative is about much, much more than simply telling stories, but in terms of filmic narratives meaning starts to be generated when plot is established. In unpicking a film or setting out to create a film, it is possible to start with an overarching story but the plot has to follow quickly in order for things to make sense.

This is essentially because plot is about causality—how one event or action leads to another. If this is not made explicit then a film makes no sense at all. As E. M. Forster said: *"The king died and then the queen died* is a story. *The king died, and then the queen died of grief* is a plot." If this is not established by the filmmaker then an audience will try and establish it themselves.

EXERCISE: FINDING THE PLOT

Take the key elements of any well-known film of your choice and write them down as bullet points. Avoid noting the causal relationships and then present this to three or four different people—can they identify the film? Then, try adding in a couple of the actual plot points, noting the different narratives that emerge. Once you have added these plot points you should show the breakdown to the same group of people and assess how many of them can identify the film from this simple breakdown.

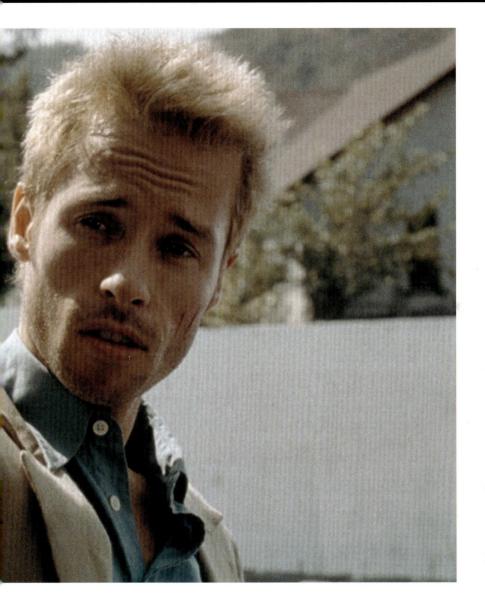

2.1

Memento 2000

director

Christopher Nolan

Memento is an interesting film on a number of levels; in this instance because of its casual relationships. It was lauded as a film that experiments with narrative. This is not the case. It is a film that clearly reverses the narrative. Part of the quest for the audience is to piece together the relationship between events. This is still conventional narrative form.

Recommended Reading

It would be valuable to read *The Screenwriter's Workbook* (2006) by Syd Field. Field has his detractors and his supporters but regardless of your opinion his work provokes thought about the rigidity of structure in Hollywood cinema. Structure is vital. This seems like an obvious statement, but budding filmmakers often think that a good structure will naturally emerge from a good story rather than being set out from the start. The temptation is also to assume that structure is the preserve of the screenwriter. While the writer undoubtedly is the first person to deal with structure, and has to be aware of the forms in which they are working, structure is an essential consideration for all members of the team. Developing a unified structure for your film will require the cooperation of everyone involved in the production.

The Formalists and Vladimir Propp

The Formalists, or Russian Formalists, worked between 1910 and 1930. They are significant in their detailed concern for the nature of poetic language. The Russian Formalists looked to the nature of "art" in its broadest sense and were keen proponents of avant-garde work. One key member aligned to the Formalists was Vladimir Propp.

Propp developed the *Morphology of the Folk Tale* in 1928, although this didn't have a broad Western impact until the late 1950s and as such became an early part of narratological analysis. Propp's work is well-trodden ground, but worth returning to as its impact cannot be overestimated.

Propp categorized the characters that appear in folktales as "The Seven Spheres of Action":

- 1 Villain
- 2 Helper
- 3 Donor (often magician)
- 4 Female in distress and her father
- 5 Dispatcher
- 6 Hero
- 7 False hero

Propp's work has been developed for film analysis by people such as Will Wright in his book Sixguns and Society: A Structural Study of the Western (1977), which examines narrative patterns in the Western. Wright uses Propp's theories and lists directly. Since then, many criticisms have been leveled against Propp's work. In some ways, this is hugely unfair as Propp never claimed that his rules could be used for anything other than the folktale. The argument follows that any film could be made to fit the lists on pages 50-51; it is an exercise worth trying. The question that comes from this is whether the lists presented by theorists such as Propp are reductionist in the way they compress the structure and content of a film into such a simple form. In analysis this depends on the type of film itself. Some films are made to reach as wide an audience as possible, and as such may use a simple structure, and the most simple and familiar is that analyzed by Propp. The filmmaker may be using their own knowledge of the fairy tale; the analyst will be using the framework presented by Propp.

Propp's 31 Narrative Elements

Vladimir Propp defined the progression of a fairy tale as being made up of 31 narrative elements—the core narrative elements. He claimed that not all elements had to be used in every story, but many would be. Questions remain about whether these elements are so broad that they can be made to fit any narrative and therefore how useful they might be.

EXERCISE: READING FAIRY TALES

Try picking a film that bears the traits of the folktale or fairy tale and see how it fits into "The Seven Spheres of Action." A film such as *Star Wars* is too obvious and has been done. Then attempt the same process with a film such as *Schindler's List* (dir.: Steven Spielberg 1993) and then something like *Week End* (dir.: Jean Luc Godard 1967). The results may be very interesting. From this you can debate why Godard's work is labeled avant-garde and why Spielberg came under some criticism for *Schindler's List*, despite laudable attempts to represent the horror of the Holocaust. Some of these criticisms focused on the need to have Schindler as the "hero" rather than a Jewish character, and other feelings of emotional exploitation.

Propp's Narrative Elements

The following list is how Vladimir Propp defined the progression of a fairy tale the narrative elements.

- 1 A member of a family leaves home (the hero is introduced).
- 2 An interdiction is addressed to the hero ("don't go there," "go to this place").
- 3 The interdiction is violated (villain enters the tale).
- 4 The villain makes an attempt at reconnaissance (either villain tries to find the children/jewels, etc.; or intended victim questions the villain).
- 5 The villain gains information about the victim.
- 6 The villain attempts to deceive the victim and take possession of victim or victim's belongings (trickery; villain disguised, tries to win confidence of victim).
- 7 Victim taken in by deception, unwittingly helping the enemy.

- 8 Villain causes harm/injury to family member (by abduction, theft of magical agent, spoiling crops, plunders in other forms, causes a disappearance, expels someone, casts spell on someone, substitutes child etc., commits murder, imprisons/ detains someone, threatens forced marriage, provides nightly torments); alternatively, a member of family lacks something or desires something (magical potion, etc.).
- 9 Misfortune or lack is made known (hero is dispatched, hears call for help, etc. Alternative is that victimized hero is sent away, freed from imprisonment).
- 10 Seeker agrees to, or decides upon counter-action.
- 11 Hero leaves home.
- 12 Hero is tested, interrogated, attacked, etc., preparing the way for his/her receiving magical agent or helper (donor).

- 13 Hero reacts to actions of future donor (withstands/fails the test, frees captive, reconciles disputants, performs service, uses adversary's powers against them).
- 14 Hero acquires use of a magical agent (directly transferred, located, purchased, prepared, spontaneously appears, eaten/drunk, help offered by other characters).
- 15 Hero is transferred, delivered or led to whereabouts of an object of the search.
- 16 Hero and villain join in direct combat.
- 17 Hero is branded (wounded/ marked, receives ring or scarf).
- 18 Villain is defeated (killed in combat, defeated in contest, killed while asleep, banished).
- 19 Initial misfortune or lack is resolved (object of search distributed, spell broken, slain person revived, captive freed).
- 20 Hero returns.
- 21 Hero is pursued (pursuer tries to kill, eat, undermine the hero).

- 22 Hero is rescued from pursuit (obstacles delay pursuer, hero hides or is hidden, hero transforms unrecognizably, hero saved from attempt on his/her life).
- 23 Hero unrecognized, arrives home or in another country.
- 24 False hero presents unfounded claims.
- 25 Difficult task proposed to the hero (trial by ordeal, riddles, test of strength/endurance, other tasks).
- 26 Task is resolved.
- 27 Hero is recognized (by mark, brand, or item given to him/her).
- 28 False hero or villain is exposed.
- 29 Hero is given a new appearance (is made whole, handsome, given new garments, etc.).
- 30 Villain is punished.
- 31 Hero marries and ascends the throne (is rewarded/promoted).

EXERCISE: USING PROPP

Take your idea for a film and pit it against Propp's character list and sequencing list. How far does this help you in forcing a narrative sequence and plot development? Surrealism: A short-lived artistic movement that sought to explore subjective dreamstates and was concerned with subverting the logic of representation. It is often incorrectly used today to refer to things that are unusual.

The Classic Hollywood Narrative Structure

Tzvetan Todorov developed Propp's notions and boiled them down even further to try and identify the barest elements of narrative structure. Todorov developed his notions of how narrative communication works during the early part of his career and these structuralist principles informed much of his analysis in the 1970s and into the 1980s. His narrative sequencing started with three elements that built on Aristotle's notion of structure.

Equilibrium (beginning) → Disruption of equilibrium (middle) → Return to equilibrium (end)

Todorov expanded this to involve the characters, to offer a recognizable reason for the initial three stages:

- 1 Equilibrium is established.
- 2 Disruption to the equilibrium.
- 3 Character(s) identify the disruption.
 - 4 Characters seek to resolve the issue to solve the problem to restore equilibrium.
 - 5 Reinstatement of equilibrium.

This is a useful aide-memoire, even if you are attempting to create a non-narrative form. In attempting to do this you cannot create something wholly random. Audiences expect narrative sequences—this is part of the language of cinema that has been established. If you want to challenge an audience the first place to start might be to play with this sequence.

A note on non-narrative forms

Be very careful when setting out to create something which is non-narrative. There is a world of difference between something that is abstract and something that "plays" with narrative form. The former tends to be video art or some of the more extreme examples of **surrealism** (such as *Un Chien Andalou* (dir.: Luis Bunuel 1929)). Other filmmakers who tend toward experimentation utilize an audience's knowledge of narrative structure and convention, for example Hal Hartley's short *Ambition* (1991).

2: Narrative 53

The Classic Hollywood Three-Act Structure

The Classic Hollywood Narrative Structure has been developed since the conception of Hollywood as the dominant seat of production. In these terms, it has become part of the vocabulary of cinema not because it is "natural" but because it has been repeated.

Syd Field is one of the most respected screenwriting gurus working in America. Field identified the following structure and suggested its use for all other filmmakers. For Field, the three key stages of any film are: setup, confrontation, and resolution. These are broken down as follows:

- Act 1 Comprises the first quarter of the screenplay. In a 120-minute film, Act 1=30 minutes.
- Act 2 The next two quarters of the film. In a 120-minute film, Act 2=60 minutes.
- Act 3 The final quarter of the film. In a 120-minute film, Act 3=30 minutes.

Recommended Viewing

There are many films worth examining to investigate Hollywood structure. A film such as *The Apartment* (dir.: Billy Wilder 1960) is a classic. An interesting exercise is to compare and contrast the structure of Hollywood remakes, such as *Boudu*, *sauvé des eaux* (dir.: Jean Renoir 1932) and *Down and Out in Beverley Hills* (dir.: Paul Mazursky 1986).

Aristotle's Poetics

As we've already seen, Aristotle's Poetics is the foundation of all criticism and theory as we understand it today. In it he defines the barest elements of narrative:

A whole is that which has beginning, middle and end. A beginning is that which is not itself necessarily after anything else, and which has naturally something else after it; an end is that which is naturally after something itself, either as its necessary or usual consequent, and with nothing else after it; and a middle, that which is by nature after one thing and also before another.

While this seems so obvious that it is almost pointless stating it, this is to misread Aristotle. Poetics is a treatise on the nature of drama and what Aristotle is pointing out is that the narrative sequencing resulting in a beginning, middle, and an end is a construction born out of the desire to make drama coherent. This is then distinct from everyday communication, where the requirement for narrative completion is not the same—everyday life doesn't have such neat beginnings, middles, and ends.

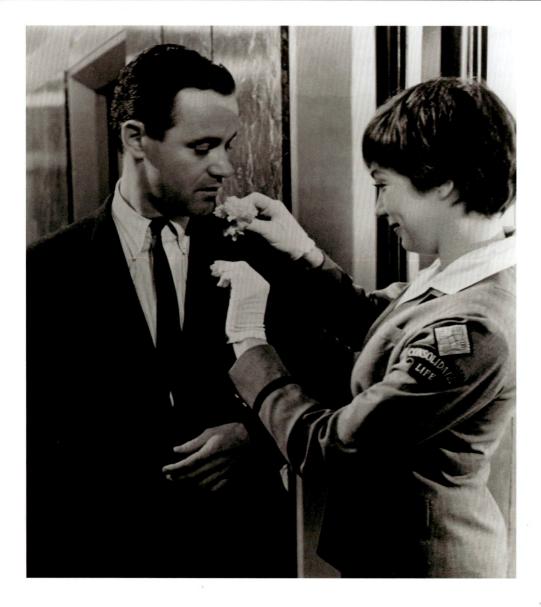

2.2

The Apartment 1960

director

Billy Wilder

Billy Wilder's 1960 film, *The Apartment*, is widely considered to be a classic of Hollywood cinema. It is a deceptively simple film in that it appears to be a straightforward romantic comedy. Any analysis of its deeper structure shows the mastery at work in making something so complex seem so simple.

The Apartment and Narrative Form

Billy Wilder was an Austrian-born American writer, director, and producer who worked mainly in the 1940s to 1970s. *The Apartment* was nominated for ten academy awards and won five; including best director, best picture, and best screenplay (with Izzy Diamond).

The narrative form is significant in that it very quickly opens where the equilibrium has been disrupted as C. C. Baxter (Jack Lemmon) is trapped outside his apartment-and this seems to be the core of the film. Instead this is the equilibrium for Baxter and gives his status as a loser. However, the film is not that simple and instead it is Baxter's relationship with Fran Kubelik (Shirley MacLaine) that is the core of the story. Baxter's apartment is a narrative device that creates comic effect with his neighbors and problems for him with his colleagues. In this sense the equilibrium is disrupted at the point that Baxter learns Mr. Sheldrake (Fred MacMurray) is having an affair with Fran Kubelik. The change in Baxter occurs when he looks after Fran following her suicide attempt, to the point of reaping the wrath of her family, and then sees her leave. It is the point where Baxter rejects Sheldrake's key to the executive washroom and thus the trappings of success that would make him like the despicable characters around him. This is the move back to equilibrium, except this time it is suggested that Fran will leave with him. The character's position of flux is not the same as the narrative being in flux.

The Classic Hollywood Narrative Structure is evident in *The Apartment*; the film starts with a problem and has a happy ending. This doesn't mean that it has closure or that all the issues are resolved. For instance, we don't know (nor care) what happens to Sheldrake despite the possible collapse of his family life; however, the narrative that the film sets up has been resolved. Baxter is no longer on his own. The initial enigma has also been resolved; he can get in to his own apartment again, although he seems to have achieved this by leaving for good.

An audience is never wrong. An individual member of it may be an imbecile, but a thousand imbeciles together in the dark—that is critical genius. Billy Wilder, filmmaker, writer, producer and artist Gérard Genette's *Narrative Discourse: An Essay in Method* (1983) is intended for all narratives in all modes. For this reason, Genette's is the most comprehensive narratology available and it is his connection of narrative and discourse that is most important of all. In these terms discourse can be defined as the imparting of knowledge and, most essentially, debate.

Story (Content)

Events Characters Settings chronology/causality actions/interactions spatiotemporal complexes

Narration (Telling)

Types Levels Voice reliable/unreliable embedded narration narrator/character

Text (Presentation)

Time Characterization Focalization order/duration/frequency traits/attributes who sees/perceives/judges events?

In *Narrative Discourse* Genette examines a number of essential points. He does not purport to provide structure, as Propp does, or to oversimplify structure as with Todorov or Field. Instead he identifies the key elements in narrative; elements that have to be present in order for a narrative to make sense. More than this he identifies the key elements that make a narrative mean something to an audience.

With the introduction of the element of "text" he identified how meaning is not down to the decision-making faculties of an audience. This is not directly the same as the ideology identified and discussed in Chapter 4; instead this is the buried and subsumed meaning that is generated from the structure of the specific narrative form.

Story

Story is the primary level of any narrative. This is the section that the inexperienced filmmaker starts and finishes with. The inexperienced critic does the same. This is where the content is developed and meaning begins, but this is not how meaning is communicated. Genette posits that events, characters, and settings need to be treated with particular consideration:

Events: things happen, but it is crucial to note the causal relationships. In these terms events become a plot.

Characters: there are characters that interact with each other (interactions) and they do things (actions). This is not the same as characterization. This is crucial because a character who does not really do anything, or doesn't progress the plot, becomes part of the setting.

Setting: things happen and characters exist in a particular time and place. This frames the characters and the events.

This then provides the starting point for developing the content, but doesn't touch on form in any great detail.

Narration

As a narratologist, Genette is concerned with all narratives and as such his levels of narration are highly detailed. Speech is often overlooked in production and analysis. Who is speaking, when, where, and to whom are all vital questions. When placed against how we view characters, this becomes even more complicated. The notion of reliability is paramount. If we have seen a character behaving in a duplicitous manner we are unlikely to believe what they are saying. Where characters are consistent we are unlikely to question what they say. This even stretches to the morally ambiguous detectives in **film noir**.

The positioning of narration is an important consideration and in cinema it can be separated into three main areas:

Extradiegetic: narration from an exterior voice, not a character in the film, or where we don't know who the character is at that stage. A voice-over. The first few seconds of *The Apartment* (dir.: Billy Wilder 1960) exemplifies this.

Homodiegetic: a character narrator. A voice-over or the rare example of a character speaking directly to camera. For instance, the opening dialogue from Lester Burnham in *American Beauty* (dir.: Sam Mendes 1999).

Intradiegetic: two or more characters speaking to each other—remember they speak to further characterization and/ or plot, not for their own benefit. Film noir: A largely American film genre often based around crime fiction. It has its roots in German Expressionism.

2.3

Forrest Gump 1994

director

Robert Zemeckis

Forrest Gump contains all three forms of narration; intradiegetic (for example, when Gump is talking to the woman on the bench), extradiegetic (where no character is in shot or the viewer sees things that Gump cannot have seen) and homodiegetic (where we see Gump in shot talking about himself). Sometimes all three of these techniques are used within a single scene.

58

Making Meaning-Text

It is Genette's category of "text" that is of most importance to the budding filmmaker and the considered critic. This is the section where meaning is generated for an audience. This is the manipulative phase. For an analyst, this is the aspect of the film to delve into. For the filmmaker, this is the aspect to prioritize.

Characterization: this helps characters become real for an audience. It is their traits and attributes, as if they were real people.

Time: this refers to characters, settings, actions; in fact all of the elements of narrative outlined above. The simplest way to consider this is in relation to repetition; the more we see things the more likely they are to stick. More than this, it is the order in which we see things and how long they last. All of these things will go to aid our prioritization of particular aspects of a film narrative.

Focalization: this is the final and crucial positioning of an audience. This is where the viewpoint of a character takes priority and dominance. This doesn't mean that a character needs lots of information or even as much information as us. It is about viewpoint rather than knowledge.

François Jost and Ocularization

François Jost's concept of "ocularization" is interesting to the prospective filmmaker because it relates directly to the prioritization of the image:

To distinguish the relationship between how the camera shows the hero and how the hero is supposed to be seen, I propose to speak of *ocularization*. In effect, this term is valuable in evoking the field of action taken by the camera. When it sees things from the position of the character this is "internal ocularization": when the opposite occurs whereby it sees things from the position of some other person, I have provisionally used the term *external ocularization*.

François Jost—"Narration(s): en deçà et au-delà," Communications, 38, 1983 (my translation).

By this Jost means that the position of the camera with, or alongside, the protagonist shifts the audience's attention to that position.

Tip

It is worth looking at the films of particular *auteurs* to establish whether the music plays a part in our familiarity with their work. For example, Woody Allen's use of familiar jazz tracks or Alfred Hitchcock's recurrent use of Bernard Herrman. Music cannot directly communicate narrative in the same way that dialogue can. However, it can provide a backdrop to visual events and dialogue and it is this subtlety that may position an audience in a way that dialogue cannot. Music is representative and emotive. It can engage an audience at a different level and capture their emotions rather than their conscious mind. It is difficult to avoid the emotive pull of a well-executed score.

Ways of Working with Music

There is one mode of storytelling that exists in cinema beyond that of showing and telling: music. This facet of cinema can have a dramatic effect on character. Music can impact on our emotions and as such can limit what emotional impact a scene has upon us; and this is different in every film. It doesn't matter whether it is the incidental music, a popular soundtrack, or a themed score; it all affects us as an audience. This use of music has been treated by theorists as an aspect of narration, but it cannot tell, it can merely aid focalization in relation to that which is being shown and told by affecting mood. This is the aspect of film that acts as a backdrop and some filmmakers, such as Ingmar Bergman, feel it should not be included as it clearly breaks with presentation of both characters and events in terms of relating them directly to the real world.

Whatever the use of music is within any film it is complex to identify its precise meaning—such is the nature of music. However, to ignore it is to ignore a powerful part of the signifying practice of cinema.

EXERCISE: MANIPULATING SOUND

Redubbing a film is always an interesting exercise. In doing this you can see how the replacement of, say, a specific score with tangentially related popular music tracks fundamentally impacts on your ability to "read" the film, even down to the point of being able to view who the main characters are and what they do.

60

2: Narrative 61

2.4

Manhunter 1986

director

Michael Mann

There are many sequences in *Manhunter* where the soundtrack dominates the film. The music is supposed to heighten the audience's reaction to the onscreen action but is not sufficiently subtle and so becomes a distraction. Instead of drawing the viewer in, the music actually distances the viewer from the storytelling.

2.5

New York Stories 1989

directors

Martin Scorsese, Francis Ford Coppola, Woody Allen

New York Stories is a film made up of three short films, *Life Lessons* (Martin Scorsese), *Life Without Zoe* (Francis Ford Coppola), and *Oedipus Wrecks* (Woody Allen). Each of these films represents a different take on the short film, but each follows a similar structure

The Specifics of Short Film

There are some aspects of short-film production and reception that differ substantially from feature films. It is worth studying these differences prior to either beginning work on your own short film or analyzing the work of others. First, it's worth noting that the actual language of film is not dependent on the length of the film, it is the way in which the narrative is constructed and communicated that differs. Overarching narratives are therefore the same as features, but the specifics are different.

Generally speaking this means that short films tend to have:

- Only a few characters—who are characterized in detail, and thus possibly more characters who are not characterized, who are there as part of the setting.
- No subplots.
- Fewer settings/locations.
- Cuts between major plot points.

Obviously, these factors are all dictated by the length of the film, but the net result is that short film can have a different character from feature films and it is important to recognize the similarities and the differences.

Three Acts?

While Hollywood films tend toward a neat three-act structure, as outlined by Syd Field, short films don't have the 90 to 120 minutes outlined in his theory. But they do still have a structure. The structure of *Life Lessons* is built into acts that take on board Todorov's conception of the dramatic narrative. There is much less time allowed for this than in a feature film, however, and not just because of the restricted running time of the film. Short-film audiences tend to be far more interested in the middle section of the narrative—the disruption to the equilibrium and the central protagonist's quest to restore the equilibrium, than they are in the initial setup.

- Equilibrium (beginning): Lionel Dobie is jealous about Paulette.
- Disruption of equilibrium (middle): Paulette threatens to leave.
- Return to equilibrium (end): Paulette leaves only to be replaced by a carbon copy.

While a little longer than many short films *Life Lessons* is a good example of a film where the equilibrium is ultimately restored. Although this doesn't mean that the ending is positive—the main protagonist is going to behave in a similar way to another person. However, this is where he started, so equilibrium is restored. This gives us the twist at the ending; after all the trouble and angst he simply starts again. This exemplifies an important point: resolution is for the audience, not necessarily for the characters.

Viewing Short Films

There are many short films available, but many of them never make it to mainstream cinema. Increasingly pay-on-demand services and online exhibitors such as Vimeo and YouTube are an excellent source for finding short films. Still the best filter is via film festivals and it can be a good idea to seek out what has been screened at festivals if you can't make it there in person. The following is a brief list of notable short films that are easily accessible online:

- Please! (dir.: Paul Black)
- Story of a Sign (dir.: Alonso Alvarez Barreda)
- The Heart of the World (dir.: Guy Maddin)
- Flapwing and the Last Work of Ezekiel Crumb (dir.: Alasdair Beckett-King)
- Persistence (dir.: Sebastian Synowiec)

It is also interesting to watch portmanteau films which are made of a series of short films with a unifying theme:

- Dead of Night (dir.: Robert Hamer, Alberto Cavalcanti, Charles Crichton, Basil Dearden)
- Kwaidan (dir.: Masaki Kobayashi)
- La ronde (dir.: Max Ophüls)
- California Suite
 (dir.: Herbert Ross)
- Coffee and Cigarettes (dir.: Jim Jarmusch)
- Creepshow (dir.: George A. Romero)

The Secret Life of Walter Mitty 20th Century Fox

Director	Ben Stiller
Screenwriter	Steven Conrad (Based on the short story by James Thurber)
Cast including	Ben Stiller, Kirsten Wiig, Sean Penn
Producers	Samuel Goldwyn Jr., John Goldwyn, Stuart Cornfeld, Ben Stiller

2.6

The pre-title sequence begins the process of establishing character. Despite the family that sticks so closely to Mitty he is essentially a loner. His attention to schedules and his inability to send a "wink" on an internet dating site suggest he is shy and nervous. Initially he is shown to be alone in a crowd.

Synopsis

Walter Mitty is a dreamer, a man who wishes he could achieve and finds himself stuck in his job and a life ostensibly alone. His modus operandi is to dream of the things he could be but can never achieve. It is quickly established that he is attracted to a coworker, Cheryl, who by coincidence he has seen on an internet dating site. His employer, *Time* magazine, is due to switch to online publishing only and as such he may find himself unemployed among a number of other workers. He quickly becomes employed in a quest to find a missing negative—an image that was due to be the final front cover of the most iconic magazine of all time. The quest is partly undertaken in response to Cheryl's urging. Mitty's journey takes him to Greenland, then Iceland, back to America and eventually to the Himalaya. He believes that Cheryl has returned to her husband but when they meet to collect their severance checks he discovers he was only visiting. The film concludes with the revelation that the photograph was of Mitty himself.

Story

The Secret Life of Walter Mitty has a deceptively simple structure. One way of reading the film is as a simple "boy meets girl" story and thus to categorize it as a romantic comedy, and as such audiences may come to the film with expectations. This, however, is not the full story; that would of course be too easy. In fact, this is a story about living life to the full and not being held back by fears or trepidation. In these terms Mitty is us and his "ordinariness" is something that is developed in the early stages of the film. It is these qualities that define his early characterization—although his traits and attributes develop throughout the film.

Plot

The plot is driven by connections between the various aspects of the story. On one level this is Mitty's quest to find the missing negative by tracing Sean O'Connell (Sean Penn) but this is intrinsically tied to his attempts to woo Cheryl Melhoff (Kristen Wiig). The visceral daydreams that define his life slip away to real adventure although his deep-seated propensity for adventure is established as a character trait. In terms of signification this has an interesting effect on the audience: at the start the dream adventures are grandiose and feature either exaggerated characterization (e.g., where Mitty sees himself as an arctic explorer) and/or exaggerated visual scenes (e.g., where Mitty fights Hendricks (Adam Scott) in exaggerated superhero manner). It is following the early imagined scenes that the "real" adventures seem simple by comparison and thus more realistic to an audience. The overarching message of "live your life" seems even more achievable. What is seemingly odd is that Mitty is an expert skateboarder; this is central to the plot and his ability to skateboard around Iceland but also confirms his reserved personality and lack of ego. It is important that when he shows Cheryl's son tricks she doesn't see it. Thus the

audience have far more information than she has and this puts them in a privileged position. Cheryl's liking for Mitty is really for who he is, not what she thinks he is.

The plot is driven by the motivation of the central character. It is Mitty's fear of failing at his job and his desire for Cheryl that informs his decision to change his behavior and thus provides the plot. This is simple and yet it is still a plot—it is still the aspect that links the elements of the film together and allows the ending to be resolution and to provide closure.

Three Acts?

Most films conform to Todorov's structure. What needs to be noted is that the starting point may show a character in flux. *The Secret Life of Walter Mitty* places the central character in a disrupted state; the ending leaves him with aspects of his life resolved yet still in a state of flux. Todorov's structure does not equal simple resolution.

- Equilibrium (beginning): Mitty's life is established.
- Disruption of equilibrium (middle): The negative is lost.
- · Return to equilibrium (end): The negative is found.

In these terms the film doesn't follow the conventional three-act structure as outlined by Field. There is certainly a sense that there is some resolution at the end; the image on the last cover of *Time* is a clear signifier that Mitty was always in receipt of the life he thought he had avoided living. The fact that he ends with no job is part of the resolution as now Mitty's life will change fundamentally, including his relationship with Cheryl. As a character he has come to terms with the issues that have held him back, stemming from the death of his father, and he has achieved his desire to travel. The elements of the story structure do not occur at such equally spaced moments within the film.

Text

As we've seen, according to Gérard Genette (page 56), text is where meaning is really generated. In *The Secret Life of Walter Mitty* the text breaks down as follows.

Time (order/duration/frequency): *The Secret Life of Walter Mitty* could have easily become driven by action from the outset to hold on to the audience—and in fact it is. It appears to have a gentle pace as the opening shows Mitty in subdued mode, but we are consistently given action sequences. These move between the imagined and the real to becoming real. The earlier imagined sequences are shorter as there is less peril than the longest adventure, into Afghanistan and the Himalaya. The recurrence of references to Cheryl is also vital in maintaining her character as central to Mitty and the film. This frequency (including calls to Todd, the eHarmony rep) reminds us of Cheryl's presence and Mitty's relationship with her.

Characterization (traits/attributes): the characterization of Mitty is unusual in that the major aspect of a character we never get access to is their psychology. The fantasy sequences are significant and the moment when Mitty is incredulous that the incident with the shark is real is echoed by the audience. The daydreams that are manifest are aspects of his psyche—something that we are unusually privy to. Mitty is established via his habits, his clothes, and his actions in relation to his bully managers. These in turn point to his personality traits and he is quickly established as an underachiever due to things that had happened to him in the past.

In short films it is important to establish the protagonists' characteristics quickly and efficiently; however, a feature film can take its time and develop characters. Crucially, characters can change. In *The Secret Life of Walter Mitty*, the protagonist's key characteristic is insecurity, shown through his inability to act in difficult situations. This insecurity is endearing and makes an otherwise weak character one the audience will want to follow. Unusually for a feature film there is little deep characterization of the other characters; O'Connell is an enigma, Hendricks is a bully (and idiot), and Cheryl is defined in relation to Mitty himself.

Point of view (POV) shot: A shot taken from the subjective perspective of a character or object in the film. **Focalization** (who sees/perceives/judges events?): as the only character who is characterized in any significant detail, *The Secret Life of Walter Mitty* establishes Mitty as the focalizer in the opening scene This is confirmed by the **point of view (POV)** image of his accounts; unusually we are seeing through a character's eyes. Mitty is a reliable character, he knows he is daydreaming and this is fantasy. If he were to believe what he was seeing then there would be perceptual problems for the audience in trusting the real. Rather we see the fantasy slip away with the "talk show appearance" being the last moment and at this point even Mitty is paying little attention.

2: Narrative 69

2.7

The ending of one quest is not the ending of the film. Mitty finds O'Connell in the Himalaya and with this discovers he had thrown the negative away. On his return he discovers that his mother has saved the wallet and he has saved the cover of the final *Time* magazine. Yet this is still not the end. When Mitty finally leaves with Cheryl he has reached the end of his quest.

DISCUSSION QUESTIONS

Walter Mitty goes on a journey of self-discovery throughout the film. How are the other characters characterized? $^\circ$

Music does not narrate, however it does impact on emotion. How do you see music being used in *The Secret Life of Walter Mitty*?

How many different storylines do you see in operation in *The Secret Life of Walter Mitty*? How and when are these storylines started and then resolved?

Tip

If you are in the position of developing a film always put yourself in the position of a member of the audience when thinking about your story. The danger is that you will know your story inside out, you will know what your characters are thinking, you will know the history of the location, etc. The important thing is to make sure that your audience have this information. In this chapter we have examined the essential structure of film via a detailed examination of narrative form. What is evident is that all narratives have common aspects to them and these aspects may be universal and may apply to any form of communication. However, there is still something specific about cinema and in analyzing this you will find the essence of film.

Knowing what your story is should be the start of good filmmaking; knowing how the narrative will be formed is to understand how you will communicate to an audience. To understand and use narrative is to understand the building blocks of communication—through consideration of character, events, and settings to the more complex aspects of meaning generated through the development of "text."

EXERCISE: ADAPTATION

The majority of feature films are adaptations. There are many reasons for this (which you can research) but in terms of structure they can appear to be the same. The danger is we start to discuss which is better; this debate will get you nowhere as they are fundamentally different. Take an adaptation and list what has changed because the producers of the film may have wanted it to and what has changed because it has to. This will reveal what is specific about film.

EXERCISE: NARRATIVE FORM

Take any film you have seen. In fact take lots of films you have seen—the more you practice the better you will get. Identify the opening—what is established. Now take the middles—what are the pivotal moments that the story hinges on, without which nothing would make sense. These are the plot points. Now look at the ending and see what is resolved. If you note these aspects down on one side of paper you will see the bare bones of the narratives—the essence of the story.

Now try this with short films and see what the differences are. Now try this with a TV series. Through this contrast and comparison you will find lots of differences that demonstrate what is specific about film.

Recommended Reading

Introductory Reading

Bordwell, D. and Thompson, K. Film Art: An Introduction, 8th ed. London: McGraw-Hill 2008. Lenos, M. and Ryan, M. Film Analysis: Technique and Meaning in Narrative Film. New York: Bloomsbury,

2012

Lothe, J. Narrative in Fiction and Film. Oxford: Oxford University Press, 2000.

Monaco, J. How to Read a Film. 4th ed. New York: Oxford University Press, 2009.

Porter Abbot, H. The Cambridge Introduction to Narrative. 2nd ed. Cambridge: Cambridge University Press. 2008.

Stam, R., Burgoyne, R., and Flitterman-Lewis, S. New Vocabularies in Film Semiotics. London: Routledge 1992.

Advanced Reading

Chatman, S. Story and Structure: Narrative Structure in Fiction and Film. Ithaca: Cornell University Press, 1980.

Fabe, M. Closely Watched Films: An Introduction to the Art of Narrative Film Techniques. Berkeley: University of California Press, 2004.

Genette, G. Narrative Discourse: An Essay in Method, Ithaca: Cornell University Press, 1983.

INTERTEXTUALITY

Films are not created in a vacuum. They emerge from a cinematic tradition and are produced within a social context that thoroughly informs both the film and its reception.

Like other forms of storytelling, movie-making requires little in the way of pure invention. It generally entails the careful assembly and grafting together of preexisting elements. Every film is supported by a standard batch of vital organs—old myths, familiar character types, and well-worn narrative conventions, all reanimated (hopefully) by an individual bolt of creative lightning.

Luckily, we are surrounded by a vast body of material from which to harvest what we need. Knowingly or not, the latest blockbuster owes its existence to this resource. The general term for this relationship is "intertextuality."

3.0

Frankenstein 1994

director

Kenneth Branagh

Every filmmaker is a Dr. Frankenstein, creating a new body from existing parts. Each movie is a patchwork of tissue taken from other movies. Only be sure you know where the pieces come from and the effect they will have—and don't leave the best bits on the cuttingroom floor! Film is a cultural product. It does not grow, it is built. The camera may reproduce the appearance of real objects, but a movie is an artificial construct, a "text" a body of discourse (words and images) based on principles born of history and convention. In Chapter 1, we looked at some of these conventional practices, and revealed how any film can be viewed as a mosaic of signs. However, semiotics is just one aspect of the intertextual nature of cinema.

The Body of the Text

It would appear that from earliest times people have made the connection between texts and textiles. Storytellers are said to spin a yarn and weave the fabric of a tale. Audiences are drawn into the story, follow (or lose) the thread, see (or not) an emerging pattern. Plots are said to become knotted and get untangled—to zigzag, crisscross, wind to a close, and reveal a final twist.

This metaphor is deeply embedded in our language. It suggests that a text is a tapestry woven from many intertwining strands, and that a filmmaker's task is to select this "stuff" and tie it into a tight and coherent whole. A text is like a quilt of disparate fragments cunningly stitched together to make something arresting and unique. This analogy is central to a great deal of modern theoretical thought.

The term **intertextuality** was first introduced by Julia Kristeva in the late 1960s. She sought to assert that the meaning we find in a text is not to be located in its relationship to the mind in which it seems to have originated, but in its relationship to other texts. In a very real sense texts have a life of their own, enabling, inspiring, and generating each other. Film begets film.

These thoughts of Kristeva's build in turn on earlier ideas about language derived from another theorist, Mikhail Bakhtin. He suggested that all human communication is **dialogic** meaning that every utterance is a contribution to an ongoing dialogue. Every word reflects what has gone before, and is shaped by anticipation of how it will be received.

Cinema, too, is dialogic. Any film refers (however obliquely) to other films, and is a response to them. What is more, the meaning a particular film has for an audience is determined by its relationship to this textual background. We read a film in the light of its resemblance to other films, and the associations (conscious or otherwise) it has for us. As a filmmaker you need to engage deliberately in this "conversation with the familiar," and ensure as far as possible that the connections viewers make are consistent with your intentions.

Intertextuality: The shaping of one text by other texts—the interrelationship between texts.

Bodysnatching?

As we saw in Chapter 1 (pages 30–35), intertextuality is explicitly at work in David Fincher's *Seven*. Other texts and contexts imported from theology, psychoanalysis, literature, painting, and classical music, as well as film, are easy to spot on its surface. David Fincher is not cheating.

All films tap into a shared cultural heritage and emerge from a web of preexisting materials and expressive forms.

Intertextuality is not theft—it is the inevitable state of all art. Any film builds on (and from) what has gone before. This may sound rather uninspired, and uninspiring, but the "artistry" is in making something that strikes an audience as new and distinct.

Far from limiting originality, the "restriction" of working within a set of conventions can be genuinely liberating. Not only is there a wealth of ready-made ideas to play with, but genre provides a backdrop against which tiny individual touches are thrown into sharper relief and take on a disproportionate significance.

The Bigger Picture

Intertextuality is not confined to the impact of one text on another. It cannot be reduced entirely to a simple matter of original sources. Nor are we always referring to direct influence and conscious imitation.

Of course, ideas do get copied or recycled for obvious commercial reasons. One successful comic book movie will spawn another, and then another, until the novelty wears off and the profits diminish. But this is in part a natural consequence of the social contexts from which movies arise. The ever-vigilant and mysterious "caped crusader" is an appropriate fantasy in an age when real terror invisibly stalks our city streets. Larger-than-life images from books and films get traded back and forth—in playground games and newspaper columns, in coffee shop discussions and classroom debates, until they become the staple currency of our thought. They reflect the anxieties and issues that preoccupy us. The media pick them up and use them as a sort of shorthand.

Figure such as Gordon Gekko in *Wall Street* (dir: John McTiernan 1989) and John McClane in *Die Hard* (dir: Oliver Stone 1988) have fallen into the collective imagination as concentrated personifications of unscrupulous greed and determined heroism. They have become part of our cultural landscape—their characters and catchphrases encapsulating attitudes toward unfettered capitalism and terrorist threats, which continue to shape contemporary reality.

3.1

Die Hard 1988

director

John McTiernan

Films emerge from and contribute to the all-embracing text we call "culture." In the *Die Hard* films, Bruce Willis's wry-smiling, nononsense character protects everything he loves from a host of international villains. The character both reflects and reinforces the idea of the lone all-American hero that has been a part of US culture since the days of *The Lone Ranger* in the 1930s.

Recommended Reading

Robert Stam, New

Vocabularies in Film Semiotics (1992)—this theoretical book offers a history of film theory, defines over 500 critical terms, and describes how they have been used. Films can interact with one another in a wide variety of ways and on many different levels. Some intertextual references are conscious and deliberate, with one film directly pointing to another. These references fall into two broad categories: quotation and allusion. Let's start by looking at some of the forms of quotation.

Appropriation

The most overt form of quotation is the appropriation of one text by another. This sort of "cut and paste" incorporation of preexisting material is relatively rare, but very instructive. For instance, in the background to Terry Gilliam's dystopian sci-fi satire *Brazil* (1985) we glimpse government employees secretly viewing old Hollywood Westerns, and hear snatches of dialogue from the wartime movie *Casablanca* (dir.: Michael Curtiz 1942). This classic wartime story represents all the action and romance that the central protagonist Sam Lowry and his coworkers crave amid their bureaucratically controlled lives. Sam's fantasies of flying away with the woman he loves are both fueled and mocked by the comparison.

This is also the case in Woody Allen's comedy, *Play It Again, Sam* (1972), which actually opens by showing Casablanca's dramatic finale. As the propellers whirr into life and the celebrated climax plays out, the camera pulls back and we see Woody's awestruck face looking up at the cinema screen mouthing the famous concluding lines.

Thereafter, Humphrey Bogart's tough-guy persona (played by Jerry Lacy) pops up from time to time offering Woody somewhat anachronistic advice on being a "guy" and getting a "dame." The question of whether escapist fantasies and fictional role models are a help or a hindrance is an integral part of the film's more serious purpose. *Play It Again, Sam* pays homage to a great film of the past and offers a telling comment on the distance between cinematic experience and real life.

Play It Again, Sam goes so far as to follow the plot of *Casablanca*, ending in a reenactment of the opening scene, in which Woody gets to be Humph. The effect of this cinematic borrowing is that something of the original aura of *Casablanca* is transferred to the later movie, creating a special bond with the audience and importing a wealth of intellectual and emotional associations that we and Woody "share."

Another Woody Allen film, *Zelig* (1983), takes appropriation still further. The film follows the history of a nondescript little man with a chameleon-like ability to transform his appearance and melt into his surroundings. As the cinematic equivalent of his psychological condition, Woody's character is magically inserted into archive newsreel footage, at one point sharing a balcony with Adolf Hitler. These self-referential games strongly appeal to filmmakers and audiences alike. They tease the imagination and raise questions about the status of the "reality" we are viewing. The illusion is at once both doubled and dismantled in the act of showing us "the miracle of film."

The interpenetration of texts gives a peculiar pleasure that has to do with the momentary revelation of their true nature that they are the material consequence of selection and arrangement, and are themselves fragments of the immense unfolding cultural tapestry we live in.

Tip

Examine your most recent film ideas, and try to identify the directors or specific films you are consciously or unconsciously in dialogue with. Your relationship to them is already shaping your thoughts and aims.

3.2

Play It Again, Sam 1972

director

Herbert Ross

Casablanca represents the high-water mark of a certain brand of romantic escapism. It inevitably stands in the shadows behind any movie that seeks to occupy the same territory. Great popular films haunt both the imagination of movie-goers and the movie-making that follows them. Invoked or not, Bogart is there.

Tip

Think about a specific piece of prerecorded music you would ideally like to use for a particular scene. Not only will the music shape the orchestration of the action, but import qualities that must complement rather than detract from your visual intentions. Identify what these are.

Dialogue

Textual quotation is not restricted to other films. In *Seven* we not only have the illustrated books Somerset consults in the library—paintings by Hieronymus Bosch and Albrecht Dürer, woodcuts of biblical scenes from Genesis and the Book of Revelation, and illustrations of episodes in Dante's *Divine Comedy* and Milton's *Paradise Lost*—but their full significance is only rendered in contrast to yet another text: a recording of orchestral music by J. S. Bach, as sober, dignified, and balanced as the visual images are twisted and deformed. Texts talk to one another.

Such references invite the age-old debate over whether the angelic or demonic in mankind will prevail. The film's own ambivalent answer comes in a response to a quotation taken from Ernest Hemingway's novel *For Whom the Bell Tolls* (1940). In this way intertextuality creates a link to otherwise remote ideas and issues, and connects the movie with the cultural database already loaded into the audience. By means of drawing on other texts and discourses, meanings are redoubled and amplified, and a modern thriller takes on a timeless resonance.

Although such *overt* referencing of other texts is relatively uncommon, it stands as a conspicuous example of something that is actually happening all the time. Texts are constantly coinciding and overlapping on the screen and in our minds. The meaning of every angelic smile and demonic glare is seen against the dense intertextual background that makes up our shared cultural memory.

Scream 2 (dir.: Wes Craven 1997) "foregrounds" this background, so to speak—not only parodying horror films in general, but commenting ironically on its own previous incarnation. When characters attend a movie based on the events of the first *Scream* film and later discuss the "rules" of a horror sequel, the swirl of in-jokes and self-reference is an integral part of the fun.

...any text is constructed of a mosaic of quotations; any text is the absorption and transformation of another.

Julia Kristeva, philosopher and literary critic

80

3.3

Scream 2 1997

director

Wes Craven

Here we see Sarah Michelle Gellar in the "film within a film" at the beginning of *Scream 2*—recreating the role played by Drew Barrymore in the first film. This ironic playfulness is significant in the development of the language of film; intertextual references have always been there, now filmmakers can make them obvious—if they want to.

Whereas quotation involves some kind of duplication in which other material is reproduced and embedded, allusion involves a verbal or visual evocation of another movie—relying on the audience to make the connection. There are numerous ways in which one film can allude to another. Here are just four.

Reference

The title of the film *The Usual Suspects* (dir.: Bryan Singer 1995) derives from a famous line in *Casablanca*, where Captain Renault of the Vichy Police is ordering the roundingup of known criminal elements in a pretense of activity intended to impress the Nazi SS. Obviously this (literal) quotation is intended to sound a familiar note and pick up some reflected glory. Nevertheless, the phrase has significance in itself—referring to the cunning smokescreen erected at the center of Bryan Singer's darkly labyrinthine plot. The police line-up which became the dominant publicity image, ironically conceals the film's narrative complexity.

References can also be visual. For example, *Brazil* (dir.: Terry Gilliam 1985) is one of numerous films to reenact the famous scene in Sergei M. Eisenstein's *Battleship Potemkin* (1925) where a baby carriage bounces down the seemingly endless Odessa Steps. Citing this iconic example of **montage** technique is a respectful nod from one director to another, and a backward wink to those in the audience who know their film history. The mental nudge toward this famous image of state repression, Tsarist Cossacks massacring innocent civilians, endorses the serious message behind Gilliam's political satire.

Self-Reference

Some movies cannibalize *themselves*. For example, films in the Harry Potter franchise constantly reflect back on previous events, not only to bring us up to date with a long and complex story but to cement our nostalgic attachment to the children's younger selves. The same comforting air of familiarity is a central appeal of sequels in general.

Montage: A general term for editing. Often associated with a montage sequence that condenses a lot of narrative information into a short space of time, or one that uses editing for a particular effect. Also a term for the kind of dialectical editing developed by Sergei Eisenstein.

Association

Other allusions are far less explicit, like those carried from one film to another by an actor. For instance, any director choosing to cast Anthony Perkins after 1961 was deliberately importing some of his notorious performance as Norman Bates in *Psycho*. His portrayal of a neurotically disturbed misfit left an indelible trace that was impossible to ignore or erase.

You can see him stuttering and twitching his way through *Murder on the Orient Express* (dir.: Sidney Lumet 1974), where he plays (you guessed it) a young man with a fixation on an older woman. At one point in this Agatha Christie murder mystery we see the back of a tall figure dressed in a kimono sashaying down the corridor of a train. The filmmaker is teasing the sophisticated film-goer who will naturally suspect (incorrectly, as it turns out) that Perkins is "doing a Norman."

Other associations may derive from the subject matter. The final sequence of *Brazil* incorporates numerous echoes, which compete with one another to form the film's defining note. The abseiling resistance fighters echo the armed assault on the evil mastermind's stronghold that concludes almost every Bond film, while Sam's medical trauma might remind us of *One Flew Over the Cuckoo's Nest* (dir.: Milos Forman 1975) or *Kiss of the Spider Woman* (dir.: Hector Babenco 1985).

Such associations set up conflicting hopes and expectations, which are less than resolved when Sam is heard murmuring the film's bittersweet theme tune. We, the audience, are left to decide precisely where Sam is, and where else we would wish him to be. These same thoughts cluster around almost every dystopian fantasy including those mentioned in the following pages.

Style

In adopting certain cinematic techniques and stylistic features, one filmmaker may allude to the work of another. So Woody Allen *does* Ingmar Bergman and Brian de Palma *does* Alfred Hitchcock—acknowledging indebtedness, but also inviting invidious comparisons.

EXERCISE: REFASHIONING

Select a favorite film moment that you could imagine recreating in your own movie. Ask yourself how you would refashion it to fit your purpose. This may reveal a lot about the general tone and style you should be adopting throughout.

Tip

Think carefully about the "ideal" casting for your movie. This will tell you a lot about your central characters, and what you need your actor to bring to the part. Intertextuality operates freely in popular culture, and especially in the sort of popular films that acquire cult status. Indeed much of their success may be due to the way they plug into something much larger then themselves; a world that fans and enthusiasts can explore independently. Let's look at some classic examples:

Star Wars

Star Wars (dir.: George Lucas 1977) borrows heavily from other textual worlds. For example, the Jedi can be seen as an order of medieval warrior knights wielding swords of light instead of metal. Luke is a young King Arthur, and Obi-Wan Kenobi is Merlin. Han Solo is a brash Lancelot, and Princess Leia a feisty Guinevere—until we discover why marrying Arthur is quite out of the question! On another (perhaps less conscious) level R2-D2 and C-3PO are a bickering Laurel and Hardy double act; one twittering but endearing, the other pompous and bossy.

More specifically the narrative point of view and the use of frame wipes as transitional devices were directly inspired by an Akira Kurosawa film, *The Hidden Fortress* (1958), whereas the climax, the pinpoint attack on the weak spot in the Death Star's defenses, is influenced by British war films such as *The Dam Busters* (dir.: Michael Anderson 1955) and *633 Squadron* (dir.: Walter Grauman 1964).

But the deepest influence on the film (and arguably the source of its unparalleled popularity) is the work of the scholar Joseph Campbell, whose comparison of ancient mythology in *The Hero With a Thousand Faces* (1949) describes a universal spiritual journey—a psychological initiation of trial and empowerment, which underwrites what some regard as Lucas's own modern myth.

Blade Runner

Possibly the greatest sci-fi movie ever made, *Blade Runner* (dir.: Ridley Scott 1982), is a modern reworking of Mary Shelley's novel *Frankenstein* (1818). *Blade Runner*'s "mad scientist" (Tyrell) has made a whole class of beings, known as replicants, now in search of their creator. Whereas Mary Shelley's "Monster" was a failed experiment cast out because of his brute ugliness, Ridley Scott's robotic life forms are threatening precisely because they are perfect, and perfectly indistinguishable from the human beings they crave to be.

The Matrix

The futuristic chic of *Blade Runner* also inspired the dystopian vision of *The Matrix* (dir.: Andy and Lana Wachowski 1999), which is a veritable encyclopedia of literary, cinematic, and cultural intertextuality. Verbal allusion is made to *Alice's Adventures in Wonderland* (1865) and *The Wonderful Wizard of Oz* (1900), while the movie's eye-catching violence upgrades the "bullet ballets" of director Sam Peckinpah and the martial arts movies of Bruce Lee. The world of liquid pods owes something to the rings of Hell in Dante's *Divine Comedy*, while the simulated reality of the matrix itself is an infinitely expanded version of the *Star Trek* holodeck.

A great deal of the film's glamour comes from associations outside movie-dom. *The Matrix* is full of references to religion (oracles, messianic Christianity, Zen Buddhism), philosophy (Plato's Allegory of the Cave, Descartes's deceiving demon, thought experiments about brains in vats) and modern anxieties about the internet, cyberspace, and virtual reality.

3.4

The Matrix 1999

directors

Andy and Lana Wachowski

The whole concept of "The Desert of the Real" (shown here) derives from two books: Aldous Huxley's futuristic satire *Brave New World* (1932) and Jean Baudrillard's *Simulacra and Simulation* (1981), a book that literally appears at the beginning of the film when Neo uses it to hide his illicit software.

Primary Plots

Some movies are straightforwardly based on other texts. Casablanca is a film adaptation of an unpublished stage play entitled *Everybody Comes to Rick's* by Murray Burnett and Joan Alison, and *Blade Runner* actually adapts Philip K. Dick's novel *Do Androids Dream of Electric Sheep*? (1968). Similarly, films such as *Gandhi* (dir.: Richard Attenborough 1982), *Titanic* (dir.: James Cameron 1997) and *Saving Private Ryan* (dir.: Steven Spielberg 1998) have their origin in real documented events.

But even more fundamental than literary or historical sources are primary story-patterns; these are the narrative foundations upon which all stories are built. These primary plots reflect the basic experiences of every human life—we grow up, face challenges, go on adventures, face various temptations, win things, lose things, fall in and out of love. These are human universals—hence our interest in seeing them acted out in books and films. Tapping into this common core of experience, a filmmaker is engaging with an audience in a potentially powerful way.

The suggestion that the infinite abundance of narrative is generated from a few basic plots may seem unlikely, but it bears the test. As we saw in Chapter 2, precisely what these stories are is a subject of debate, but with a certain amount of imagination any film can be described in one or more of the terms in the seven primary plots (see opposite).

Watching old movies is like spending an evening with those people next door. They bore us, and we wouldn't go out of our way to see them; we drop in on them because they're so close. If it took some effort to see old movies, we might try to find out which were the good ones, and if people saw only the good ones maybe they would still respect old movies. As it is, people sit and watch movies that audiences walked out on thirty years ago. Like Lot's wife, we are tempted to take another look, attracted not by evil but by something that seems much more shameful—our own innocence. Pauline Kael, film critic

Seven Primary Plots

Achilles: stories of overcoming. However mighty, the central protagonist must have a weak spot, their "Achilles's heel," which by making them vulnerable humanizes them. Think Superman and his kryptonite.

Cinderella: stories of transformation. However lowly and unpromising, the character can rise up and reveal their true nature. Think *Rocky* (dir.: John G. Avildsen 1976) and *Pretty Woman* (dir.: Garry Marshall 1990).

Jason: stories of pursuit. However meagre, difficult or improbable the quest, the character must attempt it. Think *Thelma & Louise* (dir.: Ridley Scott 1991), *The Lord of the Rings* (dir.: Peter Jackson 2001–2003) and every detective story.

Faust: stories of temptation. However absurd the bargain, the character will risk everything and put themselves in the hands of another. Think *Wall Street* (dir.: Oliver Stone 1987) and *The Terminator* (dir.: James Cameron 1984).

Orpheus: stories of irrevocable loss. However long or hazardous the voyage, the hero must undertake a perilous journey to retrieve what they have lost. Think *Regarding Henry* (dir.: Mike Nichols 1991) and *Memento* (dir.: Christopher Nolan 2000).

Romeo and Juliet: stories of love triumphant. Boy and girl meet, overcome obstacles, and come together (somehow). Think *Sleepless in Seattle* (dir.: Nora Ephron 1993) and *Moonstruck* (dir.: Norman Jewison 1987).

Tristan and Isolde: stories of love defeated. Boy and girl meet, but one of them is already taken. Think *Now, Voyager* (dir.: Irving Rapper 1942) and *Fatal Attraction* (dir.: Adrian Lyne 1987).

Genre: A French word simply meaning "type."

Sub-genre: Categories within an overarching genre that are defined by specific characteristics. For example the slasher film as a sub-genre of horror, or post-apocalyptic films as a sub-genre of science fiction. When we talk of science-fiction films, gangster pictures, detective thrillers, disaster movies, and biopics we are referring to different **genres**. When we speak more specifically or *romantic* comedies, *screwball* comedies, *political* thrillers, and *alien* invasion movies we are referring to **sub-genres**—subsets of genres. Looking at genre means looking at the way texts get categorized into types or classes, and the significance this has for filmmakers and audiences alike.

Industry Branding

The film industry uses genre as a mode of classification, a way of labeling their product and positioning it in the marketplace. The concept of genre helps to create and feed the cinemagoer's appetite for certain sorts of "product" as it helps them to personally identify with this or that sort of film. A movie can then be targeted at a particular constituent audience. Success can never be guaranteed, but thinking in terms of genre is one way of maximizing satisfaction, spotting trends, and responding to changing tastes.

Audiences are elusive, fickle, and demanding. On the one hand, they generally want to know what they are getting, and genre categories provide the orientation they need to steer them in that direction. On the other hand, they want to be surprised by something more than the standard generic product. Audiences want the same, but different.

Audiences can never come to a new film with an entirely open mind or neutral attitude. Their anticipation levels are already set by preconceived ideas concerning the genre to which this movie belongs. They ready themselves for the sort of attention it will require, the level of reality they are entering, and the degree to which they will need to suspend their disbelief. They then measure the sort of experience they are having against others they have already had.

It is important to understand the audience's preconceptions and expectations, with a view to meeting, exceeding, or subverting them. These expectations relate to both aesthetics and narrative.

An Aesthetic Category

A genre is a collection of instantly recognizable stylistic features. No strict definition of a particular genre is possible, but the words "musical," "thriller," and "courtroom drama" immediately conjure up a fairly limited repertoire of ideas: a physical environment; typical locations; the look of the characters, significant objects, and so on. Just naming a genre evokes a particular range of surface features belonging to that family of films.

The Western is a cinematic world all of its own composed of Stetsons, horses, saloons, marshals, guns, and gunfights—a largely fictional creation projected onto real untamed landscape of 19th-century America. It is a genre form tied inexorably to a particular historical past—just as science fiction is tied to notions of the future. In contrast, a romance can take place anytime, anywhere—wearing any clothes (or none at all)—because what defines a romance is the nature of the story, not the qualities of the world it occurs in.

A Narrative Category

Genre is also a narrative category carrying distinctive structural features, certain kinds of story, varieties of character relationship, and typical patterns of character development. When we recognize the genre, we anticipate being taken on a particular kind of journey. This climate of expectation allows for certain experiences, but not others—these things can happen, these can't. The limits are set by genre.

It's OK for gangsters to quote scripture and have in-depth discussions about cheeseburgers—as happens in *Pulp Fiction* (dir.: Quentin Tarantino 1994), but they can't lift buildings. It's fine for superheroes to lift buildings and see through walls (as in *Superman* dir. Richard Donner 1978); but they can't turn back time—or if they do it has to be using the perfectly reasonable method of spinning the Earth backward!

It is acceptable for wizards, given the right magical spell, to turn back time—think *Harry Potter and the Prisoner of Azkaban* (dir.: Alfonso Cuarón 2004), but going into outer space would be preposterous and wrong. Hermione Granger's "time-turner" is utterly logical within the world she and the audience inhabit.

These design limits are essential because if everything was possible nothing could be surprising. Genre places an envelope around the story, an envelope that can be pushed, but should not burst. If it does, the viewer is lost, and any sense of "reality" evaporates. Genre identity preserves the film's integrity; you lose it at your peril.

Genre Blending

Although films that lack genre definition, that slip between categories, are less likely to get made, it is also true that movies that cross or straddle genres can often prove the most successful. *Star Wars* is essentially a "coming of age" Western set in space. *Blade Runner* is a psychological, noir detective, sci-fi thriller. *The Matrix* is all these, and more.

According to the theorist Umberto Eco the unparalleled popularity of *Casablanca* is due in no small measure to the fact that it contains elements of almost every genre—being a wartime espionage-thriller romance-comedy buddy-movie with the real "horror" of the Third Reich (and a few songs) thrown in. Basically, it delivers what you want no matter what you want. It is all things to all viewers. Genres can happily cohabit as long as they don't interfere with one another.

Casablanca is not just one film. It is many films, an anthology... When all the archetypes burst in shamelessly, we reach Homeric depths. Two clichés make us laugh. A hundred clichés move us. For we sense dimly that the clichés are talking among themselves, and celebrating a reunion.

Umberto Eco, philosopher, literary critic and novelist

Genre Bending

In Terry Gilliam's *Brazil*, different genres deliberately clash to create very surprising effects. The movie's playfulness is announced at the very outset when a caption tells the audience the exact time of day: 8.49 PM, followed by the vaguest reference to "Somewhere in the 20th Century."

Stylistically, the film continues to mix the precise and the indeterminate. The action takes place in a totalitarian future, but one that has the fashions and manners of 1930s Britain. The technology manages to be both advanced and primitive; flat-screen computers attached to manual typewriters, a surveillance society operating with wire-plug telephones. The viewer simply doesn't know where they are—or when. The semiotics is confusing, things look familiar but out of place.

The juxtaposition of future dystopia and wartime nostalgia makes it difficult for the viewer to settle into ready-made assumptions about the world they are looking at. They can't distance it into a (*Casablanca*) past or a (*Blade Runner*) future. The film is about the ever-present—the extraordinary madness that can, at any moment, erupt unannounced into an ordinary world. Like *Die Hard*, the enemy is "terrorism," the difference is that it is far from "foreign."

The world of *Brazil* has created its own virtual reality—out of propaganda, plastic, and pasteboard—which, for all the absurdity, more closely resembles the world we actually live in. The movie is an absurdist comedy that uses the blurring of genre to sharpen its satirical edge and the subversion of genre expectations to keep the audience guessing. This "Brazil" is nowhere because it is everywhere—and now.

EXERCISE: AUDIENCE PROFILE

Make a list of the generic features relevant to your film and the sorts of pleasure that derive from their inclusion.

Write out a detailed "profile" of your target audience—their likes, dislikes, and expectations, and the key texts within the genre that are likely to have informed their taste.

List the limitations that most sharply impinge on your film due to genre considerations. This should clarify the boundaries to the fictional "reality" you must work within.

Ci	tize	on	Ka	-	~
U	UZ.	CII	na		e

RKO Radio Pictures

Director	Orson Welles
Screenwriters	Herman J. Mankiewicz, Orson Welles
Cast including	Orson Welles (Charles Foster Kane) Joseph Cotten (Jedediah Leland) Dorothy Comingore (Susan Alexander Kane) William Alland (Jerry Thompson)
Crew including	Gregg Toland (cinematography) Bert Shipman (camera operator) Robert Wise (editing) Van Nest Polglase (art director)
Tagline	The classic story of power and the press.

Synopsis

Charles Foster Kane dies. His immense public notoriety and colossal wealth make his death a media event. But the editor-in-chief of "News on the March" is dissatisfied with the standard newsreel obituary and sends a reporter, Thompson, on a mission to discover the mystery behind Kane's last dying word: "Rosebud." Thompson interviews those who could claim to know Kane best, but the contradictory impressions he receives suggest an even greater enigma.

Intertexts

The movie begins with an array of striking images designed to implicate the viewer in the act of intruding upon a man's private life. The first thing to greet the audience is a visual joke, a "No Trespassing" sign, beyond which the eye immediately wishes the camera to transgress.

This first scene may have been directly influenced by the famous opening of Hitchcock's *Rebecca* (1940) where the camera seems to pass magically through the iron gates of Manderley; another "haunted" house. Whether or not this was an intentional reference, the movie's original audience is likely to have made the connection and expected a similar tale of romantic passion and murderous secrets.

In fact, *Citizen Kane* is completely free of such stock Hollywood material. What the two films do share is a retrospective narration orientated around the task of uncovering the truth behind the public image of the elusive central figure.

The somber moment of Kane's death is shattered by the raucous signature music of a cinema newsreel reporting the event. It quotes the lines from Samuel Taylor Coleridge's famous poem, which gives the Kane estate its name: "In Xanadu did Kubla Khan/A stately pleasure-dome decree." Kane's legendary status and virtually limitless power and excess are instantly established by such exotic parallels.

The word Khan (or King) touches on the central ambiguity of Kane's political career. He begins as a democratic champion of the people, but gradually turns into a brutal despot—a contradiction the movie is about to explore.

The film bombards us with Kane's name and its biblical echoes are unavoidable. The story of Cain, the first son of Adam and Eve—and the murderer of his brother Abel touches on themes that are deeply ingrained within the film, such as belonging and exile, brotherhood, and selfishness. Kane suffers numerous childhood "expulsions," exhibits massive egotism, and is ultimately cut off from worldly affection, lost and rootless in a desert land. In this case, the mark of "Kane" is his notoriety, behind which he is a lonely isolated figure.

In addition to being a vast repository of European art, Xanadu is also "the biggest private zoo since Noah." This second biblical allusion suggests not just the desperation with which Kane has amassed everything he could lay his hands on ("the loot of the world"), but invites comparison between one man serving God and saving His Creation, and another feeding his ego by creating a world of his own.

The fictional screen obituary hosts a wealth of appropriated material including operatic recordings and stock newsreel footage. These "real" documentary images are mixed with "faked" ones, which appear to show Kane rubbing shoulders with Hitler. In 1941, the technology did not exist to produce the effects we see in *Zelig* (in fact, Woody Allen's film is alluding in part to this moment in *Citizen Kane*), but Welles nevertheless created a curious effect for a cinema audience that only minutes before had been watching a "real" newsreel probably alluding to the very same political figures.

Urtext: An original or the earliest version of a text, to which later versions can be compared.

Urtext

Two immensely compelling stories underlie *Citizen Kane*— Achilles and Orpheus. Kane is a larger-than-life tragic hero with a fatal flaw. Everyone Thompson speaks to seems to concur with this, but there is no consensus as to what this critical defect actually was. The most thorough account of "Charlie" seems to come from his closest friend, Jedediah Leland, who tells us that he simply wanted everyone to love him unconditionally.

True or not, and no one interpretation of Kane seems adequate, we are certainly pointed in the direction of a man trying to recapture what he lost in childhood. Some in the film speculate it was "Rosebud." But in the attempt to find it he was distracted by power and "things" (and at one point a woman's laughter). The film also sends us on that journey.

3.5

Kane's refuge resembles those dark Gothic castles familiar from tales by Bram Stoker and Edgar Allan Poe. There is certainly something vampiric in Kane's relationships with other people, and the house itself is a grotesque mausoleum where he has chosen to bury himself and his wife *alive*.

Meta-discourse

Citizen Kane is highly self-reflexive, drawing attention to the language of film. The news documentary enlists a whole repertoire of associated journalistic discourses: the loud-hailer voice-over, political speeches, personal interviews, library pictures, spy footage, official records, illustrative maps, spinning newspaper headlines. The narration adopts a variety of modes and tones: informative, triumphant, dramatic, revelatory, mythic, historical, topical, scandalous, comic, elegiac.

More than mere imitation, the dazzling variety and sheer energy of the mock report sums up the media world of which Kane is both a promoter and a product. Welles's performance makes Kane as mercurial and ephemeral as a copy of his beloved *Inquirer*—his identity is a thing he is constantly "making up" as he goes along, creating an artificial reality to suit himself. In more ways than one Kane is a media creation.

The moment that the newsreel ends is truly startling. As the piece of film we have been watching suddenly becomes a "text"—an artifact under construction—so too does the entire movie into which it is embedded. The whole materiality of cinema is compressed into the sound of a reel running out, a beam of white light cutting across the darkness, and an editor calling up to a projection room. Suddenly, the raw condition of all film is made present to us, just as it was for Welles and his team when they first sat and viewed the film's rushes at a screening exactly like this.

Citizen Kane playfully breaks the unwritten rule against revealing its own artifice, but in so doing it cements a different relationship with a cinematically literate audience that can enjoy being taken into a filmmaker's confidence to explore the mechanisms that make film work. One of these is genre. Film noir: A largely American film genre often based around crime fiction. Has its roots in German expressionism.

Genre

Aesthetically, Welles and his cinematographer adopt the visual idiom of **film noir**—extremes of light and deep shadow, exaggerated angles, distortions of scale, and an extended depth of visual field. Because it is associated with gritty crime dramas of dark underworld dealings and even darker motives, this stylization encourages the audience to suspend its judgment and look beyond the surface appearance of things, toward some deeper mystery.

Citizen Kane may not be "whodunit," but it *is* a "who-washe"—a detective investigation attempting, through a splintered structure of interlocking flashbacks, to piece together the man behind the name.

Much of the controversy that surrounded the film on its first release related to the fact that it appeared to be a thinly veiled portrait—a biopic—of a real-life tycoon and media magnate, William Randolph Hearst. But the movie has a very complex and extensive intertextual relationship with American politics in general, which goes well beyond one individual.

The representation of Corporate America on the one hand and the mechanics of popular democracy on the other constitute a serious discourse that Welles was clearly interested to explore. The fact that Kane can be characterized as a communist one moment and a fascist the next makes him a telling comment on a political culture in which the absence of any real principles may be a positive electoral advantage. Kane (as the name might suggest) is a hollow man.

Innovation

Citizen Kane is the most celebrated movie in Hollywood history. If innovation and originality exist anywhere it is here. And yet, even in this unconventional and technically groundbreaking film, we see the auteur figure of Orson Welles calling upon the ready-made intertextual resources at his disposal. Under his directorship, these "other" materials may be reshaped, blended, and even inverted, but without them the movie wouldn't have come into being. Welles's genius was in knowing what to do with them—knowing how to bend them to his particular purpose.

3.6

One final intertext is the life and career of Welles himself. Kane's hostility to the established order and his determination to attack it from the inside mirrors something of Welles's own position within the Hollywood studio system. Regrettably, Welles never again had the creative freedom to bite the hand that fed him.

DISCUSSION QUESTIONS

Citizen Kane abounds with signifiers that relate to other films and other films are full of references that relate back to it. When watching other works that relate to this iconic example consider why they are making these references that relate back to it. When watching other works that relate to this iconic example consider why they are making these references. What do they do or say to an audience?

Citizen Kane borrows from the techniques of film noir. Why is this so? Do we find comfort in genre?

Tip

In describing your film you probably find yourself saying: "It's a bit like x, but..." or "It's x meets y." In order to distinguish your project from someone else's, be as explicit as you can about these similarities and differences. In this chapter we have looked at the intertextual nature of film. Texts never stand in isolation. For movie-maker and movie-goer alike, they exist in relation to other texts. Every movie is spun from preexisting narrative materials (myths, plot-patterns, genre conventions, etc.). The same basic stories, tropes, and characters reappear in endless variation. This is neither improper nor unduly restrictive—the variations can be subtle and unique, shaping expectations and springing surprises. Some films deliberately reference others, some are influenced by a particular directorial style, but all films draw from the existing language of film—the common fund of narrative and screen techniques built up over time. Great films add to this language.

It is only because audiences share a set of cinematic and cultural references that they find films engaging and intelligible. It is against this background that your film will be perceived and judged. As a filmmaker you are part of an ongoing tradition of cinematic storytelling, and you should be acutely aware of the company your film is keeping in the mind of the audience.

EXERCISE: THE ICONOGRAPHY OF STARDOM

The very concept of the film star is an intertextual one, relying as it does on correspondences of similarity and difference from one film to the next, and sometimes too on supposed resemblances between on- and offscreen personae. Thus, Sergio Leone's *Once Upon a Time in the West* ironically inverts Henry Fonda's normal heroic role to make of him a particularly sadistic villain; Mike Nichols's *Who's Afraid of Virginia Woolf?* exploits parallels between the stormy domestic life of George and Martha on screen and that of Richard Burton and Elizabeth Taylor off it.

Keith A. Reader, 1990, p. 176

Look at the career of your favorite high-profile movie actor. Assess the qualities they bring to each film and the way they inevitably import some of their previous screen presence (and real-life public image) into subsequent roles.

EXERCISE: PLOT AND ORIGINALITY

Look at the "Seven Primary Plots" (page 87). Which story (or stories) is your film telling? Closely examine the way your film follows (and departs from) the basic narrative form of the "original." In other words look to identify how your movie both is (and is not—is more than) an archetypal tale of triumph and disaster, love and loss, etc.

Recommended Reading

Introductory Reading

Allen, G. Intertextuality. London: Routledge, 2000.

Boyd, D. and Palmer, R. B. After Hitchcock: Influence, Imitation and Intertextuality. Austin: University of Texas Press, 2007.

Goodwin, J. Akira Kurosawa and Intertextual Cinema. Baltimore: Johns Hopkins University Press, 1994. Hayward, S. Key Concepts in Cinema Studies. Abingdon: Routledge, 2006.

Kline, T. J. Screening the Text: Intertextuality and the New Wave French Cinema. Baltimore: Johns Hopkins University Press, 1992.

Orr, M. Intertextuality: Debates and Contexts. Cambridge: Polity Press, 2003.

Stam, R., Burgoyne, R., and Flitterman-Lewis, S. New Vocabularies in Film Semiotics. London: Routledge, 1992.

Advanced Reading

Bauman, R. A World of Other's Words: Cross Cultural Perspectives on Intertextuality. London: Blackwell, 2004.

Boyd, D. and Palmer, R. B. *After Hitchcock: Influence, Imitation and Intertextuality.* Austin: University of Texas Press, 2006.

Kristeva, J. The Kristeva Reader. New York: Columbia University Press, 1986.

Reader, K. A. "Literature/Cinema/Television: Intertextuality in Jean Renoir's Le Testament du docteur Cordelier." In Intertextuality: Theories and Practices, M. Worton and J. Still (eds), Manchester: Manchester University Press, 1990.

Sanders, J. Adaptation and Appropriation. London: Routledge, 2005.

IDECLOGY

4.0

How I Won the War 1967

director

Richard Lester

Richard Lester is an interesting director for those who are intrigued by the disruption of reality and film form. His playful style reminds the audience that they are watching a piece of fiction. The inclusion of John Lennon is no accident; it offers a very late-1960s attitude to an early-1940s setting. Ideology is a difficult and slippery term. There are many, many books that seek to explain ideology and they all seem to arrive at different definitions. This is not to suggest it is a term that has no use, nor does it have multiple uses; rather it has specific uses. The consideration of ideology is essential in cinema whether you are a filmmaker, a theorist, a critic, or simply a member of an audience.

Ideology is pervasive. As with narrative and semiotics, ideology is part of human communication and stretches to every part of life. However, film communicates in a specific way and as such transmits ideology in a particular way and this is what we need to consider.

Recommended Reading

Terry Eagleton's *Ideology: An Introduction* (2007) is a generic textbook about all forms of ideology. While quite complex in parts, it is worth examining for the opening few pages. Eagleton clearly and systematically articulates the ideologies we all engage with. The uses of ideological analysis for the theorist or the critic are pretty self-evident. The function of the study of **ideology** for the filmmaker is similarly clear. The most dangerous position a filmmaker can take is to think that they are free of ideology. We all have our beliefs, our views, and our social and cultural positions. Some of these are known to us, others are so deeply embedded that they appear to be "natural."

So What Is Ideology?

Ideology is difficult to pin down and, given that it is everywhere, it is difficult to isolate. However, cinema is a specific medium, and, as has been discussed, it uses its own codes and conventions. Therefore the ideological aspects of cinema can be examined in order to understand its specific impact and why it is so powerful.

When you watch a film you are engaging in the transmission of knowledge. When you make a film you are communicating something to an audience—whether you mean to or not. That is one of the issues with ideology; it is unseen. For example, think of your own behavior when you attend the cinema: do you attend as a student of cinema or even as a filmmaker, or do you go to be entertained? Ideology is at its most invidious and powerful when its audience is relaxed, receptive, and unaware that they are exposed to it.

Despite earlier comments that ideology is essentially impossible to define, without some working definition any further discussion would be equally impossible. In defining ideology the complexities of the term are drawn out.

Defining Ideology

Ideology is a systematic body of ideas, attitudes, values, and perceptions. It is also the collective views, attitudes, positions, and dogmas of a societal group. Ideology is both specific and general. It is seen and unseen. It can be conscious, but is more often unconscious. It is pervasive and impacts on every aspect of human existence.

Text and Context

Over time, two broad schools of thought have developed around the nature of ideology and how cinema should be treated—these can be defined as text and context. Text looks at film as film, and draws out of it themes that reflect back on society while context looks at the context in which the film was produced.

Real analysis comes at the intersection of these two views. For the filmmaker this is a difficult position to adopt. After all, it means trying to establish your film's ideological impact before you have even made it. In terms of text, this requires being aware of the specific language(s) you use and the controls you place on the film's form. Context is harder; this relies on you having absolute control, or at least minimizing the control others have. It is also requires you to be wholly aware of your own position as an individual to clearly see how your own ideological viewpoint fundamentally impacts on the shape and nature of your film.

Time and Place

It seems an obvious statement to note that what you believe is hugely dependent on where you come from and when you live. Theories of ideology suggest that as complex individuals we are actually an amalgam of the specific experiences that have gone to "construct us."

This means that there might be universal ideologies that we share, but there are also specific issues that are contingent to time. This is sometimes referred to as "contextual determinism." This idea is best exemplified by watching any science-fiction film, as they tend to date at a faster rate than other genres.

EXERCISE: FINDING IDEOLOGY

Try taking a film which is promoted as pure entertainment. There are often elements of ideology being replicated in these films and as such we don't tend to see that they are there. An audience will find their way in through characters and there is an argument to suggest that we empathize and even identify with characters. If this is the case examine the characters. Are they portraying traditional or even reactionary characteristics? If so, what are the implications of this?

Collective Authorship

While film directors often like to believe that they are the "auteur," single-handedly dictating every aspect of their film's development, there are countless people who influence what appears on screen. The production of a film is a collective process in part, but a hierarchical one in others. This hierarchy and the nature of collaboration shifts in relation to the stage of production you are in.

The structuralist approaches outlined in Chapters 1 and 2 suggest that meaning is generated between the flickering images on the screen and the individual sitting in the audience. However, although the filmmaker sets the parameters of meaning (they decide what appears on screen) this is actually affected by a great number of things and the input of a large number of people. The many variables that affect what appears on screen can render statements about what a director (or editor or composer, and so on) "meant" largely irrelevant. The idea that an audience "reads meaning into a film" is quite right; actually this is the analysis of what appears on screen by the audience. This also means that the circumstances on the day of filming might subtly but importantly change what things mean in the mise en scène. Pinpointing the original ideological impetus becomes increasingly difficult, and in fact there may be an ideology or ideologies present that you never intended to put there.

Examine the simplified view of the production flow for a film shown in Figure 4.1 in terms of who takes responsibility where. There are many people who are vital to the production of the film, and many who have a profound impact on the aesthetic and thus the form of the film. It is these people who are crucially shaping the ideological world view the film presents and represents.

Propaganda: The tools used to deliberately influence the population.

EXERCISE: ANALYZING PROPAGANDA

View Leni Riefenstahl's *Triumph of the Will* (1935). Do you find it difficult to see why people were taken in by something so blatant? If so, imagine yourself in Germany in 1936 with no knowledge of the atrocities the Nazis were perpetrating—now how does the film look? Such is the power and danger of film.

4: Ideology 105

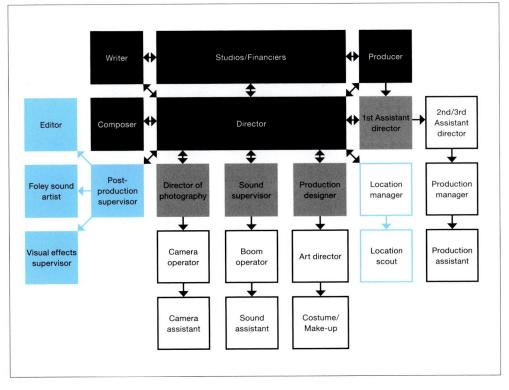

Key

Blue outline Blue box Grey outline Grey box pre-production post-production production pre-production and production

4.1

Production flow diagram

Figure 4.1 shows the main departments and major roles in the production process. Most feature films have personnel lists running into hundreds of people; short films can be as few as five or six with people doubling up on roles. The composer stands outside the main production process and is commissioned at the start of the process and then again at the end. The omnipresent figures are the director, the producer, and, of course, the studios/financiers.

Form

While it is undoubtedly true that the way in which characters behave and what they say is partly how film ideology is communicated, this is simply one level of meaning. There is much more complexity to it than that. This is where the notion of film form comes into play.

A film's form often goes unnoticed by its audience, and this is what makes it so essential to its ideological impact. In fact, most viewers suspend their disbelief when they enter the cinema. Earlier chapters have demonstrated the specific codes and conventions that film uses. If the audience were to focus on these codes and conventions, rather than the story or experience they are conveying, the film would make little sense. It might even seem absurd. Therefore the form a film takes has to remain hidden to its audience, while being wholly visible to the filmmaker.

Let's take a look at *Dirty Harry* as an example. While there is still an undoubted cool to Clint Eastwood's Harry Callaghan character, it is now very easy to mock the flares and feel very distant from the message. This is to miss the point of the ideological impact the film is having on us. Look at the form of the film. While Harry is certainly morally questionable, the "bad guys" are worse and he always gets results. Harry is presented as the only chance of bringing salvation to the sympathetic characters in the film, and the viewer wants him to win. Outside the context of this film, this may potentially perpetuate a fairly right-wing view of individualism and the right to violence.

My movie is born first in my head, dies on paper; is resuscitated by the living persons and real objects I use, which are killed on film, but placed in a certain order and projected on to a screen, come to life again like flowers in water. Robert Bresson, director

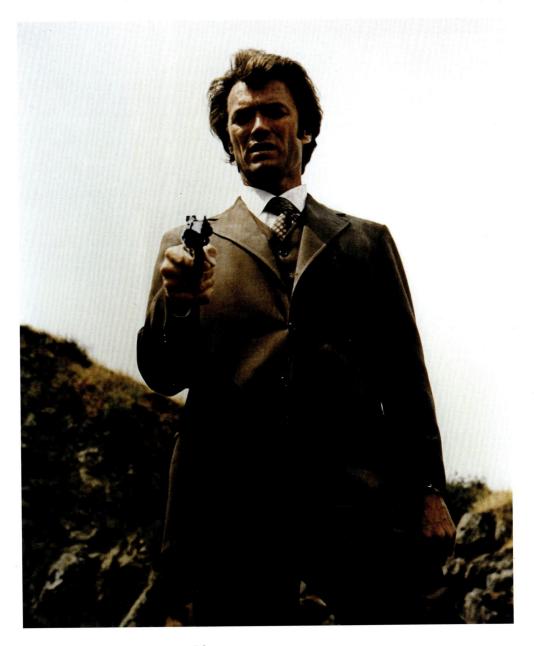

4.2

Dirty Harry 1971

director

Don Siegel

Dirty Harry is a classic example of a film that bears the hallmarks of 1970s attitudes to violence, gender and race.

Realism: A style of fillmmaking that attempts to mimic material reality as closely as possible.

As with ideology, there are many definitions for **realism**. A good starting point is to think of realism as an amalgam of the devices used by filmmakers to disguise the fact that what the viewer is shown isn't real. In other words, realism is the illusion that what is shown on-screen is in some way connected to reality. Of course, what's on screen is not reality; just because it is recognizable it doesn't mean that it is real. It's still just flickering lights in a dark room—where meaning is generated between audience and screen.

Historical Context

The term "realism" emerged in mid-19th-century France to refer to a particular kind of fine art. A key factor in its development was the camera and particularly the public reception of photographs. The belief was that the camera was able to capture an objective truth about the world. The illusion must have been powerful, as this view spread to the other arts. As cinema became established, it is no accident that realism quickly became a dominant form of expression. Filmmakers in the 19th and 20th centuries believed that they could present a truth about the world through fiction, again as if they were not part of it and were placing no bias upon it.

The Theorists

There are many theorists who have dissected the concept of realism and its dominance. The three who stand out more than any others, and who have lent their ideas to decades of later theorists, are Rudolf Arnheim (1904–2007), André Bazin (1918–1958), and Siegfried Kracauer (1889–1966). Of the three, it is Bazin who remains most influential in his view of cinema's ability to record and represent reality. As he noted: "photography does not create eternity, as art does; it embalms time, rescuing it simply from its proper corruption," by which he implies that it also has a historical purpose in capturing a view of the world forever. However, this is problematic because, unlike real life, film usually presents a clear viewpoint; it offers ideological resolution, if not narrative resolution. Thus realism inevitably presents ideological unity, and an ideological world view.

How Realism Works

Realist film presents what appears on the screen as natural. A key means of achieving this is to make it appear unmediated and this is often achieved through the narrative as much as it is through the form. It is this that allows realism to take so many forms. For example, many non-realist films ensure that the hero is clearly identifiable, but this would simply not work in a realist film. To make a protagonist appear as a real person, rather than a "real film character" they need to embody characteristics that the audience will perceive as being close to their understanding of reality. This often includes moral ambiguity of some kind. And, as with real life, conclusions are not always neat in realist films, or they appear not to be neat even when there is a resolution within the filmic narrative. It is a film's ability to tell the viewer what to think, balanced with an illusion of free choice, that makes it so powerful. There are many realist films that are well worth examining; among the most notable are Jean Renoir's Toni (1935) and Sidney Lumet's The Hill (1965).

EXERCISE: READING PERSONAL IDEOLOGY

Select a photograph that is familiar to you and show it to two or three of your friends. Ask them to describe what they see and the context they imagine the photograph was taken in. Then ask them to identify the signifiers that are providing this information. You may find that they have created a narrative about what they see.

Repeat the exercise with a cropped film still. Take out sections of the *mise en scène*. When they believe the film still is a photograph do your friends invest it with some authority—do they trust what they see? How does this change when they know it is fiction?

Recommended Viewing

It is a useful exercise to view a film such as *La Règle du Jeu* (dir.: Jean Renoir 1939) and compare it to a film such as *My Name is Joe* (dir.: Ken Loach 1998). These are radically different films, but share many aspects of form.

Meet the Realisms

To complicate matters there are multiple forms of realism available to see and to use and they cover a variety of genres and forms. The various forms may seem fairly disparate, yet they are connected in their attempt to present unity, totality and a connection to the real world. The following list covers some of the most common forms of realism:

- Magic realism: where elements that might be associated with the fantastic intrude into film form. This may be subtle, as with *The Night of the Hunter* (dir.: Charles Laughton 1955) or overt as in *Pan's Labyrinth* (dir.: Guillermo del Toro 2006). In both cases, the use of fantastic elements emphasizes and/or underscores the realism of the main theme. Not to be confused with fantasy film.
- *Dirty realism*: where stories are reduced to the barest elements. This often leads to a bleak quality. Established as a literary movement in America, this has spread to cinema, particularly in the UK with films such as *Red Road* (dir.: Andrea Arnold 2006).
- Gritty realism: a critical term assigned to a number of films that tend toward the bleak but also try to capture the nature of everyday life. This extends to the work of people such as Ken Loach, but also to films like 28 Days Later (dir.: Danny Boyle 2002).
- Heroic realism: this incorporates the cinema of the Nazi regime and Soviet Russia. It includes films that support the dominant political viewpoint and is often aligned to propaganda.
- Naturalism: a movement that seeks to locate the individual at the center of the story, and to show them as a victim of natural forces. It involves close attention to detail in the mise en scène to make film form look "natural," as in the work of Jean Renoir.

Social Realism

Social realism is a form of filmic expression that prioritizes depictions of working-class life and portrays this lived experience as legitimate. Three key examples are:

- Soviet socialist realism: a form of realism dictated by the state during the establishment of the Soviet state. This was an important movement in that it was the first to fully recognize the ideological potential of cinema and other artistic forms. The works of Soviet socialist realism simply support the dominant political view, often by unusual forms. The most notable filmmaker to work within this form was Sergei Eisenstein.
- Italian neo-realism: as a form for production, neo-realism is interesting as it was developed by critics writing for a film journal. It is no accident that the movement emerged during Mussolini's stranglehold on Italy. In these terms, it emphasized democracy and the proletariat. The main focus was on lived experience, the emotions of "real people." To preserve the illusion of reality many films used "real" people rather than actors. Locations that stressed the desolation caused by World War Two brought the message of the films closer to the audience. Formally, there is a lack of lighting and complex sound dubbing. The first work of neo-realism is often seen as *Rome, Open City* (dir.: Roberto Rossellini 1945). Other key practitioners include Vittorio De Sica, Federico Fellini, and Michelangelo Antonioni.
- Kitchen-sink realism: this movement emerged during the 1950s in Britain and stems from a tradition of social concern stemming from Charles Dickens. The form has developed alongside the gradual decline of Britain as an industrial power and is set in Northern England. A key characteristic is the use of dialect, accent, and real locations. Early works such as *Look Back in Anger* (dir.: Tony Richardson 1959) show the clash of the modern against tradition with youth being a key feature. Important directors such as Lindsay Anderson and Ken Loach stemmed from this period. The movement developed and continues to inform British cinema to this day with directors such as Mike Leigh, Mark Herman, and Shane Meadows.

4.3

The Hill 1965

director

Sidney Lumet

The Hill presents us with what appears to be morally ambiguous characters. We never know whether Joe Roberts is guilty or not, yet it is impossible not to take his side. Beyond characterization the skill and power of the film is in the form. Set in an internment camp, there is the omnipresent sound of marching boots and no music at all. This locates the audience in the camp and makes them feel the pressure and pain of the lead characters.

Dogme 95

An interesting case study of more contemporary attempts to develop a realist movement is Dogme 95. This was a shortlived movement established in Denmark in 1995 by Lars Von Trier and Thomas Vinterberg.

One facet unique to the group was that they set out their aims in a manifesto, which they referred to as a "vow of chastity." This was a clear move back to the principles established by the neo-realists. However, unlike this earlier movement, Dogme was focused on form rather than the fundamental relationship between form and content.

4.4

Festen 1998

director

Thomas Vinterberg

Festen is a fiction film based on a true story. It is a fascinating film and exists in part as an experiment with the Dogme style. Professional actors and crew work with the techniques to create an unsettling effect, which matches the subject in hand. It is interesting to note that most of the Dogme films continue with bleak themes.

The Dogme 95 Vow of Chastity

I swear to submit to the following set of rules drawn up and confirmed by Dogme 95:

- 1 Shooting must be done on location. Props and sets must not be brought in (if a particular prop is necessary for the story, a location must be chosen where this prop is to be found).
- 2 The sound must never be produced apart from the images or vice versa. (Music must not be used unless it occurs where the scene is being shot.)
- 3 The camera must be hand-held. Any movement or immobility attainable in the hand is permitted. (The film must not take place where the camera is standing; shooting must take place where the film takes place.)
- 4 The film must be in color. Special lighting is not acceptable. (If there is too little light for exposure the scene must be cut or a single lamp be attached to the camera.)
- 5 Optical work and filters are forbidden.
- 6 The film must not contain superficial action. (Murders, weapons, etc. must not occur.)
- 7 Temporal and geographical alienation are forbidden. (That is to say that the film takes place here and now.)
- 8 Genre movies are not acceptable.
- 9 The film format must be Academy 35mm.
- 10 The director must not be credited.

Furthermore I swear as a director to refrain from personal taste! I am no longer an artist. I swear to refrain from creating a "work," as I regard the instant as more important than the whole. My supreme goal is to force the truth out of my characters and settings. I swear to do so by all the means available and at the cost of any good taste and any aesthetic considerations.

Thus I make my VOW OF CHASTITY Copenhagen, Monday 13 March 1995

On behalf of Dogme 95, Lars von Trier, Thomas Vinterberg

Every film connects to a genre in some form or another; no film is separate from either genre or movement. Genre is important for many reasons, not just for the audience, but also for the filmmaker and studio. The relationship between genre and ideology is a fundamental one and yet it is easy to overlook.

What Is Genre?

In essence, genre is a signifying practice that has emerged over time by the repeated use of particular codes and conventions. Genres may stem from literary sources through adaptation or be specific to film. They are used by audiences in selecting a film, as the genre often gives an indication of a film's style and content. In this way, they can be used by the filmmaker to either meet or subvert audience expectations. Studios like genres as they provide a useful marketing tool and have established measures of success.

Genre's Relationship to Ideology

Genre plays a fundamental role in setting the ideological framework of a film. On one level an audience is so familiar with the codes a genre piece employs that it works in the same way as realism—it lulls an audience into a false sense of security and thus a message can pass quickly and easily from filmmaker to viewer. There are certain preexisting ideological principles that exist within genres that revisionist or hybrid genres can use or challenge, as long as they are there in some form. In film noir, this would include gender positions where the hero is male and morally ambiguous and the female characters are either the *femme fatale* or the perfect damsel in distress.

Unraveling Ideology

While there are semioticians and **narratologists** who specialize in film, there are very few film specialists in the world of ideological studies. It can therefore be useful to return for a moment to the origins and main points of the analysis of ideology outside of film studies.

Many of the thinkers involved are Marxists but "Marxist" criticism shouldn't be conflated with political belief; although many of the concepts are shared, the emphasis is very different. Some of the key terms are explained in the boxes on page 117.

Narratology: A branch of Structuralism that examines narrative structure and narrative communication.

Marxism

Base and superstructure: In traditional Marxist terminology "base" refers to finance—the economic base of society. The "superstructure" is the sociocultural world that surrounds the economic base. This suggests that as film is a medium reliant on money it will always be controlled by the base. In Marxist terms this is true of all forms, but it is particularly evident in cinema.

Dialectic: According to Karl Marx the term "dialectic" refers to two opposing forces that, through conflict, reach a resolution. As the essence of drama is conflict, this plays a fundamental role in film form. However, as a simplified form (film only normally lasts for about two hours or so), the nature of conflict has to be simplified.

Structuralist Marxists

Hegemony: Antonio Gramsci states that hegemony is leadership or dominance, usually of one social group over another. In terms of cinematic ideology, this can be seen in the systems that a film will use to make its ideology appear natural. In cinema this would be the repeated and often subtle prioritization of one viewpoint over another.

Post-structural Marxists

Interpellation: According to Louis Althusser interpellation is where the individual already exists as a subject receptive to ideology. In these terms, this is where film plays to our existing expectations about who and what we are. Normally this is the notion of individuality as outlined by the "hero."

	Dead Man's Shoes Warp Films/Big Art Productions/EMMI/Film 4
Director	Shane Meadows
Producers	Mark Herbert and Louise Meadows
Screenwriters	Paddy Considine, Shane Meadows, and Paul Fraser
Cast including	Paddy Considine (Richard) Tony Kebbell (Anthony) Gary Stretch (Sonny)

4.5

Dead Man's Shoes plays with notions of genre in publicity shots and on advertising posters. This has a particular effect on the audience; when going to see a horror film we expect certain things from it. Meadows' film has underlying elements which are horrific but not of the horror genre. This contrast is immediately unsettling for an audience.

Synopsis

Dead Man's Shoes is essentially a revenge story set in the UK town of Matlock. Richard (Paddy Considine) returns to his hometown after leaving the army. During his time away his brother Anthony (Tony Kebbell) has been invoked with a local group of small time hoodlums and drug dealers led by Sonny (Gary Stretch). Richard begins his revenge by tormenting Herbie when he is attempting to deal drugs and then Herbie, Soz, and Tuff in their flat. It is Herbie who remembers that he is Anthony's brother and we get a clear sense that something bad has happened in the past. Richard takes their drugs, leaving them with the difficult task of explaining what happened to their leader, Sonny (Gary Stretch).

The gang try to track down Richard as we learn more of what they did to Anthony. When they encounter Richard he is evidently unafraid of them. That evening Richard kills one of the gang with an axe, forcing their retaliation, and the gang go to the farm where Richard is hiding, to shoot him. Sonny misses and instead kills one of the gang. Later that day one of the gang runs while Richard drugs the remaining three and then kills them while they are in their drugged state.

Richard goes to a nearby town to track down the final member of the gang, Mark. When Mark discovers Richard is looking for him he confesses all to his wife. We learn that Anthony hanged himself when the gang had him high on drugs and left him. Richard has been alone throughout the film. In the end Richard kidnaps Mark, takes him to the farm, and, in the end, makes Mark kill him to end his killing spree.

Dead Man's Shoes: The Form

Dead Man's Shoes is a realist film. This seems a strange statement when the film is a revenge movie and such unrealistic things happen. But, of course, realism is nothing to do with reality at all. As we've already seen, it is the devices a film uses to make us believe that what is being shown is real. Dead Man's Shoes uses the conventions of the realist drama that have emerged in 21st-century British cinema. This includes providing the audience with a veneer of gritty reality, which hides the fictionality of the piece in question. Dead Man's Shoes uses carefully selected locations and costumes tied to the story and seems very close to the world in which we live.

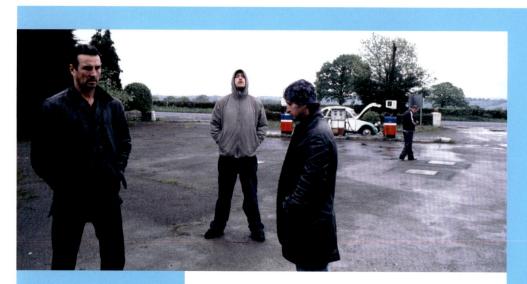

4.6

The filming style, locations, accents, and semi-improvised performance add a level of authenticity to the film and the story. The flashbacks in black and white and the revenge killings are far from real but the nature of the story is tempered by the gray, ordinary streets where the drama plays out.

Ideology and Representation

Dead Man's Shoes uses dialogue that to modern ears sounds realistic. As it sounds like it could come from a particular region in England therefore, it is real whether the audience viewing the film have any specific knowledge of the place in which the film is set. The other subtle factor that furthers the realism inherent in the film is the careful production design. If you look around your house you'll tend to see furniture from a number of historical periods. Historically dramas tended to be designed to fit a particular period. If the drama was set in 1972 then all furniture, clothes, etc. would be from 1972. This had the inadvertent effect of moving the sets away from rather than closer to reality, or at least an audience's perception of reality. *Dead*

120

Man's Shoes has interiors that look contemporary but also where the characters might exist. Sonny's house has the lone Bob Marley poster on the wall; the den of the drug dealer is complete in its absence of thought or attention.

This perception of accuracy is important to the process of ideological communication. It means that the audience is less likely to question the presentation and are subtly absorbed into the drama. The ideology can thus be communicated effectively.

4.7

Anthony is always shown behind Richard. Their relationship is defined by his guiding in a way that he couldn't when he was in the army. The character relationship is established by the time that it is revealed that Anthony is dead and the conversations a manifestation of Richard's psyche.

What Is Dead Man's Shoes About?

It is impossible to be completely neutral in the analysis of any film as it is necessarily affected by the viewer's ideological position. However, there are certain narrative themes and signifiers in *Dead Man's Shoes* that are important to explore. On the surface, this is a story about the revenge, regardless of the setting or time. However, there are other implicit messages which, as they are seemingly subsumed into the overarching narrative, can manipulate us as an audience. The film is also about class: the film focuses on ostensibly working-class characters and provides very little view of people outside of this social group. Actually the film focuses on a specific underclass—Richard has managed to escape the bleak environment in which he finds himself and has to pay for it.

The film is also about masculinity. It has two minor female characters, of whom one has no lines. This does not mean that it portrays the male characters in a positive light. It is arguably the case that acts of aggression are socially seen as male characteristics and yet in the end all the characters pay for this with their lives. It is only Mark (Paul Hurstfield) who is left alive. He is the regretful character, the one who has managed to break away from restrictions of his earlier life.

DISCUSSION QUESTIONS

How does *Dead Man's Shoes* represent the North of England? Do you think that an audience unfamiliar with a particular part of the country might see a film such as this as representative of the whole?

What is the difference between ideology and propaganda? Is it merely intent?

Dead Man's Shoes is about a very specific group of people, but what does it say about class and gender as ideological constructions? Does it manage to construct a view of class and gender? What does the relative absence of female characters do to the film?

The film makes statements about revenge – does it portray revenge as a justifiable act or not?

4: Ideology 123

Regarding authorship, some of the points above may have been intended, some of them may not be. As ideological beings we communicate, transmit, and conform to ideologies all the time.

4.8

The isolation that Richard feels is pronounced by the empty landscapes and the desolate farm he uses as home. This is a location in which he puts himself to atone for the guilt he feels in abandoning Anthony.

Tip

There is a strong argument to suggest that an audience empathize with characters. Always think about the characters in the film you are analyzing or the film you are making. Their gender, race, ethnicity, or sexuality will position them for an audience and will say something about that issue to an audience. You need to decide if it is the right message. This chapter is entitled "Ideology," a complex concept but in essence we are talking about how a film constructs meaning and how this meaning is transmitted to an audience. Some of this is through the form a film takes. Chapters 1 and 2 deal with semiotics and narrative and talk about how a film is structured and how a film communicates to an audience. This chapter has discussed how a film communicates.

If you are setting about making your own film you should ask the same question you would ask about any other film:

- What does your film have to say to an audience?
- Are you aware of your own ideological position?
- Are you deliberately manipulating an audience?
- · How is your film communicating to an audience?

Any consideration of the ideology of film demonstrates that film is a very powerful medium indeed.

124

EXERCISE: CHARACTER AND IDEOLOGY

Take a film, any film of your choice, and now list the main characters. Note who they are and what makes them who they are; note down their characteristics, such as whether they are violent or passive. Now look at their social status, what does their social grouping, gender, sexuality, etc. say about the group they belong to? What do you think this form of representation would say to an audience on a broader level?

EXERCISE: CONSIDERING CULTURAL AND CONTEXTUAL IDEOLOGIES

Ideologies can change over time and in different geographical locations. Take a film made more than 40 years ago. What ideological position do you think it was conveying to an audience at the time it was made? To understand what a film meant in the time it was made you have to try and put yourself in that position and research has to be undertaken. What doesn't change is how it is communicating its ideological position and this is the second part of the exercise. Note down the form and structure. From this ask yourself what you think the film means to an audience now. What is static in this is the film. It is a fixed text in which meaning fluctuates given the audience that view it. It is up to you analyze what the difference in meaning is.

Recommended Reading

Introductory Reading

Braudy, L. and Cohen, M. (eds.). *Film Theory and Criticism: Introductory Readings*, 7th ed. New York: Oxford University Press, 2009.

Comolli, J.-L. and Fairfax, D. *Cinema Against Spectacle*. Amsterdam: Amsterdam University Press, 2014. Dix, A. *Beginning Film Studies*. Manchester: Manchester University Press, 2008.

Freeden, M. Ideology: A Very Short Introduction. Oxford: Oxford University Press, 2003.

Grant, B. K. Film Genre: From Iconography to Ideology. New York: Columbia University Press, 2007.

Advanced Reading

Bazin, A. What is Cinema? 2 vols. Berkeley: University of California Press, 1967–1972.

Bordwell, D. *Figures Traced in Light: On Cinematic Staging*. Berkeley. University of California Press, 2005. Eagleton, T. *Ideology: An Introduction*. London: Verso, 2006.

- Kracauer, S. Theory of Film: The Redemption of Physical Reality. Princeton: Princeton University Press, 1997.
- Lapsley, R. and Westlake, M. *Film Theory: An Introduction*, 2nd ed. Manchester: Manchester University Press, 2006.

FRAMES AND IMAGES

5.0

The Good, the Bad and the Ugly 1966

director

Sergio Leone

Film language has no distinctive grammar and its vocabulary is heavily reliant on context for its meaning. Every shot is chosen from an infinite number of possible framings, compositions, and arrangements. When directors and cinematographers shoot, they draw on their experience with images for their targets. With very few exceptions, every film is made up of hundreds of different shots. Each one contributes a specific meaning to a film's overall storytelling.

Everything within the frame of the image is selected for its meaning, from the color of an actor's costume to the way a set has been lit. It's what makes film's storytelling cinematic—by showing, not telling. Cinema tells stories through images, not just with dialogue. Alfred Hitchcock told François Truffaut that "we should resort to dialogue only when it's impossible to do otherwise... first try to tell a story the cinematic way, through a succession of shots and bits of film in between."

The camera gives us our perspective on the action, and its distance, height and angle from what's seen all add meaning. We can never speak about the camera simply "recording" what is in front of it.

The action staged in front of the camera is referred to as the pro-filmic event. But it's like theater and becomes cinematic only when we consider how the shot has given us a vision of events. When we connect those images together in a sequence the grammar of film, for want of a better term further meaning is added, providing a context that adds meaning outside the image (we'll look at this in Chapter 7). Abstract: To remove (like a dental abstraction) for scrutiny; a concern with form rather than content (as in abstract art). The Soviet filmmaker Sergei Eisenstein called the shot the basic unit of film. For him, a shot was a cell in a bigger organism, a construction he called "montage."

Perspective

The shot has its own vocabulary, one reliant on contexts of narrative and editing for meaning. Nevertheless, images can be read like words. Different shot angles, heights, and types have their own established meanings derived from their use in thousands of films made over the last century or so.

The camera has several properties that transform and **abstract** the material depicted in front of the camera:

- **Distance:** The distance of the shot in relation to the actor or object being filmed.
- **Height:** The physical height of the camera in relation to the actor or object being filmed.
- Angle: The angle of the camera from the scene being filmed.
- Depth of field (focus): Sometimes the camera will only have shallow focus, with the background indistinct and out of focus (shot with a long lens); alternatively it can show everything in focus (deep focus with a short or wide-angle lens).
- Movement: Using a number of methods, from tilting the camera to moving it physically on tracks or a crane, moving the camera adds dramatic effect or simply avoids the need to cut.

To me style is just the outside of content, and content the inside of style, like the outside and the inside of the human body. Both go together, they can't be separated.

Jean-Luc Godard, filmmaker

Whose Eyes?

Every shot can be described in one of two ways: objective or subjective.

The majority of shots are objective. They show the viewer things in an "impossible" way, giving them a godlike view of the events they are witnessing. Objectivity is about being detached and unobtrusive; documentary filmmakers often attempt to be as objective as possible so as not to interfere with their subjects. Since someone has to choose where to put the camera, how to frame the shot and where to put the actors, objectivity is really an illusion. However, we still refer to these shots as objective.

Shots can also be subjective. Subjective shots show us the world from the perspective (the point of view or POV) of a character or object in the film.

In the opening scene of *Psycho* (1960), Alfred Hitchcock uses subjective shots from the point of view of the main character to portray her desire for power in her relationship with the married man with whom she is having an affair. The subjective shots depict her wish to become a subject with power, rather than just the "other woman." Hitchcock also uses POV shots from the perspective of a bundle of money, the true subject of the thriller. Atypically, he includes no subjective shots from the perspective of the man in this scene, who is weak willed and dominated by his father. Hitchcock here uses POV shots to give us a subtle sense of power in the scene, as well as to set up the narrative.

Recommended Reading

Film Art: An Introduction (1979) by David Bordwell and Kristin Thompson is an in-depth and detailed analysis of film form and narrative systems. It provides the basis for some of the most used terminology in film studies.

Non-diegetic: Anything in the film but not in its fictional world.

Story and Plot

Story and plot might seem the same but they are actually two different, but interrelated objects. According to David Bordwell and Kristin Thompson, the story is the linear sequence of events in the film while plot is the visual treatment of the story.

Story is composed of inferred events (things unseen but referred to in the story) and explicitly presented events.

Plot is composed of the same explicitly presented events and also added **non-diegetic** material (for example, the opening credits, sound, camera angles, editing, and so on).

These two overlap and can't be broken apart—it is impossible to have a film story without those non-diegetic, narrational devices that present the story to the audience visually and structurally.

All shots have distance, height, and level of some sort. For example, most shots of people are taken at eye level, but the camera's positioning can be manipulated for artistic or dramatic effect. Many shot types have longestablished uses and meanings, although this is always bound to the context of the narrative. However, this does not always run according to rule and directors might exploit shots for the opposite or ironic effect.

Angles

Camera angle is normally split into three types:

- Straight-on: the camera is pointed straight at its subject. This can often be referred to as frontality. Silent cinema was often frontal, with performers acting direct to camera, as though the audience was watching a theater play in a **proscenium**.
- Low angles: the camera is positioned below the subject, looking up. Low angles can often suggest a powerful subject who looms over us.
- High angles: the camera position above the subject, looking down on them. High angles are often used to make the audience feel superior to whatever they are watching. Higher angles could also suggest voyeuristically intruding on a scene.

As mentioned above, directors do not always run true to form, and Orson Welles uses some of the lowest angles in *Citizen Kane* (1941), shot from a pit specially dug for the camera, at Kane's lowest point after an election defeat. Kane looms large over us, literally, although he is powerless.

The height of the camera works similarly. A low camera height can produce a low angle, although not necessarily. The Japanese director Yasujirô Ozu always shot characters at eye level no matter who he was shooting. The height was lower for children and babies. This often had the effect of making characters, unusually, speak directly into the camera during conversations. Although direct address by characters often reminds us we're watching a film, Ozu's style of shooting puts us right into the heart of the action.

Proscenium: A theater stage or space that has a frame or arch as its main feature. Cinema still has very close links with theater, and the camera frame was initially conceived as like a proscenium arch, as a window on the world. You will still see films shot in this style, such as Susan Stroman's stagey adaptation of *The Producers* (2005).

On-Screen/Offscreen Space

The camera can only depict what is in front of it; this is obviously **on-screen space**. Technically, the camera cannot present space to us because any "space" in the image is an illusion of framing, lighting, and the arrangement of actors and setting. We relate what we see on-screen to our understanding of our own reality to create a believable picture of the world on-screen, which we refer to as part of the **diegetic** space.

In addition, renowned American film critic Noël Burch identified six zones of **offscreen space**:

- · Left of the frame.
- Right of the frame.
- Top of the frame.
- Bottom of the frame.
- The back of the frame, usually filled with scenery or a location.
- The front of the frame, the "fourth wall" which divides the diegetic space from the audience. Many filmmakers choose to break this "wall" by making characters address the audience directly to remind us we're watching a film rather than a "slice of life."

There are several ways in which offscreen space can be implied for the viewer:

- It can be spoken about in dialogue: Characters can speak about other places the viewer can't see—this might be just across the road or a distant planet.
- A character or object can leave the frame; if we see a character leave frame right, we have to assume there is more space there: They can't just disappear!
- A character might glance at a character or an object outside the frame. Again, we have to assume something is there for them to look at.
- Just as characters can leave the frame, they can also reenter, again implying a space beyond that which the viewer can see.
- On-screen sound is the most common method by which the audience is made to understand that there is a space beyond the camera's vision. Although it might have been added in post-production, it is **diegetic sound** emanating from a space within our story's world. Sound can suggest a 360° space (we'll look at this more in the next chapter).

Recommended Viewing

Take a look at the opening of Francis Ford Coppola's *The Conversation* (1974); he chooses to begin with a long high-angle telephoto shot that scours a crowd for a couple talking about a murder. Think about how the height of the shot gives us a feeling of power, but also how sound is used to make us unsure of what we're looking for.

Diegetic: Any object within the fictional world.

Diegetic (or actual) sound: Sound that emanates from characters or objects within the narrative's fictional space-e.g., dialogue, music from jukeboxes, etc.

Recommended Viewing

Watch the end sequence of The Good, the Bad and the Ugly (dir.: Sergio Leone 1966) and try to see how Leone uses different shot distances to build the tension toward a climax. Also look at how he gives us a view of the psychology of the characters in close-up. Shot distances are often dependent on the narrative, genre, and overall style of the film. Depending on the context, shot types can have different meanings, although an audience would still expect to see a closeup for an important piece of dialogue or a character's reaction. It is important to show significant details to make the narrative work.

I'm Ready for My Close-Up Now

We can roughly identify each shot by their distance and the ways in which they present setting and characters:

Extreme long shot (XLS): often used in Westerns or sci-fi films, the XLS shows us massive backgrounds and tiny, often insignificant people. Stanley Kubrick uses massive XLS in *2001: A Space Odyssey* (1968) to show just how insignificant the human race is against the infinite expanses of the universe.

Long shot (LS): human figures are more distinct, but background is still very visible. Musicals, martial arts, and action films often use lots of long shots to let us see the action.

Medium long shot (MLS): the human figure is framed from around the knees upward. French critics refer to this shot as the *plan américain* (American shot).

Medium close-up (MCU): individuals framed from the waist upward. This is one of the most typical shots in television, which, due to its greater intimacy over the cinema screen, often avoids big close-up shots.

Close-up (CU): generally emphasizes individual details such as faces, hands, feet, small objects. CUs are regularly used to give the viewer an insight into significant narrative details: important character reactions, a significant item (like a key being secretly hidden in someone's pocket) or to stress the importance of a line of dialogue.

Extreme close-up (XCU): isolates very small details such as eyes, lips, details of small objects. Sergio Leone loved to shoot XCUs of eyes in his Westerns.

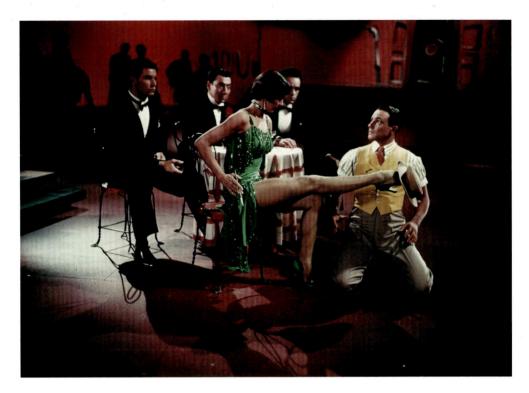

Camera Level

The camera's level can also be changed to add additional meaning to the image. Canted (or Dutch), angled, images were popular in film noir to suggest the world losing control. After World War II, the US was rapidly changing, especially for men, and film noir portrayed this anxiety, often with unusual camera levels, dark lighting and moody, rain-slicked streets.

Of course, the reverse could also be true: the level of the camera might also be manipulated to make slanted objects appear flat. In *The Bed Sitting Room* (1969), Richard Lester shoots two characters attempting to drink from a can that pours upward. Only when the scene cuts to a wider shot does the viewer understand that they are upside down. The initial shot portrays the absurdity of the situation and exposes the futile endeavors of the individuals trapped in this post-apocalyptic world.

5.1

Singin' in the Rain 1952

directors

Stanley Donen and Gene Kelly This long shot is typical of the musical, giving us a clear view of the dancers' movements, as well as the colorful background. Longer shots allow the filmmaker to follow action without interruption, as well as letting us watch the bodies of dancers, one of the main pleasures of the musical. Exposition: The means by which narrative information is relayed to viewers. This can be done visually, but is often conveyed in dialogue, an "information dump" or a super-villain "monologuing."

Composition and power

The screen is generally assumed to be split into three portions. The middle of the screen is generally held to be the most powerful. If a character or object is framed centrally, they are given power over what is in the margins of the screen.

Again, the opposite is also true. In *Taxi Driver* (dir.: Martin Scorsese 1976), the protagonist Travis is often framed in the margins of screen. This signals his own social marginality as a person on the edge. Sometimes Scorsese leaves Travis offscreen altogether to remind the viewer of his powerlessness, the very thing that leads to his shocking act of violence at the end of the film. All of the clues are visual, and added by camera style, rather than explained to us in **exposition**.

EXERCISE: COMBINING SHOTS

Select a five- to ten-minute sequence of any film. Try to break it down shot-by-shot. What types of shots does it use? What meanings do they add to what is depicted within the frame?

5.2

Taxi Driver 1976

director

Martin Scorsese

Travis (Robert De Niro) is a damaged Vietnam veteran who occupies the margins of society. Scorsese signified this by often framing him at the edge of the shot—he is rarely framed in the more powerful central part of the frame. **Mise en scène** is a critical term concerning the organization of objects within the camera's frame. It does not include the angle and distance of the camera, although these provide a perspective to help the viewer's understanding of the material in the *mise en scène*. Additionally, it doesn't include things the viewer can't see, like sound.

5.3

Amelie 2001

director

Jean-Pierre Jeunet An example of a tight close-up. The viewer is invited into the space of the film with the character. It's a very intimate shot.

In the Frame

Mise en scène is a French term derived from the theater. Pronounced "meez ahn sen," it literally means "putting in the frame." Everything we see within the camera's frame comes under the auspices of *mise en scène*: actors and their performances; lighting; costume; setting; colored lens effects; theatrical blocking (the organization of actors in space); and props. This all combines to give the viewer an image of cinematic space.

Lighting

Lighting is one of the most important elements of producing realistic or nonrealistic images. The most common lighting setup is known as **three-point lighting**. It uses three lights to simulate a three-dimensional image.

- The **key light**: the brightest of the three, this highlights details on the face by casting shadow on the unlit portion.
- The **fill light**: usually positioned on the other side from the key, this light is softer and less bright, which lessens the effect of shadowing on the face.
- The **back light**: located behind the subject, the back light gives the subject the appearance of depth by creating a haloing effect around the subject. This means that the figure won't appear as a flat part of the background.

This is an important lighting technique that helps to create the illusion of a three-dimensional image. Remember that the film image is only a flat image projected onto a flat screen. Lighting is used to give the image the appearance of depth. Without this the viewer wouldn't perceive it as a "real" image.

Lighting can be either **high-key** or **low-key**, depending on the emotional effect that the director and cinematographer are looking for. Low-key (or high-contrast) lighting uses harsh light and black shadows to show a dark, dangerous and corrupt world. This is particularly popular in film noir, while horror films often use low-key lighting to hide monsters in shadows. In *The Day the Earth Stood Still* (dir.: Robert Wise 1951) low-key lighting is used to suggest on-screen violence as our heroine is menaced just by the shadow of the massive robot Gort.

High-key (low-contrast) lighting is often used to limit the contrast range of the image. This kind of lighting produces softer, brighter images for daylight scenes or soft-focus close-ups in old Hollywood movies.

Tip

Keep in mind that once filmed, the actor is an object onscreen. Actors are surfaces composed of signs and symbols, and the viewer will tend to read them as such.

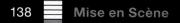

5.4

Don't Look Now 1973

director

Nicolas Roeg

Throughout *Don't Look Now*, the bright red coat becomes a repetitive motif in the *mise en scène*, symbolizing John's guilt around the death of his daughter, as well as playing a role in the ghostly story of past and future.

Recommended Viewing

Seek out *The Red Shoes* (dir.: Michael Powell 1948) and watch its central ballet sequence. Think about its expressive use of color, setting, costume, and just about every other aspect of style in one of the most important visual sequences ever produced for the screen.

Expressionism

Expressionism is an important stylization of *mise en scène*. Although the style has its roots in the early 20th century artistic movement in Germany and in the short-lived German expressionism movement, since then it has become an important tool of filmmakers.

Expressionist films are overtly stylized. Realist films attempt to hide the marks of construction that remind the audience that they are watching a film. Expressionists, however, show the viewer all those things by overtly manipulating the image.

All elements of *mise en scène* can be manipulated to express the inner state of mind of a character or to express something about the filmmaker. In *The Cabinet of Dr. Caligari* (dir.: Robert Wiene 1920), the setting is distorted and painted in jagged lines to express the mental turmoil of the protagonist. Similarly, the color of Sister Ruth's lipstick in *Black Narcissus* (dir.: Michael Powell 1947) is an intensified red to express her unbridled sexual libido.

This attention to detail can also be seen in the frame from *Eternal Sunshine of the Spotless Mind*, every aspect of which is meaningful. It is important to explore all elements of the *mise en scène*, as they have all been selected in order to provide meaning for us, whether it is telling us something about the character or about the story.

EXERCISE: READING MISE EN SCÈNE

Using the same sequence as the exercise on page 125, isolate a still frame and explore the individual signs of the composition and *mise en scène*. What does each element of *mise en scène* and framing say about the characters, their environment and the plot?

EXERCISE: CONSIDERING FILM STYLE

Choose a film that you wouldn't normally watch, one that is not to your normal taste. How might you describe the overall style of the film? What does it do differently?

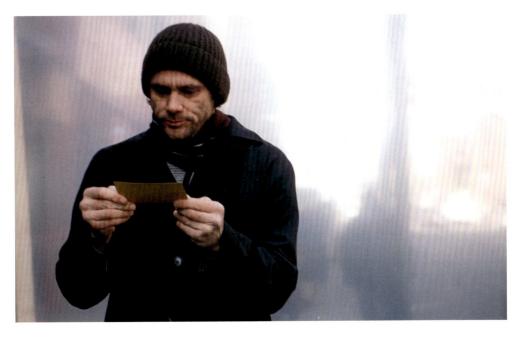

Shot: MCU framed just below eyeline. This shot gives us a clear view of Joel's face and the object he is scrutinizing. Joel is framed slightly off center—he is decentered, in emotional distress. He is not powerful at this point in the narrative, his life is out of control, and therefore Gondry does not frame him centrally.

Focus: The shot has a very shallow focus. This is an important clue to the narrative. Although we don't know it yet, we are inside Joel's head during the memory erasure procedure. His background is literally eroding. This is signaled for us visually.

Color: Muted and dull, the color again reminds us of the receding background.

Performance: Jim Carrey gives us a quizzical look. Joel is puzzled and perturbed, lost. How about the way he is holding the card? Does this look like a confident person in control? Does he hold the card like this just to remind us it's an important narrative object?

Costume: Although it seems obvious, Joel's hat and scarf remind us that it's cold.

5.5

Eternal Sunshine of the Spotless Mind 2004

director

Michel Gondry

Since the majority of *Eternal Sunshine of the Spotless Mind* takes place in the mind of its protagonist, we can read many of the symbols in its *mise en scène* as expressionistic.

Recommended Viewing

Take a look at a film that uses a subjective camera, such as *The Blair Witch Project* (dir.: Daniel Myrick and Eduardo Sanchez 1999) or *Cloverfield* (dir.: Matt Reeves 2008) and think about how all of the properties of the camera, such as height, distance, and the mobile frame are used to play around with the perspective of the camera, especially in the finales.

Recommended Reading

Geoff King's Spectacular Narratives: Hollywood in the Age of the Blockbuster (2000) is an exploration of Hollywood cinema in the era of spectacles such as video games, theme parks, and CGI. In particular, he looks at how modern films are driven by a dynamic, often aggressive, style to shake the viewer. Camera movement is one of the unique opportunities available to film over other art forms. In the early days of cinema, the camera was often static. It started to move during the silent era, but became static and theatrical when sound was introduced due to the bulky cameras. Since that time, cameras have become lighter and more manageable for camera operators to move, granting cinema an important dynamism and fluidity.

Panning, Tilting and Moving the Camera

While camera movement can add speed and movement to the image, it can also counteract the need to edit a sequence together. The camera will reframe without cutting. A longer take might begin in close-up, move out to a wide shot and finish on a two-shot by reframing. This could be achieved by cutting, but by moving the camera, the director can suggest a much more unified and coherent sense of space within the frame of the camera, instead of constructing it afterward through editing.

There are numerous ways in which the camera can move:

- Pan (panorama): the camera can pan left and right, as though turning its head on a horizontal plane.
- Tilting: the camera tilts up and down on a vertical line.
- **Tracking (dolly or trucking) shot:** the camera is fixed on a track, which can be laid in any direction.
- **Steadicam:** the camera is strapped to the camera operator using a special mount, which produces smooth, floating shots that are more flexible than tracking shots. Stanley Kubrick used this to considerable effect in *The Shining* (1980) to suggest a fluid, disembodied presence following Danny's tricycle.
- Hand-held: similar to the Steadicam shot, but with a shaky effect that is often associated with a documentary-style realism or with the subjective POV of a character. The technique has also been used for horror films that claim to be composed of "found footage," like *The Blair Witch Project* or *Diary of the Dead* (dir.: George A. Romero 2007).
- Crane (also helicopter or airplane) shot: mounting the camera to a crane can produce stunning shots from a great height, either to look down on diminished characters or to show scenery.

Simulated Camera Moves

Not all camera movement moves the camera; sometimes this can just be simulated:

- Zoom: a lens fitted to the camera allows the operator to change the focal length and alter the dimension of the image. For example, Robert Altman always shot with a telephoto lens to allow him to pick out significant detail in crowd scenes without letting his actors know. The speed of a zoom can also signify meaning, for example a fast zoom into the face of the villain in a martial arts film can be exciting, while a slow fade out from a character can be melancholic or sad.
- **Reverse zoom:** this is a special technique first used by Alfred Hitchcock in *Vertigo* (1958). It is achieved by tracking toward a character while simultaneously zooming out, changing focal length and making the background stretch into the distance. Hitchcock used it to suggest Scottie's vertigo, while Steven Spielberg uses the technique in *Jaws* (1975) to show Chief Brody's sudden realization of another shark attack.

Camera Movement

Camera movement is important in action films, where cuts can be made dynamic by jarring movement together. Normally a camera movement should be continuous across cuts, but directors can use jarring movement in opposite directions to produce impact and jar the viewer's senses. Geoff King has called these **impact aesthetics**. They are used throughout *The Bourne Supremacy* (dir.: Paul Greengrass 2004), especially where shaky hand-held close-ups are cut together jarringly.

Furthermore, because camera movement can suggest a much more realistic image of space, filmmakers often use camera movement in conjunction with long takes to suggest a continuous space. For example, Jean-Luc Godard used a very long hand-held tracking shot of Jean-Paul Belmondo and Jean Seberg in *Breathless* (1960) to create a unified sense of space, something he then disrupted with the use of jump cuts (we'll consider this in more detail in Chapter 7).

Logistically difficult but often stunning, the **long take** is one of cinema's most impressive features.

Duration

Not to be confused with long shots, the long take is a sequence of long duration. According to David Bordwell, the average shot length (ASL) in contemporary cinema is around 4–6 seconds, compared to 8–11 prior to 1960. A long take, however, could last up to around ten minutes—the length of a reel of film. In the era of digital video, this is becoming longer and longer; Alexander Sokurov's *Russian Ark* (2002) consists of just one shot spanning over 90 minutes and more than 200 years of Russian history.

The long take makes time in the image meet real time so that the diegetic time is the same as the discourse time (the time it takes to tell the story). Normally filmmakers can contract or expand time to speed up events or to delay a climax; a good example is the 60-second countdown in *Star Trek II: The Wrath of Khan* (dir.: Nicholas Meyer 1982), which takes more than two minutes!

André Bazin

André Bazin is probably the most significant film critic who ever lived. He co-founded the influential film journal *Les Cahiers du Cinéma* and helped promote the auteur theory, which stated that the director should be thought of as a film's author as he or she shapes the visual treatment of the material. He also inspired many of the directors of the French Nouvelle Vague who wrote for *Cahiers*, many of whom, including François Truffaut, Jean-Luc Godard, and Eric Rohmer, put Bazin's critical ideas onto the screen.

Bazin's most notable contribution was as a theorist of realism. He favored long takes, shot in extreme depth of field; whole sequences shot in single takes with every detail in focus. He claimed these "**sequence shots**" were:

- More realistic—editing could only present reality a little more forcefully, creating false drama.
- More ambiguous—they allowed the viewer's eyes to wander, to pick out important information for themselves rather than have it made obvious via close-ups.
- More like looking at reality—Bazin thought anything that made the film image more like looking at real life was a good thing.

144

Time

Time can also be manipulated in several ways:

- Fast motion: the camera can run at slower than 24 frames per second (fps) to produce faster motion on playback; this is also known as under-cranking.
- Slow motion: the camera is run at more than 24 fps to produce smooth slow motion, even up to around 2,000 fps, which is becoming popular in sports broadcasting to scrutinize the action closely; also known as **over-cranking**.
- Slow-motion effects can also be produced by duplicating individual frames; this produces a less fluid, jerkier, slow motion.

Manipulating time in the image can be very effective. Slow motion can mythologize action, as in Sam Peckinpah's *The Wild Bunch* (1969), or emphasize simple moments, such as a close-up of two hands briefly touching in Hal Hartley's *Flirt* (1995).

Fast motion can often be used to make slow movements flow more realistically in "real time": combined with long takes this can produce realist and spectacular effects. For example, Prachya Pinkaew includes a four-minute single-take sequence in *Warrior King* (2005) that avoids cutting. This assures the viewer that no stunt doubles were used and the action was continuous, although it would have been filmed with slower action which is under-cranked. This realist effect reinforces the impact of the action for the audience.

Digital systems are now providing even more manipulations of time for impact. Take a look at how Zach Snyder compresses and expands time in *300* (2006) and *Watchmen* (2009) to emphasize the impact of violence, while the Wachowski siblings pioneered **bullet-time** in *The Matrix* (1999) to suggest the possibility of manipulating time in the computer-generated world of the matrix. Like the filmmaker, the characters become able to manipulate time and space in their constructed world.

Recommended Reading

André Bazin's most notable work is collected in *What is Cinema*? (1967). His article "The Evolution of the Language of Cinema" argues for ambiguous reality over abstract editing, and is one of the most important critiques of film style ever written.

Recommended Viewing

Watch the climactic gun battle in *The Wild Bunch* (dir.: Sam Peckinpah 1969). Think about what the use of slow motion adds to the sequence: Is this a celebration of violence? A mythology for the passing of the West? A bullet ballet?

Visual Devices

The filmmaker has a host of visual devices to narrate a story. Every shot is selected from an infinite number of unused options, each of which could bring a subtle or significant difference of meaning to a sequence.

The image is never simply produced to look interesting or entertaining, but to present a specific image of space, time, and narrative meaning.

Cine-literacy is a matter of reading films, just as one reads a book by understanding its language and grammar. If you are planning to make and use images, then you must be cine-literate.

You must be able to identify and describe shots as well as being able to critically show what those techniques mean and how they contribute to a film beyond the basics of the narrative. After all, this is the narration itself; you wouldn't read a book without thinking about the author's word choices and use of grammar.

EXERCISE: THE LONG TAKE

Think about your favorite long take. Now try to work out how you could present the same sequence with multiple shots and editing. Would this add extra meaning to the sequence? How would the meanings of the sequence change?

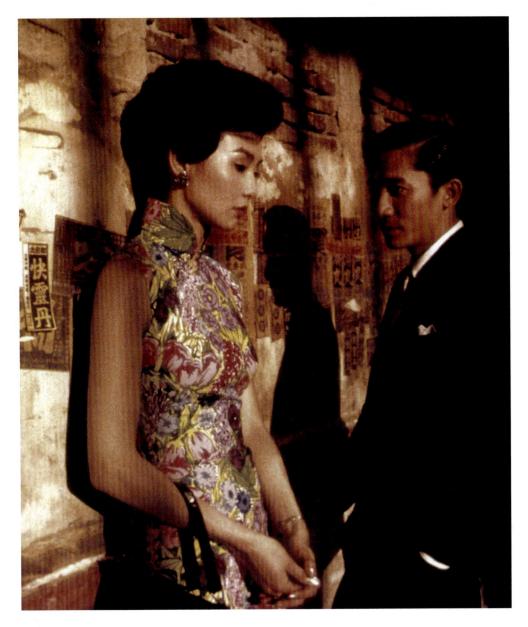

5.6

In the Mood for Love 2000

director

Wong Kar-Wai

Wong Kar-Wai's use of slow motion in *In the Mood for Love* gives sequences a dreamlike quality as time slows and the moments the couple steal together stretch into eternity.

Hero (Mandarin: Yingxióng)

Sil-Metropole Organisation/CFCC/Elite Group Enterprises/ Zhang Yimou Studio/Beijing New Picture Film

Director	Zhang Yimou
Cinematographer	Christopher Doyle
Screenwriters	Feng Li, Bin Wang, and Zhang Yimou
Cast including	Jet Li (Nameless); Tony Leung Chiu-Wai (Broken Sword); Maggie Cheung Man-Yuk (Flying Snow); Chen Daoming (King of Qin); Zhang Ziyi (Moon); Donnie Yen (Long Sky)

5.7

The *mise en scène* in the film is color coded. This red/orange sequence matches costume to the surrounding environment. The color coding comments on the subjective nature of experience.

148

Hero is based on the ancient Chinese story of a prince's failed attempt to assassinate the king of Qin in 227 BC—the man who would become the first emperor of China. The film's themes are about peace, unity, and nationality. When it was released it was lauded for its beautiful cinematography, the stunning fight sequences (choreographed by Tony Ching Siu-tung) and the complexity with which its themes were treated, although it was also criticized for what seemed like a pro-unification message about China and surrounding territories like Taiwan and Tibet.

Synopsis

A nameless warrior (Jet Li) arrives in the capital city of Qin claiming to have killed three assassins from the neighboring province of Zhao who threaten the king. With their weapons as evidence, the king allows Nameless to approach within 100 paces. Nameless tells a story in which he fought with and killed Long Sky and then drove the lovers Broken Sword and Flying Snow to furious combat over Sword's infidelity with Moon, and her affair with Sky. Snow had killed Sword and then Nameless has dueled with and killed Snow. The king doesn't believe him. He tells Nameless a different story in which the assassins are all in league with each other, and Nameless's story is merely a way to get close to the king to kill him. Nameless admits he is an orphan from Zhao, and that the duels were staged as a way to assassinate their enemy. He explains that Sword had convinced him of his desire for a unified, peaceful land. When Snow heard of Sword's will, she had attacked him, killing him as he refused to defend himself. She committed suicide. The king takes mercy on Nameless, but must still execute him as an example. The warrior dies in a hail of arrows, a hero.

Story and Plot

If we look first at *Hero*'s story and plot, the situation is very complicated. The story is told in non-linear fashion, with the earliest sequences referring back to Broken Sword's attempt to kill the king of Qin, told as a flashback in a flashback. In the most complicated fashion though, one of the story's narrators is lying and it's up to us to decide what we think is true, and what really happened. The plotting of the film is complex, but fortunately we're given ways to understand the structure of the story.

We can break the story down to six units:

- 1 Nameless visits the king to tell him how he killed the three assassins; the king's paranoid interpretation; Nameless's confession and execution.
- 2 Nameless's first story: the fight with Long Sky.
- 3 His first story continued: he finds Broken Sword and Flying Snow in the calligraphy school, undermines their relationship and the resulting fights.
- 4 The king's story: the assassins are in league and are plotting his killing.
- 5 Nameless's confession: his partnership with Sword and Snow and how his beliefs changed.
- 6 Broken Sword's flashback: his own attempt to kill the king.

We repeatedly cut back to unit 1 throughout the film, while units 5 and 6 are intercut. This all sounds complicated because it isn't linear, but Zhang and Doyle give us a code in the *mise en scène* to understand where we are, and each unit has a dominant color: (1) Black; (2) Gray; (3) Red; (4) Blue; (5) White; and (6) Green.

Each section gives us a personal perception from the perspective of the teller or the character whose space we enter. The darkness of the king's palace gives us a sense of his isolation and paranoia, which is also shown to us in the empty space of the throne room. The red, blue, white, and green sections could be interpreted as representing common emotional symbols. Since the red sequence is about a romantic spat, we might see the color representing anger, or the green might represent envy. Since we see the text as open, these are all valid interpretations, but we need to remember what the narrative is saying to us overall: the truth is relative. Each color then takes on a different shade or nuance of memory depending who is telling the story.

But we can also see the colors matching the environments. The red matches the autumnal colors of the trees where Snow fights Moon; the blue matches the water on the lake; white matches the color of the desert. The colors establish patterns or motifs that deepen the storytelling, heighten the cinematic spectacle and make us think about the nature of truth. Since Sword writes the characters for "Our Land" in the sand, the link between the environment and color makes thematic sense.

5.8

The cool blue costume of this sequence is a reminder of the blue water—the *mise en scène* comes to echo the colors of the environments in the film.

Mise en Scène

Mise en scène is obviously present in all of the shots of the film, but often some are more expressive than others. Here everything is expressive of the teller of the story and their image of the truth (the film is not unlike *Rashomon* (dir.: Akira Kurosawa 1950) in this regard). Although the *mise en scène* might be seen as realist, it has all been manipulated to a level of expressionism to support its central concept.

The colors are present in all aspects of the film's environments: the costumes, sets, and lighting. Some of these are achieved on set, particularly costumes and sets. Other effects are achieved in other ways—the green fabric that falls to the ground after Sword fights the king in the green sequence was color corrected digitally in post-production to achieve the correct green that couldn't be achieved in the hand-dyed material.

Close Analysis

Breaking a film apart like this can let us see why a director has chosen certain techniques to make the film a cinematic spectacle; it deepens the narrative (here in something that could be "just" an action film), adds complexity, and creates an absorbing spectacle through the manipulation of *mise en scène*.

Try doing this with any film to see just how much the director of the film has used the techniques at her disposal to make the storytelling more expressive and cinematic by "telling the story in a cinematic way."

DISCUSSION QUESTIONS

What do you think *Hero* is trying to say about history and our understanding of it through its visual devices?

Color symbolism often tells us that certain colors represent specific emotions; why do you think films might try to resist those conventions?

Does an emphasis on visual spectacle make viewers less inclined to be critical about the messages being conveyed in films, especially action films?

5.9

Since this is a martial arts film, we want to appreciate the action—a genre known as wire fu, since the performers are supported by wires to give the action a spectacular quality. Therefore we see many long shots to frame the action. The action is also heightened through the use of under-cranking to speed up individual movements and then stressed through diegetic sounds created in post-production.

Tip

When you watch films, try to look for patterns or systems that directors create—the final shot might remind us of the opening shot or a particular pattern of images might be created. This is a test of concentration, observation, and memory. If you can't do this with other people's films, it will be difficult for you to do it with your own. In this chapter, we've seen that we don't just think about *what* we see on-screen, but about *how* that is presented to us. The camera changes the nature of how audiences encounter what's on-screen. Consequently, this adds meaning to what is seen and the creative choices of the filmmakers develop the story in particular ways.

For every shot in a film there are an infinite number of alternative choices—a close-up could be replaced with a long shot, the level of the camera could be canted instead of level, or the *mise en scène* could be designed blue instead of red. By substituting one choice for another, we would significantly change the meaning of a shot or alter its contribution to our overall understanding of the film's story. Of course, these details can fly past us in a second or two, or details could be really tiny on the big screen. Sometimes you need to pause and study the image or sequences to really understand what's going on. This is the beauty of digital video and DVD—they allow a different kind of scrutiny than was possible with film.

EXERCISE: ANNOTATE A SEQUENCE

Mozilla's PopcornMaker (popcorn.webmaker.org) is a free web platform that lets you turn any video file on YouTube or Vimeo into a video essay. It will also let you add music from SoundCloud or any image of Flickr or Giphy to play with the meaning of images and sound.

Try importing a music video or short film from YouTube or Vimeo and make it into a short video essay, add text to show which shots are used, insert images to compare one shot with another, or change the soundtrack entirely to achieve another effect altogether.

Using a platform like PopcornMaker gives you a way to play with images to understand how important context is for their overall meaning. No element of the film or video is separate from the next, but now digital tools let us recombine, refashion, and rework material to create new patterns or meanings.

Recommended Reading

Introductory Reading

Dix, A. Beginning Film Studies. Manchester: Manchester University Press, 2008.

Advanced Reading

Bazin, A. What is Cinema? 2 Vols. Berkeley: University of California Press, 1967–1972.

Bordwell, D. Figures Traced in Light: On Cinematic Staging. Berkeley: University of California Press, 2005. King, G. Spectacular Narratives: Hollywood in the Age of the Blockbuster. London: I. B. Tauris, 2000. Kracauer, S. Theory of Film: The Redemption of Physical Reality. Princeton: Princeton University Press, 1997.

Truffaut, F. Hitchcock. New York: Simon and Schuster, 1985.

Wollen, P. Signs and Meanings in the Cinema. 4th ed. London: BFI, 1998.

= SCUND

6.0

Blow Out 1981

director

Brian De Palma

A variant on Antonioni's *Blow-Up* (1966), De Palma's film is about the power of sound; collecting sounds for a slasher film one night, a sound technician thinks he records a murder. The film plays with our subjective experience of hearing, just as the earlier film played with vision.

What makes film so distinctive? Its visual spectacle? The medium's ability to show and not tell? Editing's capacity to play with our point of view? What about sound? It's often considered secondary, a lesser part of film's overall impact. Sound isn't as glamorous as directing or cinematography, but it plays a vital role in our overall experience of cinema.

We have to remember that cinema is audiovisual, not just visual. Ambient sound plays a vital role in the realist effect of film, as well as being another part of the filmmaker's toolkit that can be designed, manipulated, or subverted to help tell compelling and complex stories. It's never simply a case of *just* recording clean dialogue (although that's important too). There is so much more to understanding how film uses sound rather than just words and music.

Synchronous sound:

Sound that is "in sync" is synchronized temporally with the image on-screen. It is simultaneous, so we hear the dialogue as the actor's lips move. Until 1927, cinema had no **synchronous sound**. We often refer to this period as "silent" cinema, but this is really something of a misnomer. Cinema was never silent. There was always some sound, whether it be a pianist, or an orchestra, or a narrator—even actors behind the screen dubbing the dialogue on screen. That's even before we consider the sounds implied on the screen visually. Michel Chion suggested a better term for this was a "deaf" cinema, one where sound was ever present, but never heard.

The important point here is that cinema is a *sound art*. It is not a purely visual medium. Sound's importance to the overall experience has previously been a neglected area of critical exploration, although that's something we'll begin to redress here.

158

Recommended Reading

Michel Chion's *Film, A Sound Art* (2009) is an important exploration of sound's role and function in cinema. Other books, such as *The Voice in Cinema* (1999) and *Audio-Vision: Sound on Screen* (1994) have made him one of the premier thinkers in the field of film sound.

6.1

Twin Peaks: Fire Walk With Me 1992

director

David Lynch

David Lynch's films regularly use surreal sound effects in dream sequences, or nightmarish realities. In Twin Peaks: Fire Walk with Me, the sequences in the black lodge (the red room pictured here) have heightened and directed sounds. The Man from Another Place (Michael J. Anderson) always speaks intelligible dialogue, although it's backward. Other sound effects are also reversed and isolated as there is no atmosphere holding the sounds together. Some shots, such as the eating of creamed corn, have no synchronized sound at all. The effect is otherworldly, dreamlike, and surreal. They are typical of the creative and unsettling uses of sound in Lynch's films.

Sound has a number of innate qualities, with which we are familiar, that can be manipulated, distorted or edited to create particular effects, either to aid realism or to disturb it. We have to remember though that what we hear synchronized with the image on screen might not necessarily be made by the object on-screen.

David Sonnenschein defines seven categories of sound qualities, and their opposing extremes:

- Rhythm, from rhythmic to irregular
- Intensity, from soft to loud
- · Pitch, from low to high
- Timbre, from tonal to noisy
- Speed, from slow to fast
- Shape, from impulsive to reverberant
- · Organization, from ordered to chaotic

In *Film Art: An Introduction*, David Bordwell and Kristin Thompson split this series of **sound qualities** into two overarching categories, acoustic properties and dimensions of sound, some of which overlap with Sonnenschein's categories:

- Acoustic properties:
 - loudness (akin to intensity)
 - pitch
 - timbre
- · Dimensions of sound:
 - rhythm
 - fidelity (the degree of faithfulness of sound to image)
 - space (akin to shape, the sound envelope)
 - time (the degree of synchronization)

All film sounds will exhibit these qualities to some degree. In *Ringu* (dir.: Hideo Nakata 1998), the sound of the cursed videotape is manipulated for pitch and timbre to sound metallic and scratchy, and to affect the audience physically. Other films, such as Lynch's *Mulholland Drive* (2001), play with the fidelity of sound—its time, space, and organization. This helps the audience question the sounds used and to explore the lack of reality in the relationship between film and its soundtrack.

Recommended Reading

Sonnenschein's Sound Design: The Expressive Power of Music, Voice, and Sound Effects in Cinema (2001) is both a theoretical and practical guide to understanding and producing sound for moving images.

EXERCISE: SOUND QUALITIES

Select a short sequence of film. Try to describe all the different parts of the soundtrack and their use of the qualities of sound. What is the intensity or rhythm of the dialogue? Are any sounds used that exploit the extremes of Sonnenschein's scales? Can you hear any sounds that you didn't expect to be there?

In *Star Wars*, I wanted to come up with a very massive rumble for a spaceship flying overhead... I recorded the air conditioner in my motel room, slowed that sound down so it was even deeper and that became the rumble for the spaceships. Ben Burtt, sound designer

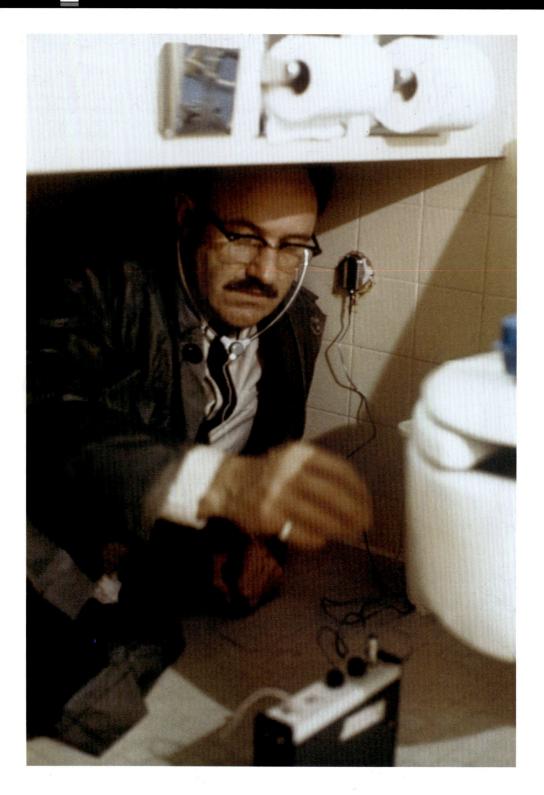

Sound in Space

In a classic of 1970s political paranoia cinema, Walter Murch's sound in *The Conversation* is at the heart of the plot, which revolves around a surveillance expert's obsession with a conversation he's hired to record. A misheard word draws him into a murder plot.

The opening sequence of the film, when the conversation is recorded, distorts pitch, timbre, space, fidelity, and organization as it's made difficult to see who we're supposed to be following in the sequence, as well as the complications of making out what's being said by the couple we're following. The recorded noise seems tinny, metallic, at times too loud, and the organization is highly chaotic, with overlapping dialogue (as the camera picks up different individuals from the crowd), and music that is too loud from the camera's perspective (an extreme long shot). Once we're aware of who we're following and the action switches to the surveillance van, the dialogue from the couple is too loud, and too clear to be just what we're hearing characters hear in headphones.

We're placed in the position of the surveillance team, eavesdropping on a very private moment in public. The chaos of the sound and the **sound perspective** eventually settle down to let us hear the clear recording, although exactly what's heard (different from what's been said) won't be revealed until later on in the film.

Recommended Viewing

Watch the first half hour or so of *Wall-E* (dir.: Andrew Stanton 2008) and listen to the ways in which the sound, designed by Ben Burtt, is used to tell the story. There is no dialogue, so the narrative needs to be driven in other ways. Try to hear how the acoustic properties and dimensions of sound are manipulated.

Sound perspective: Like shot distances, sound also adopts perspective relative to the camera position. Distant sounds tend to be quieter and echo more in space, while close-up sound is louder and clearer. Close-up shots should match close-up sound (although, as with so many of these rules, they're often broken to create specific meanings).

6.2

The Conversation 1974

director

Francis Ford Coppola

Harry Caul (Gene Hackman) becomes obsessed with a conversation he's hired to record. The plot centres on a mishearing, and, as such, shows us the subjectivity of our perception. **Diegesis:** The fictional story world within the film, the sum of on-screen and offscreen space. Any object within the diegesis is diegetic, while anything in the film but not in its fictional world is nondiegetic (such as the score, credits, and so on).

Asynchronous sound: That

which does not match the image. It might be dubbed dialogue that doesn't match the on-screen lip movements: a dog might meow.

Alternatively, synchronous sound is that which is heard at the same time that it is produced in the diegesis, for example dialogue or gunshots. Synchronized sound can be on-screen or off and is simultaneous with the image.

Tip

Asynchronous sound is often exploited for artistic or comic effect, as in *Singin' in the Rain* (dir.: Stanley Donen and Gene Kelly 1952) when an early sound film goes out of sync. This technique usually reminds the audience that they are watching a film.

Sound can roughly be broken down into two categories: diegetic and non-diegetic.

Diegetic (or actual) sound refers to any sound emanating from the fictional world (the diegesis) within the film, including:

- · characters' voices
- · sound effects, both on- and offscreen
- music that can be identified as coming from a source inside that world such as jukeboxes, instruments, and so on.

Non-diegetic (or commentary) sound refers to anything that does not emanate from the fictional world, including:

- voice-over narration
- · dramatic or imagined sound effects
- a musical score or soundtrack.

This is not to be confused with live or post-production sound. Diegetic sound can, and usually is, added in post-production. Some cinemas have traditionally worked entirely with postsynchronized sound, especially in Italy and Hong Kong.

Simultaneous and Non-simultaneous Sound

Sound can be further employed in relation to the ordering of the story. Both diegetic and non-diegetic sound can be both simultaneous and non-simultaneous.

- Simultaneous: sound that occurs at the same point in the story as the images on-screen
- Non-simultaneous: sound that occurs either earlier or later in the story than the images on-screen

Sound that occurs earlier in the film than the images onscreen is usually a flashback to the past, something we might have heard before, or something we might not have. In *Blade Runner* (dir.: Ridley Scott 1982), when Deckard picks up Gaff's origami unicorn, we hear Gaff's earlier line, "It's too bad she won't live, but then again who does?" This is a diegetic sound flashback. Hearing the line again brings significance to the presence of the unicorn, and raises questions about the identity of our antihero.

Memento (dir.: Christopher Nolan 2000) almost always uses simultaneous diegetic and non-diegetic sound (the nondiegetic sound mostly the musical score). Since Leonard has only short-term memory, it makes sense that the sound is also in the present. The exception is when he recounts the story of Sammy Jankis, the man Leonard investigated when he worked in insurance who suffered from the condition they now share. We now see non-simultaneous sound as Leonard's voice-over is from later in the story than the images (we have an image flashback), but we also have sound simultaneous with the flashback.

164

The most common usage of non-simultaneous sound is the reminiscing narrator, who is narrating from a point later in time. It's also normally a sign that our lead character won't die, except for Joe Gillis in *Sunset Boulevard* (dir.: Billy Wider 1950) whose corpse narrates the film floating face-down in a swimming pool.

Subjective and Objective Sound

Like the view point of the camera, sound can be objective or subjective. Objective sound gives us a realist soundscape, capturing everything that's going on in the space we're watching. Subjective sound however, can take us into the head of characters. There is a very famous use of subjective sound in Saving Private Ryan (dir.: Steven Spielberg 1998). In attempting to defend a bridge in Ramelle, Captain Miller (Tom Hanks) is caught too close to an exploding tank shell. He's knocked to the ground, his helmet coming off in the process. Shell-shocked, Miller gets to his knees, disoriented. The sound envelope collapses. It sounds like we're listening to the soundtrack under water, as all sounds are muted and we can hear the distorted ringing in Miller's ears. It's giving us the subjective experience of being in battle, just as the opening D-Day sequence gives us the terrifying sound perspective of bombs going off around us and bullets whipping around our heads in surround sound.

Direct sound: This

describes sound recorded on set, which can often combine dialogue, sound effects, and music. It's common in realist films, such as Abbas Kiarostami's *Ten* (2002).

EXERCISE: LISTENING TO THE SOUNDTRACK

Try listening to a sequence from one of your favorite films with your eyes closed. Listen to the soundtrack closely. How do you get a sense of space just from listening to the soundtrack? Open your eyes and watch the same sequence. How does the soundtrack refer to the images? Does the sequence use any non-diegetic or asynchronous sound?

Taking the sound out of the battle became an interesting device to get inside someone's head

Gary Rydstrom, sound designer

Sound can give an audience the illusion of a 360° world. Often, film sound can seem spatialized and directed, so the audience might hear dialogue perfectly, even if characters are speaking in a noisy environment like a nightclub or a crowded restaurant. Sound would be prioritized due to the narrative's requirements. Therefore, sound has perspective, just as vision does.

The DVD made us more familiar with some of the technical terms associated with film sound: Dolby Digital, DTS, 5.1 surround, etc. Dolby Digital (also AC-3) is a compression codec (also known as noise reduction, since it filters out sounds outside the human range of hearing) for encoding and reading sound files, as is the DTS (which is named after the company that produces it, Digital Theater Systems, Inc.) system. For home systems, variants of these systems can deliver up to 7.1 channels of sound.

What does that mean though? The answer is really important for how we understand the way space can be produced by the placement of speakers.

6.3

The setup of a 7.1 surround system in your home would look like this.

The 7.1 refers to the number of discrete channels in the soundtrack:

- 1 Front left
- 2 Front right
- 3 Center
- 4 Surround left
- 5 Surround right
- 6 Surround center left
- 7 Surround center right

The .1 refers to a subwoofer for base frequencies which is non-directional.

Like a camera, sound can pan from left to right, or sweep from the front to the surround channels. We're used to being at the cinema and having bullets ping past our eyes, or helicopters or spaceships fly over our heads. Even though we can't see where the object is going, we understand it goes somewhere—it can't just have disappeared (although technically it has, because once it goes offscreen, it ceases to exist).

The process by which we "fix" sounds to objects in the diegesis is called magnetization (Chion). As Figure 6.3 shows us, the speakers are not in the same place as the screen (just as they aren't in the cinema, although they might be behind the screen). We therefore need to "attach" sounds to the things we see on-screen. Chion calls this process magnetization, the acceptance that what we're hearing is actually coming from the space on-screen.

The surround speakers can be used to envelope us in the space of the film. But dialogue will normally come from the center front speaker, and the other channels will be used to create atmosphere and develop an expansive and plausible 360° space. The opposite effect can be created though. When Joakim Sundström designed the soundscape for Andrea Arnold's *Fish Tank* (2009), he designed a limited mono soundtrack to supplement the claustrophobic 4:3 image.

Recommended Viewing

Alfonso Cuarón's Gravity (2013) relies heavily on its sound for its overall effect (try to experience it with surround sound), even though a great deal of its appeal was visual (its use of 3D, special effects and that it only features an unusually low 156 shots). Because sound doesn't travel in space (no matter what sci-fi films have told us in the past), we're locked into the sound in characters' helmets. Dialogue is unusually in the surround speakers, and the placement of sound puts us right into the point of view of Sandra Bullock's astronaut lost in space.

Worldized sound: Sounds

that are re-recorded in their space of audition to capture the acoustics of the space in which they are heard in the diegesis. A technique developed by Walter Murch for *American Graffiti*'s (dir.: George Lucas 1973) many car radios.

Multilayered Sound

Robert Altman developed a very distinctive and realist way of using sound. Altman often directed films with big ensemble casts, from *MASH* (1970) to *Gosford Park* (2001). He recorded sound with radio microphones attached to individual actors. Therefore when we watch one of his films, sound is often cluttered with dialogue from multiple characters. The sound perspective is often directed toward particular characters. At times, however, we might see characters on-screen, but be listening to dialogue from offscreen. The overall effect was a constant 360° space filled with characters and activity that doesn't stop just because it isn't necessary for the narrative or is offscreen.

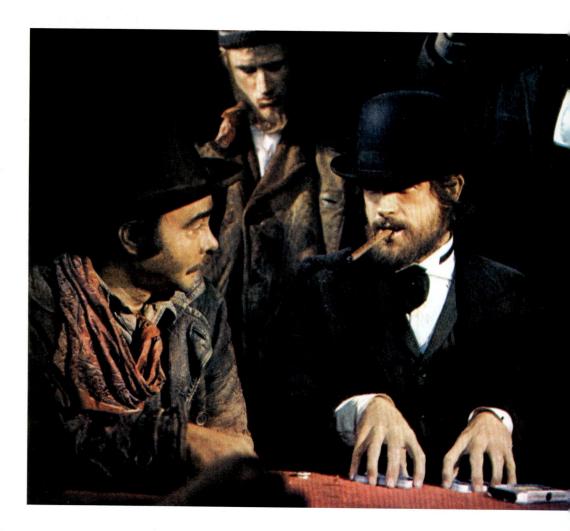

168

6: Sound 169

With recorded material you can manipulate sound effects—the sound of the world—to great effect. In the same way that painting, or looking at paintings, makes you see the world in a different way, listening to interestingly arranged sounds makes you hear differently.

Walter Murch, film editor and sound designer

Recommended Reading

Sound Practice, Sound Theory (1992) is a collection of essays edited by Rick Altman that looks at the technique, theory and history of film sound. Each essay discusses a different aspect or type of film sound, from the sound of cartoons to the recording of women's voices.

Recommended Viewing

M (dir.: Fritz Lang 1931) is widely regarded as the first film to use sound creatively. It's generally held that the coming of sync sound helped turn cinema back into theater (due to the loudness of sound cameras and their size), but *M* understood the storytelling potential of sound, using offscreen diegetic sounds to strong effort, and creating a sound motif as a key plot point.

6.4

McCabe and Mrs. Miller 1971

director

Robert Altman

McCabe and Mrs. Miller is one of Altman's most distinctive and realist films. It uses multilayered sound to convey a space beyond the vision of the camera.

Recommended Reading

Michael Caine's Acting in Film: An Actor's Take on Movie Making (revised edition, 2000) gives an excellent perspective on the work of the actor in front of the camera, including the use of the voice. Cynthia Baron and Sharon Carnicke's Reframing Screen Performance (2008) is a really strong exploration of why understanding actors' performances is essential to the overall effect of cinema.

Tip

The voice we hear on-screen coming from a character might not be the actor's voice. In Greystoke: The Legend of Tarzan, Lord of the Apes (dir.: Hugh Hudson 1984), Andie MacDowell's entire performance was dubbed by Glenn Close's voice. MacDowell's appearance fitted the role, but her strong Texan accent wasn't considered right for the role of a character from Baltimore. This is an important issue when we consider the overall illusion of the cinema.

Michel Chion explains to us that there is a "hierarchy of perception" when it comes to what we hear coming from the screen. At the top of that hierarchy is the human voice. The voice, Chion says, is not just one sound among many: there is the voice, and then there is every other sound. The sound of the voice is a special one. When we hear, we tend to isolate the sound of the voice first, and then we seek out the source of the voice and magnetize it to an individual.

Since this isn't a book about actors and film performance, it isn't possible to go into too much depth about actors' performances, but we should understand that the voice of the performer can be manipulated in all the ways we've learned about during the chapter: intensity, pitch, timbre, speed, and space. One of our key examples, *The Conversation*, even hinges on the tiny difference between "he'd kill *us* if he got the chance" or "he'd *kill* us if he got the chance"; tiny inflections in the actor's voice misheard by our protagonist.

Acousmêtre

Derived from the combination of the term **acousmatic** (the sound without identified origin), and the French word être (being), the acousmêtre is a specific kind of vocal character whose voice is heard, but remains offscreen. The acousmêtre is imbued with a kind of mythic potency and power. It is a figure that is all-seeing, omnipotent, and omnipresent, all-knowing and immaterial. The radio is always an acousmatic presence for instance.

Cinema's most notable acousmêtres include the unseen criminal mastermind Dr. Mabuse in *The Testament of Dr. Mabuse* (dir.: Fritz Lang 1933), or the omnipotent eye of HAL 9000 in *2001: A Space Odyssey* (dir.: Stanley Kubrick 1968). But we can also add to this the unseen narrators of *The Age of Innocence* (dir.: Martin Scorsese 1993), *The Virgin Suicides* (dir.: Sofia Coppola 1999) or *The Turin Horse* (dirs.: Béla Tarr and Ágnes Hranitzky 2011) whose disembodied voices are invested with narrative power, but never revealed visually.

You should also consider the power of the documentary narrator under this category. We aren't often asked to question these voices, but to accept their discourse as "fact." Therefore, the voice of Morgan Freeman in *March of the Penguins* (dir.: Luc Jacquet 2005) is invested with the same kind of authority and omniscient insight as the fictional characters mentioned above.

De-acousmatization

De-acousmatization refers to the process by which the acousmatic voice is given an image and revealed to us. When this occurs, the power and mysticism of the voice are stripped away and it becomes rooted to a place, no longer disembodied in space. The unseen narrators are rarely deacousmatized, nor are the powerful (mostly male) voices of the documentary. But many acousmêtres are returned to space in this fashion.

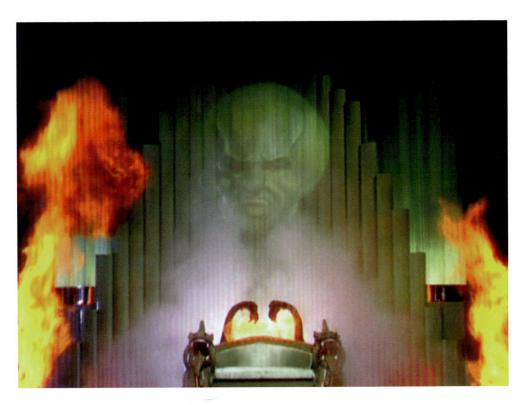

6.5

The Wizard of Oz 1939

director

Victor Fleming

Probably the most famous acousmêtre in film history is the Wizard of Oz. De-acousmatized by Toto the dog, the Wizard loses all of his power and mystery when the apparatus behind his voice is revealed to be just an illusion. It's an old adage that if you leave the cinema whistling the film's theme tune, it hasn't been effective. Film music is generally held to be felt, not listened to.

Music is an important part of the communication system of film—it communicates emotionally and tonally, and signals key points in the narrative. Not everyone who watches cinema is a music expert, and so we can't assume a knowledge of musical form and structure at the level of a composer or musicology expert, but we are often good listeners who can spot and understand repetition and variation, tone, pitch, and timbre.

We can understand the dark ominous tones of the two-note tuba motif from John Williams's score for *Jaws* (dir.: Steven Spielberg 1975) in relation to the shark we don't initially see. The music partly compensates for us not seeing too much of the shark, but we understand its impending threat right from the opening credits, played over an underwater point of view shot.

The shrieking strings of Bernard Herrmann's *Psycho* (dir.: Alfred Hitchcock 1960) score are atonal and discordant, although rhythmic like the stabbing of the knife, and we respond to the ways that the score has impact on us, both psychologically in relation with the images and the physiological effect on our nerves, as the music affects our perceptual system.

Sometimes music can use a cultural signifier, such as the small cue played on an Asian flute toward the end of *Godzilla* (dir.: Gareth Edwards 2014), which reminds us of the Japanese origins of the monster.

Motif and Leitmotif

The most common means of structuring a film score is through a leitmotif: a melody, harmony, or progression associated with a character, a place or object in the film that is varied and repeated across the film. A motif might recur at a different point in the film in a different key, slightly varied in melody, tone, or pace, or in different orchestration. At the end of *Return of the Jedi* (dir.: Richard Marquand 1983), the "Imperial March" motif returns to play after Darth Vader's death, but it's much softer, a less grand, imposing orchestration than the one established in *The Empire Strikes Back* (dir.: Irving Kershner 1980) to signifier Vader's power.

Pop Music

Since the 1960s, there has been a big shift toward the use of pop music in place of film scores. This performs several functions:

- to establish a time period: Dazed and Confused (dir.: Richard Linklater 1993) opens with "Sweet Emotion" by Aerosmith to signify the film is set in the 1970s
- as anachronism: the use of "I Want Candy" by Bow Wow Wow (from 1982) is totally out of place in the 18th century-set *Marie Antoinette* (dir.: Sofia Coppola 2006), but it supplements the theme of the film in a hedonistic montage
- for characterization: British indie music from the 1980s and 1990s is used to say particular things about the characters in (500) Days of Summer (dir.: Marc Webb 2009)
- as counterpoint: "Blue Moon" by Sam Cooke might not seem a frightening choice of music in *An American Werewolf in London* (dir.: John Landis 1981) because the light musical choice counterpoints the horror on-screen. The film is filled with a number of pop songs, all with moon in the title
- as a variation on the film's theme: "My Heart Will Go On" from *Titanic* (dir.: James Cameron 1997) is a variation on James Horner's orchestral score for the film. This also worked to promote the film commercially
- as synergy: the lyrics of "My Beloved Monster" by indie rock group Eels fitted just perfectly with what was on screen in *Shrek* (dir.: Andrew Adamson and Vicky Jenson 2001), but at the time the band were signed to a record label owned by the studio who made the film, and therefore this is a good example of a media corporation maximizing its profit in a single property

Recommended Reading

Edited by K. J. Donnelly, *Film Music: Critical Approaches* (2001) is a good entry point to understanding the function and work of film music, written in an approachable style for the musical layperson. Director and screenwriter Supervising sound editor Cast including

Berberian Sound Studio Warp X/Illumination Films

Peter Strickland

Joakim Sundström

Toby Jones (Gilderoy), Cosimo Fusco (Francesco Coraggio), Antonio Mancino (Giancarlo Santini), Fatma Mohamed (Silvia as Teresa), Salvatore Li Causi (Fabio), Chiara D'Anna (Elisa as Teresa), Tonia Sotiropoulou (Elena), Suzy Kendall (Special Guest Screamer)

Synopsis

Giallo (plural gialli):

A genre of Italian thrillers and horror films made throughout the 1960s, 1970s, and 1980s. The genre takes its name from the Italian word for yellow, the color of spines of the lurid novels that inspired the first films in the cycle. The most notable examples are the films of Dario Argento, such as *Deep Red* (1975) and *Suspiria* (1977). Somewhere in the 1970s, British sound recordist and engineer Gilderoy arrives in Italy to work on a film called *II Vortice Equestre (The Equestrian Vortex)*, which he believes to be a film about horses. Upon meeting the producer Francesco, he discovers that the film is a lurid *giallo* filled with violence and debauchery. More comfortable making soundtracks for quaint English nature documentaries, Gilderoy struggles with the content of the film, recording and mixing a series of screams, witches, goblins, and all kinds of butchery. Having to deal with an overbearing producer and a pompous, lecherous director, Giancarlo Santini, and a collection of characters who have few qualms about what they're putting on screen, Gilderoy ploughs on.

A tape of sounds from his last project, the pleasantly English *Local Perspectives*, and letters from his mother about the chaffinches nesting in his shed are his only solace. Nevertheless, he begins to lose his mind. During a conversation with Gilderoy, Silvia, one of the actresses working on the film, confesses that Santini sexually assaulted her. She destroys the work they've completed so far; Gilderoy begins to be unable to tell what's film and what's real. Santini simply recasts her part with another beautiful actress and immediately begins an affair with her. The gentle Gilderoy struggles with his grip on reality until he is finally consumed by Santini's film.

Sonic Nostalgia

As might be expected from a film about a sound mixer and recordist, Berberian Sound Studio has a deep affinity for the analogue technologies and artistry of sound postproduction. Director Strickland has called this the "alchemy" of sound. As mentioned earlier in the chapter, Italian cinema has conventionally worked with post-synced soundtracks, with everything from dialogue to ambience created in postproduction. The film follows Gilderoy through that process, as he records everything for the film: the actors' dialogue, Foley of splattering falling bodies, scream after scream after scream, the non-diegetic score. What might be surprising for a film about filmmaking is that we don't see a single frame of the film that Gilderoy is working on, only the opening credits at the beginning. We're only given description of the scenes by the engineer: things like "Signora Collatina's sacrificial attack is thwarted and the tables are brutally turned." But we hear every sordid sound effect and its effect on Gilderoy.

When he first arrives at Berberian sound studio, Gilderoy is met by Francesco, the producer, and given his first glimpse of the film. After his attempt to be reimbursed his travel expenses is rebuffed (a recurring plot point), Gilderoy is introduced to the film. Even though we don't see a single image of what's on screen, we hear all the sound effects, as well as the way in which they're produced. As is common in Foley studios, a great number of vegetables are butchered during the film. Two Foley artists, both named Massimo, smash melons to pieces.

Sound perspective is manipulated throughout the sequence: there is a recurring feature of the soundtrack that whenever film plays thorough the projector, we hear close-up sound of the gears of the projector and the film feeding through. We hear the same with the smashing and squelching of the melons. The camera lingers on the destruction of the scene, which echoes what is presumably on the screen in the sound studio too, the red pulpy flesh of the melons, but also the sounds with which we're so familiar. Although there are no bodies mutilated, the images and soundtrack are of destruction and violence. Foley: Foley artists, named after Jack Foley, create sound effects in postproduction, on a Foley stage, filled with props. Common effects include footsteps, clothes rustling, punches, and creaking doors. You can simulate the sound of bones breaking by recording carrots being snapped in half.

6.6

Vegetables are a common feature of Foley studios, from melons to cauliflowers to cabbages. The film returns to images of rotting old vegetables. Boiling vegetables produce the sound of a deep background rumbling; stems pulled off radishes are the sound of hair being pulled out; and a melon splattering on the floor is a body smashing into the ground. A drowning victim is simulated by sloshing cabbages in a tank of water while the other Massimo blows through straws into a glass of water. Gilderoy struggles when simulating searing flesh by splashing water into a hot frying pan. The violence inherent in the production of the Foley effects takes its toll on Gilderoy's psyche.

176

Confusing Diegetic and Non-diegetic Sounds

Berberian Sound Studio has an unconventional diegetic soundtrack. All of the sounds that we hear are produced within the story world—every scream, sound effect, and even the score (which is by British electronica band Broadcast in the style of the 1970s *gialli*). We would normally expect the score to be non-diegetic, but here it's played within the world of our story, the added wrinkle being that we're hearing something that in the film within the film is non-diegetic. Strickland said he wanted to produce a film with a diegetic soundtrack that "fooled the audience into believing it's a nondiegetic sound mix."

Sound tends to be bridged from one scene to another. When Gilderoy is in his apartment recording the sounds coming from a pan of boiling vegetables, the sound shifts from what we'd expect a stew bubbling away to sound like to the deep rumbling of the film's soundtrack (what Gilderoy's microphone is picking up). This is a shift in sound perspective as we go from the objective sound of the pan boiling to the subjective sound effect once Gilderoy puts his headphones on. As the sound mixes, it bridges two scenes; the camera tilts up through the steam from the pan to reveal the face of Massimo. We're now listening to the objective sound of the film's soundtrack. The film cuts from Massimo's face to the red SILENZIO (silence) sign outside the studio, before cutting to a close-up of one of the actresses looping dialogue. The soundtrack cuts as Gilderoy flicks a switch on his console, moving on to the next sound effect, the drowning of a witch. Playing with what's subjective and what's objective in the soundtrack occurs throughout the film, until, like Gilderoy, we're unable to tell what's real and what's not, so damaged is he psychologically. It's the play of direct and commentary sound that makes us confused about what's diegetic and what's not.

Sound bridge: A type of sound edit that bridges one scene into another either by introducing sound from the next scene, or extending sounds from the previous one.

ADR (Automated or **Additional Dialogue** Replacement, also Looping): the process of re-recording dialogue, usually because it hasn't been recorded cleanly on set. Actors will synchronize their performance to the image looped on screen in front of them. It won't always be the actor we see: for Blade Runner: The Final Cut (dir.: Ridley Scott 2007), Harrison Ford's son provided ADR for his father's performance.

178

Case Study: Berberian Sound Studio (2012)

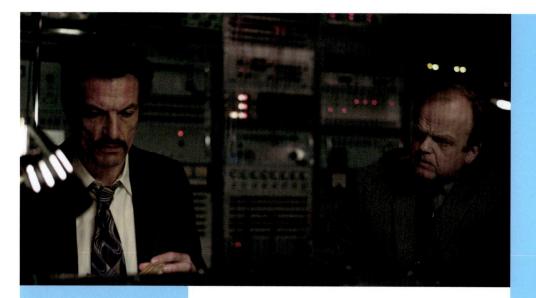

6.7

Throughout the studio sequences (one of only three locations in the film, along with Gilderoy's apartment and the corridor outside the studio), we see the cue sheets for the film's soundtrack. They read things like "Monica hits the ground," "Teresa's song (sorrow)," "witch drowning/gulping (with gaps)," "underwater in barrel." This is the visual representation of the soundtrack's organization. At times it's juxtaposed with the cue sheets from Gilderoy's nature sounds, with items like "mantel clock," "'orrible bootlaces" or "Len's poultry." These sounds are a world away from the Satanic paganism of *The Equestrian Vortex*.

Audio Meltdown

As the film progresses, Gilderoy becomes more and more physically disheveled. After a session recording footsteps (with Massimo and Massimo wearing high heels), we cut from the studio to the corridor outside. We can still hear the diegetic (eventually non-simultaneous) sound of the footsteps from the studio. The long shot of the corridor dissolves out of focus and we cut to the SILENZIO sign. As the camera drops down and we hear an echoing wind sound, the camera eventually comes to rest on Gilderoy asleep in bed. The sound of the footsteps stops once the camera settles on Gilderoy's face. Offscreen, the doorbell rings. This is **point-of-audition sound**—we can't see the source, just as Gilderoy can't. Sleepily, he gets up and goes toward the front door. "Who's there?!" he shouts. He checks his tape recorder as he goes past it, just to see it's not playing. The doorbell keeps ringing, and he asks again, "Who's there?" No answer. Then, we begin to hear the door rattle—someone is trying to get in. He threatens to call the police, but the sound of the door rattling continues. Terrified, he pulls a knife out of the drawer and goes to the door. He opens it, and there's no one there.

Gilderoy goes through the door, but only enters the studio. He walks to the center of the room, still holding the knife. We can hear the same low wind sound as before. Then, the projector bangs into life, and we can hear the film running through it. The film on-screen is exactly what we've just seen, only now Gilderoy is dubbed into Italian (he'll be dubbed into Italian from now on). A door in the studio begins to rattle, as it does on the screen. Just as Gilderoy goes to brace it, the film breaks down. Images are misaligned, as though the film is jammed in the projector. As the film eventually melts, the soundtrack is an aggressive mixture of sound cues, dialogue reversed, sounds of smashing, static, crackles, fuzz. The sounds all emanate somewhere from within the filmalthough they're now no longer simultaneous-but no longer objective. The soundscape has deteriorated, just as Gilderoy's psyche has. Finally, the film melts down to reveal the Box Hill documentary that he had previously worked on, a retreat into another space. From here on, Gilderoy seems to have been consumed by Santini's film, unable to tell the film from reality.

Berberian Sound Studio is an example of an especially complex soundtrack. It plays with sound perspective, and features a great deal of point-of-audition sound, as well as acousmatic voices. It complicates the difference between objective and subjective sound, and "fools" us into thinking what is diegetic is commentary sound. That the film is also about the process of making sound effects for a horror film gives us some insight into how sound is made, and that what we think we hear isn't always what we do hear.

Point-of-audition sound:

Sound whose intensity, pitch, and space imply hearing from a particular subjective point in the diegesis, where the hearing/hearer of the sound is seen rather than its point of origin. The sounds coming from the hotel room next to Barton Fink's in the Coen Brothers' film (1991) are point-of-audition sounds, since we see only their point of hearing.

Tip

Just as you'd ask 'who is seeing?' try to keep asking 'who is hearing, from where, and is that logical?' Look out for how you're being located in the objective or subjective space of the film. This chapter has explored the ways in which filmmakers have used sound in their films to help create a plausible world for the film or to deepen the emotional impact of the story. Producing sound for film is an extremely specialized and time consuming process, and one that is so often taken for granted or relegated to an afterthought. This is often the case with amateur and student filmmaking, where sound is left to the last minute.

Sound doesn't simply accompany the images, but is an essential part of the film experience. It helps create the realist film world, and can produce artistic complexity. We've seen in this chapter that sound can be direct or add commentary; that it can take us inside character's heads; it can play with us; or that music tells us exactly when and where we are. Sound is an essential narrative device.

Viewers will forgive filmmakers for many things—the odd out of focus shot, plot holes, a lack of logic, jumpy cutting—but they won't tolerate inaudible or amateurish sound. In an era when strong images are much easier to produce, it can often be the soundtrack that makes the difference between professional and amateur filmmaking. Understanding what makes a compelling soundtrack, as well as how to produce it technically, is a necessity.

DISCUSSION QUESTIONS

In what ways can the soundtrack of a film make us question what we're seeing on screen?

Think about a memorable sounding film. What makes it memorable? Is it the ways that sound is manipulated to tell the story or show us a character's perspective? Or was it the music in the film?

Why do you think audiences and amateur filmmakers don't normally think a great deal about what they're hearing? Why don't we normally think about film as audio and visual?

Can you describe what a laser pistol sounds like? If you can, how do you think that sound was made?

180

EXERCISE: CHANGING THE SOUNDTRACK

Returning to your PopcornMaker sequence from the previous chapter, you can change the soundtrack for any online video by adding music from an external source, from SoundCloud or another video. What is the effect of changing a soundtrack? What happens to the pace of the images? What does this tell you about how much of an impact the soundtrack has on us?

Recommended Reading

The website filmsound.org is an excellent resource for theoretical and technical information about film sound. It features interviews with sound designers and editors, and has a huge depth of knowledge about the ways in which sound can be understood and produced. It's an excellent resource for thinking about the soundtrack.

Introductory Reading

Altman, R. (ed.). Sound Practice, Sound Theory. New York: Routledge, 1992. Sider, L. Soundscape: The School of Sound Lectures, 1998–2001. London: Wallflower, 2003.

Advanced Reading

Chion, M. Audio-Vision: Sound on Screen. New York: Columbia University Press, 1994.
Chion, M. Film, A Sound Art. New York: Columbia University Press, 2009.
Chion, M. The Voice in Cinema. New York: Columbia University Press, 1999.
Donnelly, K. J. (ed.). Film Music: Critical Approaches. Edinburgh, Edinburgh University Press, 2001.
Sonnenschein, D. Sound Design: The Expressive Power of Music, Voice, and Sound Effects in Cinema.
Studio City, CA: Michael Wiese Productions, 2001.

CONSTRUCTING MEANING

7.0

CQ 2001

director

Roman Coppola

As ever, film is a construction of hundreds of individual shots. The skill of the editor is to construct a coherent whole out of this material. One of the most significant debates throughout the history of film has been the battle between the formalists and the realists. The formalists thought film was an abstract art form based on artistic principles of composition and manipulation. The realists argued that film was a reflection of our material reality, like photography, although with the capacity for recording movement. At the heart of this battle was editing.

There were those, such as André Bazin, who felt editing added little, and reminded the audience that they were watching a film; he preferred the long take. Others, such as Sergei Eisenstein, saw cinema as montage, as a construction that was intellectual and dialectical. Throughout the 1920s he battled with his Russian contemporaries, such as Vsevolod Pudovkin, who saw editing as a series, a progression of continuous shots.

Meanwhile, on the other side of the world, D. W. Griffith had developed what we now know as **continuity editing**, a logical, coherent and psychologically dramatic mode of editing that remains the dominant mode of editing today in both film and television.

ontinuity Editing

Continuity editing: The dominant economical style of editing, used to create coherent space and narrative, avoiding unnecessary content and repetition.

Jump cuts: The term jump cut can be used in two ways. First, it can refer to a shot that is arrhythmic or disjunctive and produces a noticeable skip between two shots, either because action isn't matched or the shots break the 30° rule. Most commonly, though, jump cuts refer to cuts that interrupt a single shot, literally producing a jump. Continuity is the dominant style of editing used by filmmakers. It has developed over more than a century as a way in which space, time, and narrative can be constructed out of hundreds of fragments to form a coherent, logical, and continuous whole. It allows two shots that might have been filmed months apart, in different locations, to be cut together following a pattern of established rules to suggest they happened one after another.

The Rules

Continuity has often been criticized as a conservative method of filmmaking. It slavishly follows rules and presents the viewer with an image of the world that is ordered, coherent, and structured.

Of course, the real world doesn't function this way but film audiences have been conditioned to accept these editing rules as dominant, hegemonic even, so that any deviation from this pattern looks "wrong" and shatters the illusion. Of course, some filmmakers want to achieve this effect, but we'll leave that until the next section.

Continuity editing follows a series of rules that fulfill several purposes:

- To tell a story. Everything must be used to tell the story. It is economical, and anything unnecessary must be cut out, while repetition must be minimized.
- To construct and preserve a coherence of space.
- To maintain a continuity of time.
- To create and sustain graphic and rhythmic relations.
- To hide the means of construction from the viewer.

The cliché goes that, like film music, editing is successful when the viewer doesn't notice it. Pacing is maintained, there are no **jump cuts** and the sense of space and time is preserved. If the viewer notices a cut, then the editor has failed. This, largely, is nonsense.

Continuity editing is a style, albeit a realist one, but the editor does not need to slavishly follow rules. Art can be subversive and it is often in breaking the rules that the artist makes his or her trade. If you see a film in which the editing is visible, don't immediately think that it's just a mistake, but try to think why the filmmaker has included that cut and what it means.

Continuity editing has a number of "rules" that need to be observed to preserve either temporal or spatial continuity; these are:

- The 180° rule
- Match-on-action
- · Eyeline matches
- The 30° rule
- Shot-reverse-shot editing

A typical scene edited in this style will follow a similar pattern. The scene will begin with a **master shot**; this will often be a long shot that establishes the basic spatial pattern for the scene. From here, the editor will cut closer into the action. If it is a dialogue-driven scene, there may be a combination of two-shot medium close-ups from the waist up or close-ups for important lines of dialogue and reactions. An action scene will tend to use more close-ups. Modern action scenes will often use montage principles of metric or rhythmic pacing for impact.

The 180° Rule

The **180° rule** is intended to preserve spatial continuity in a sequence. When the sequence is shot, the director will observe an imaginary 180° line across which he or she will not cross.

For example, if in one shot, a character is walking left to right and exits frame right, the character must enter the next shot from frame left and continue to walk left to right. If the director places the camera on the other side of the action, the action will be inverted; even if the location is the same and the character is walking in the same direction, when cut together the actor will appear to be walking in the opposite direction, thereby breaking spatial continuity and confusing the audience.

Match-on-Action

Like the 180° rule, the **match-on-action** is used to preserve spatial continuity. However, it is also used to show the temporal progression of the action. If the character in the previous example encountered a door, the action would need to be matched across shots. The first shot would show the actor opening the door and beginning to walk through. The next would show the actor coming through the door without repeating the door opening or skipping part of the action.

If the action is not matched, the cut would be visible, producing a noticeable jump. This is fine if you want to call attention to the cut for an artistic purpose, but not if you want to show a smooth, flowing action.

Master (or establishing)

shot: Often the first shot of a scene, the master, usually a long shot, shows the viewer the whole scene, the setting, spatial relationships between characters and important action. Sometimes, whole scenes are shot "in masters."

Tip

A violation of the 180° rule is known as "**crossing the line**." This can sometimes be avoided by inserting a buffer shot from a head-on angle to make the transition to the other side.

Recommended Viewing

Watch the car chase at the factory in *Goldfinger* (dir.: Guy Hamilton 1964). Look out for a moment where Bond's car crosses the line. Why do you think the director has included this? It's not just because the footage didn't edit together, so what is its effect?

Recommended Reading

Ken Dancyger's *The Technique* of *Film and Video Editing* (2006) is a comprehensive exploration of the role of the editor and the style, history and technique of editing.

Eyeline Matches

Eyeline matches are another important device used to preserve spatial coherence.

Imagine our actor again: they've entered a new room and we see them look off frame right, slightly down. In the next shot, we see another actor; they're looking at our first actor. This second actor needs to be looking slightly upward toward the eyeline of the first actor. This is an important point of continuity. The lines must match to show that the two actors aren't just staring off into space. Of course, they probably haven't been looking at each other on the set, but the matched cut constructs that relationship.

The same would be true of a point of view (POV) shot from our actor's perspective. If he is looking downward out of frame, the subjective shot that follows would need to tilt down to match that eyeline.

If you want to see an example of how this important continuity rule isn't followed, just watch Ed Wood's *Plan 9 from Outer Space* (1959), notoriously regarded as the worst film of all time. Wood and his editor don't follow any of the conventional rules of continuity.

The 30° Rule

The **30° rule** is a simple, but important, rule that editors and directors must remember. If shot angles differ by less than 30° , the cut will produce a noticeable jump as the angles are too similar to be cut together.

Again, this doesn't stop directors breaking the rule. For example, François Truffaut breaks this rule in *Shoot the Pianist* (1960) when he uses a triple-cut (cutting closer and closer within the same shot like a zoom) of a character hovering over a door bell, but choosing not to ring it. The jumpy cut says a lot about the fragmented, hesitant state of mind of our protagonist (an example of expressionism).

The secret to film is that it's an illusion. George Lucas, producer, screenwriter and director

7.1

Persistence 2013

director

Sebastian Synowiec

In this brief sequence, we see a good example of shotreverse-shot organization. The two characters are shot in tight close-up, and it seems very intimate at this important narrative moment. The eyelines here don't match though, as the second man is looking offscreen at an important object.

7.2

Persistence 2013

director

Sebastian Synowiec

The second of these two cuts is matched on action, as the young woman's run into frame is matched. However, this also crosses the line as she runs first left to right, but then enters running right to left. The geography is established by the first shot of the two young men, so we know where she is in relation to them. Cutaways: Shot-reverseshot might also include shots of a character reacting to a line of dialogue; shots like these are known as cutaways, or, in TV, "noddies."

Tip

Many editors cut on emotion, selecting the best takes of performances to construct a sequence around.

Shot-Reverse-Shot Editing

Shot-reverse-shot editing is the "meat and potatoes" of continuity editing. It's where all the rules come together.

Following the 180° rule and principles of continuity, shotreverse-shot editing refers to the back-and-forth method often used for conversations and reaction shot **cutaways**. To return to our two actors who have now met: they strike up a conversation. The cutting of close-ups would be as follows:

- Shot one: Actor one, framed to left of frame in medium closeup (MCU) looking toward frame right.
- Shot two: Actor two, framed to right of frame in MCU looking toward frame left.
- · Shot three: as shot one.
- Shot four: as shot two (and so on).

This pattern will preserve the coherence of space. If we were to flip shot two, it would appear the same as shot one and would have crossed the line. This would make the actors appear to be either in the same place or talking away from each other. Either way, space would be shattered and the images would look too similar, producing a jump cut by violating the 30° rule.

Missing Reverse Shot

Shot-reverse-shot can also be used to hide things and trouble the viewer. For example, *Halloween* (dir.: John Carpenter 1978) begins with a long hand-held sequence in which the viewer witnesses a brutal murder from someone's perspective (the action is shown through mask holes—it's an obvious POV shot). The viewer isn't offered a reverse shot for a long time. It is troubling not to know who is committing this horrific crime. As such, the viewer is implicated in the murder as a voyeur.

Carpenter only inserts (or "sutures") a subject into the subjective shot with the final reverse shot—when the viewer is shown the six-year-old Michael Myers. Carpenter could have included a reverse shot much earlier to provide us with this information, but he decides not to. The viewer naturally wants to know who the murderer is, but this information is withheld until the end of the sequence. It is typical of the horror film to withhold narrative information from the viewer by avoiding reverse shots for POVs. Part of the pleasure of the horror film is identifying with monsters and villains; the missing reverse shot can help make this possible.

188

Transitions

There are a number of common devices that an editor can use to imply ellipses (cuts in which material is implied as missing). Similarly, these devices can be used to suggest jumps in time and space:

- Dissolve: a smooth transition from one shot to another.
- Fade: a transition from one shot to another with a fade to black (or other color), and fade into the second shot.
- Wipe: a line wipes one shot from the screen, which is replaced by the next.
- **Iris:** a circular frame closes on one shot and opens on another, often isolating an important detail; irises were commonly used in silent cinema for emphasis.
- Freeze frame: the frame may freeze before a transition or can stop time for emphasis. Often an arty technique.

Unlike straight cuts, most of the above are "soft" transitions and are less jarring for the viewer.

Similarly, **graphic matches** are edits that create visual relationships between shots. They often emphasize thematic or spatial relationships between objects/subjects. For instance, in *2001: A Space Odyssey* (1968), Stanley Kubrick uses a single cut to show the viewer the history of human evolution. The "Dawn of Man" prologue ends with a shot of an ape throwing a bone in the air. The bone spins and begins to fall, at which point Kubrick cuts to a shot of a spaceship drifting through space. The movement and shape of the two objects is matched graphically, stressing a thematic relationship between the first tool and the invention of space travel. It is all done in a single cut.

EXERCISE: READING THE EDIT

Choose a five-minute sequence in a narrative film. Explore the editing of the sequence. Try to look for the ways in which the editor follows the rules of continuity editing, especially graphic and eyeline matches. Are there any moments where those rules aren't followed? If there are, what is the consequence of those moments?

Film editing is now something almost everyone can do at a simple level and enjoy it, but to take it to a higher level requires the same dedication and persistence that any art form does.

Walter Murch, film editor and sound designer

Recommended Viewing

Watch *Star Wars* (dir.: George Lucas 1977) and see how many different kinds of transitions are used to move from one scene to another smoothly. This is a motif used throughout the series and its spin-offs. **Discontinuity editing**, as its name suggests, is a variation on continuity editing. Although it sometimes uses the same devices, such as graphic matches, it is not concerned with the narrative experience of cinema. As such, it tends to use devices that subvert or disrupt the coherence of space and time in a film.

Discontinuity Outside the Mainstream

Discontinuity techniques are popular in avant-garde or art films where narrative is not the main concern of the filmmaker. Editing will often refer to character psychology, graphic and rhythmic relationship, or comment on the ideological form of the medium.

Many of the techniques of discontinuity editing have now also found their way into the mainstream. Montage and graphic matching are common in music videos, where narrative takes a backseat to the music, or in action films to give images impact to physically affect the viewer. Michael Bay's films, like *Transformers* (2007), use many discontinuity techniques.

Un Chien Andalou (dir.: Luis Buñuel 1929) is probably the most famous avant-garde film ever made. Using a series of discontinuous editing techniques to fragment space and critique the devices of continuity, the film subverts narrative flow, and confronts the logic of space and time. It takes the form of a surreal dream about sexual, political, and religious themes.

Fragmenting Space

The opening sequence of *Un Chien Andalou* is a perfect example of how avant-garde films use discontinuity editing without concern for presenting the viewer with a coherent narrative. The shots can be broken down as follows:

- 1 An intertitle that reads "Once Upon a Time...."
- 2 A close-up, from an elevated angle, looking down at a man's hand sharpening a razor. The man's arms are framed toward the frame right.
- 3 A medium close-up: the man with a cigarette in his mouth looks down, presumably at the razor. He is framed toward frame left. Spatially, in relation to the previous shot, the man must be on the left side of the razor sharpener, not the right, as in the previous shot.
- 4 Return to Shot 2: the man tests the sharpness of the razor against the back of his thumbnail.
- 5 A medium long shot: the man folds up the razor and the sharpener, opens the balcony window and begins to leave.

- 6 Matched on action: the man walks out onto the balcony in another medium long shot. He stands for a moment and then leans on the balcony.
- 7 Medium close-up: the man looks up toward frame left.
- 8 Long shot: a POV of the moon in the sky.
- 9 Return to Shot 7.
- 10 Close-up of a woman's face. A man, standing just to her right, pulls open her left eye and puts the razor toward it. This man, unlike the man we've already seen, wears a tie.
- 11 Return to Shot 8: a cloud drifts across the moon.
- 12 In extreme close-up: the razor slices an eyeball open.
- 13 An intertitle that reads "8 Years Later."

This sequence displays some of the key principles of discontinuity editing:

- A lack of concern for logical temporal progression: the intertitles make no sense, they are arbitrary and the man in the opening sequence never returns.
- Little interest in coherent spatial relationships: the man clearly swaps sides of the razor while sharpening it.
- An obsession with graphic matches: the cloud drifting across the moon is graphically matched with the slicing of the eyeball.
- Surreal logic and dream states: the eyeball slicing is a daydream, and the progression of the narrative is alogical (not just illogical, but lacking logic altogether).

Lack of Narrative

As the list of shots shows, discontinuity editing may use some of the same devices as continuity editing, such as shot-reverse-shot, match-on-action, and graphic matches, but there is little or no concern for narrative. Instead the filmmakers are concerned with using the medium to explore subjective mental states and to investigate the artistic properties of the medium.

Discontinuity editing could be thought of as "bad" editing because it breaks the rules of continuity editing. However, we need to consider why filmmakers might break those rules and what meanings are uncovered by their transgressions.

Recommended Viewing

Jean-Luc Godard mixes realist long takes and discontinuity editing in *Breathless* (1960) to create a contrast of styles. Notice how jump cuts are used as a distancing device to remind the viewer of the unnaturalness of the film text and the arbitrary rules that govern most continuity editing.

Discountinuity Editing

192

7.3

Un Chien Andalou 1929

director

Luis Buñuel

As one of the most important and significant avant-garde films, *Un Chien Andalou* can show us how discontinuity is used to fracture a film's space. The slicing of the eyeball is also a visual pun on editing as cutting.

Derived from the French verb monter, meaning "to assemble," montage is a general term for editing in film. However, it is now most often used to describe a particular mode of intellectual or non-realist editing that creates meaning out of unrelated material. Montage is heavily associated with the Soviet school of filmmaking of the 1920s and 1930s, although many of the principles developed by those filmmakers have found their way into mainstream cinema.

The Kuleshov Experiment

Lev Kuleshov was a Soviet pioneer of montage. He conducted an experiment in which he took a shot of an impassive actor's face and cut it together with shots of emotive material: a plate of food; a child's body lying in a coffin. The montage effect was such that viewers thought the actor was expressing an emotion even though he had no expression on his face. Cutting the face together with the food connoted hunger, for instance, by what is called the **Kuleshov effect**. The actor was even praised for his performance!

This experiment, although the original footage is long lost, has had long-lasting repercussions for filmmakers, especially concerning actors' performances. Film acting is often subtle, with emotional effects created in editing.

Montage Sequences

Montage can also be used to describe a sequence that condenses narrative information into a short sequence of linked shots, often set to music. Wes Anderson uses this technique in *Rushmore* (1998) and *The Royal Tenenbaums* (2001) to quickly give the viewer narrative details in a fast and snappy way.

Perhaps the best-known sequence of this kind is a spoof in *Team America: World Police* (dir.: Trey Parker 2004), a parody of training montages in films such as *Rocky* (dir.: John G. Avildsen 1976), set to a pulsating rock song called "Montage!"

7.4

2001: A Space Odyssey 1968

director

Stanley Kubrick

Kuleshov Effect in Action: The Kuleshov effect is used whenever we see the computer HAL 9000's ominous eye. The eye is simply a glowing red light, but cut with implied point of view shots, and in the context of the narrative, we understand the emotions of the villainous computer. Here, he observes the two astronauts on board the Jupiter plotting against him; the cutting means we know HAL is watching, and the Kuleshov effect implies his emotions.

7.5

Rear Window 1954

director

Alfred Hitchcock

Hitchcock once said the best actors were good at doing nothing. James Stewart's performance in *Rear Window* is minimal, with effects often created, Kuleshov-style, in the montage effect between his face and what he is looking at.

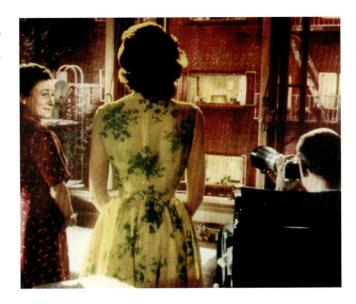

Recommended Reading

Eisenstein's own writing is the main body of writing on montage. *Film Form: Essays in Film Theory* (1969) is his most significant work regarding the development of montage, as well as his theories on film sound. Additionally, you should also look at Eisenstein's films for demonstrations of his techniques, as these are discussed in his writings.

Dialectic: The opposition between two conflicting forces or elements.

Sergei Eisenstein

Undoubtedly, the master of montage was Sergei Eisenstein. Eisenstein developed his theories of attractional, agitational montage in the theater following the Russian Revolution of 1917. He believed the business of film was conflict of all kinds: of lines, angles, colors, and ideas.

The most significant mode of montage is **dialectical** or intellectual. Here, the filmmaker takes two unrelated ideas and cuts them together to make a thematic or intellectual point. In *Strike* (1925), Eisenstein inserts non-diegetic shots of cattle being slaughtered into scenes of workers being massacred by government forces. The thematic point created makes a point about the mistreatment of collective groups, an important ideological concern in post-revolution Russia. Francis Ford Coppola uses the same cross-cutting technique in *Apocalypse Now* (1979) to juxtapose the murder of Colonel Kurtz with the killing of a cow, to comment on abuses of power.

The basic premise of Eisenstein's method was a vulgar Marxist notion of dialecticism, derived from Lenin. His equation was simple:

Thesis + Antithesis = Synthesis

Montage came in the moment of synthesis. This is where the intellectual concept was created, in the conflict between two opposing ideas. There's nothing particularly subtle about this method, nor was there intended to be: "It is not a cine-eye that we need," claimed Eisenstein, "but a cine-fist."

Eisenstein developed several other modes of montage that were intended to produce emotional, thematic and visual resonances in a film:

- Metric: lengths of shots are determined by factors not depicted in the image, such as musical time signatures. Not favored by Eisenstein, but still popular in music videos, and used by Martin Scorsese at the beginning of *Mean Streets* (1973), where a triple-cut is cut to the beginning of "Be My Baby" by The Ronettes.
- Rhythmic: similar to metric montage, but the rhythm of shots is determined by material in the shots themselves. The "Odessa Steps" sequence in Eisenstein's *Battleship Potemkin* (1925) was an experiment in rhythmic montage, with the shots getting shorter as the action in the sequence accelerated. This is mimicked in *The Untouchables* (dir.: Brian De Palma 1987).

- **Tonal:** montage determined by the dominant emotional tone of the sequence. The fog rolling into the port in Potemkin is one of the key examples of this form of montage in Eisenstein's work.
- **Overtonal:** the conflict between different types of the above montage effects. Darren Aronofsky creates some very aggressive and distressing effects from overtonal montage in *Requiem for a Dream* (2000).

7.6

Battleship Potemkin 1925

director

Sergei Eisenstein

The "Odessa Steps" sequence in *Battleship Potemkin* is an experiment in rhythmic editing. Eisenstein uses the pace of the editing to show the acceleration of the action. He also uses editing to signify violence; we don't see the act of violence, which is implied in the cut.

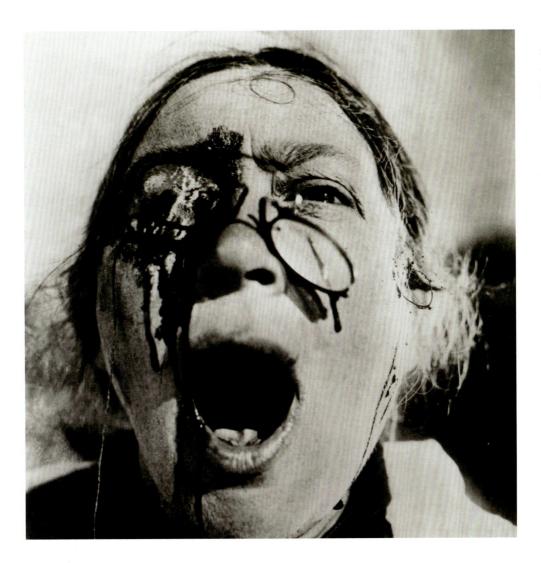

Pace is an important consideration for editors, as well as geography. Like a symphony, film narratives have slower movements, along with quicker ones. Understanding the principles of rhythmic montage are important, because they can help us comprehend how rhythm and pace are developed across sequences, and then across whole narratives.

If we consider a film like *The Dark Knight* (dir.: Christopher Nolan 2008), we can see editing being manipulated to accelerate and slacken the pace in relation to the emotional tone and impact of scenes.

At the beginning of the film, the pacing of the editing is fairly lax. Although it begins with the Joker and his crew robbing a bank, most shots are in the range of two to four seconds, sometimes much longer, particularly for establishing shots. Most of the pacing in the sequence is provided by camera movement, by long helicopter shots or shots that track with characters. The cutting is motivated by the action or dialogue in the scene, especially when the bus rams through the wall of the bank.

By the midpoint of the film, the editing is more "elastic," with pace snapping back and forth depending on what we're seeing on-screen. When Batman chases the Joker through Gotham after the attack on the police convoy transporting Harvey Dent, we have an example of pacing intensifying and then slackening. Once the Batmobile has self-destructed and Batman is on two wheels, a lot of the pace in the sequence is provided by camera movement and rapid action in the mise en scène (most shots are about two seconds in length, mostly long shots with some elliptical cutting). But as Batman confronts the Joker in his truck, whipping underneath threading wires across the street, the cutting accelerates, to around one second or less per shot. Just before the truck flips, there is a pause, a longer take. It's like we're holding our breath, waiting for the action. The pace has slackened off, and does so in the short dialogue scene that follows. The sequence is an example of how the pace of editing is manipulated, motivated by the action within the scene. The montage here is rhythmic, and it's a good demonstration of how Eisenstein's ideas have become the default mode of cutting for editors.

198

Intensified Continuity

David Bordwell has noted that the standard continuity style has intensified since the 1960s, becoming dominant in the 1980s. The **intensified style of continuity** is still rooted in the traditional premises of spatial continuity. However, Bordwell firms that this modern style of continuity tends to use fewer master shots than previous examples, which reestablish space when characters move. The style is also marked by:

- more editing
- · more and tighter close-ups
- · more shots overall, especially of reactions
- use of longer lenses, producing tight long shots
- · fewer medium shots.

Rather than turning toward a greater montage style, Bordwell sees these changes as an intensification of the existing style rather than a change in pattern. The new rule is *more*, *tighter* and *faster*.

EXERCISE: UNDERSTANDING MOTIVATION

Watch films to see what is motivating the cutting. Is it an important line of dialogue? Is it a look offscreen? Is it movement? Watch closely. Often editors will motivate their cutting by movement, often very *very* small moves.

	Psycho Shamley Productions/Paramount Pictures
Director	Alfred Hitchcock
Editor	George Tomasini
Screenwriter	Joseph Stefano, based on Robert Bloch's novel
Cast including	Janet Leigh (Marion Crane); Anthony Perkins (Norman Bates); Vera Miles (Lila Crane); John Gavin (Sam Loomis); Martin Balsam (Arbogast)

Simply put, *Psycho* is one of the most famous and important films ever made. It casts a very significant shadow of the horror and thriller genres. In many cases, though, the film is an exercise in editing and montage. Throughout, it plays with the audience, puts them in some uncomfortable positions and uses montage to shock and unsettle us. Power shifts throughout the story and this is often reflected in the cutting.

Synopsis

An entirely ordinary secretary in a Phoenix office, Marion Crane, steals \$40,000, trusted to her by her boss, to pay off her boyfriend's debts so that they can get married. Seizing the opportunity to change her life, she begins a journey from Arizona to California to surprise Sam with her new found wealth. Beyond nervous, she is paranoid about the police pursuing her, and uses some of the money to buy a new car. Eventually, she feels secure, but bad weather forces her off the road. She stops at a roadside hotel, the Bates Motel. There, she meets a young man, Norman Bates, who lives a lonely existence with his mother, running the motel. After talking with Norman, Marion decides to return the money, but is suddenly murdered in the shower by an unseen attacker with a knife. The focus of the narrative then shifts to Marion's sister's efforts to find out what happened to her, to solve the mystery of the Bates Motel and Norman's mother.

Opening Power Games

If we look at the film's opening scene, we can begin to see how the editing of the film begins to play with power, as well as how shot-reverse-shot editing is used to signify one character's greater importance for the narrative.

We begin overlooking a city, the camera panning left to right. Two dissolves join shots together. Three captions give us the time and place:

PHOENIX, ARIZONA FRIDAY, DECEMBER THE ELEVENTH TWO FORTY-THREE P.M.

As the camera pans around, we begin to zoom in on a building; a further dissolve takes us closer until we can see a window with its blind slightly open. A sudden jump cut takes us level with the window and the camera tracks in, first into darkness, then light (as the camera's aperture changes). The camera then pans right to reveal a man and a woman. We can see her in her underwear lying on the bed, but he's just framed knees to (shirtless) chest. The selection of shots initially favors her. It's obvious what they've been doing though. At the moment, we're seeing from no one in particular's point of view. The camera is an intruder, a voyeur; we haven't been invited into this private moment.

Sam tells Marion that she "never did eat [her] lunch." As he says that we cut to a close-up of the uneaten lunch, the sandwich still wrapped in film and a cola bottle unopened. The cut gives us further information about just what they've been up to during their lunch hour.

We then cut to a long take, initially of Sam standing up, framed centrally, and then tilting down as they lie down and begin canoodling. The framing is initially balanced, but it's an intimate shot—we're again reminded that we're voyeurs in this situation. We haven't yet cut to the point of view of either character though. As the scene develops, Marion talks about getting married. She's tired of the "secrets" and "stealing lunch hours." She wants a legitimate relationship, "respectably... in my house with my mother's picture on the mantel and my sister helping me broil a big steak for three!" After Sam makes a tawdry comment about turning "mother's picture to the wall" (foreshadowing the problems with mothers later in the film), he consents. As he tells her "alright," we cut from long shot of him to a medium shot, but the angle doesn't change—the cut violates the 30° rule because it doesn't differ by more than 30°. What is important is that the shot more or less matches Marion's POV, designating her as more important than him. Her association with the camera makes her more prominent.

This continues during the scene, as the camera regularly aligns with her POV, but not Sam's. Marion tends to be framed in more neutral side-on shots. The editing echoes the main relationships here, not between Sam and Marion, but between Sam and unseen characters. He talks about his father's debts and paying alimony, the circumstances that mean they can't get married and that lead to her stealing the money.

The shot-reverse-shot editing is unconventional, because it's unbalanced. But the cutting has gone from placing the audience in the position of voyeurs to placing Marion in a position of significant power, and aligning us with her perspective. The choice of shots also reminds us of Sam's lack of power, both socially and in terms of the narrative. He has no agency, and therefore he isn't granted the power of the look of the camera.

Patterns like this emerge again and again during the film when power shifts in sequences. There are even point of view shots from the perspective of the stolen money, and Hitchcock's use of a POV shot down a toilet was shocking for the time as the Hollywood Production Code prohibited toilets being shown on screen.

In the Shower, Everyone Can Hear You Scream

It doesn't really need to be said that the attack in the shower in *Psycho* is a *tour de force* sequence, one of cinema's most famous. It's been much parodied, and the staccato strings have become a much venerated part of our popular culture. Hitchcock initially wanted the sequence to be silent, but Bernard Herrmann composed the score anyway.

The three-minute sequence has 50 cuts in it. Thirty of those come in the space of just 23 seconds. Like the attack, the pace is frenzied. The music is in rhythm with the stabbing and the cutting (of the editor and the attacker), and we only once see the knife against Marion's skin (blink and you'll miss it though). The editor's cuts mirror those of the attack.

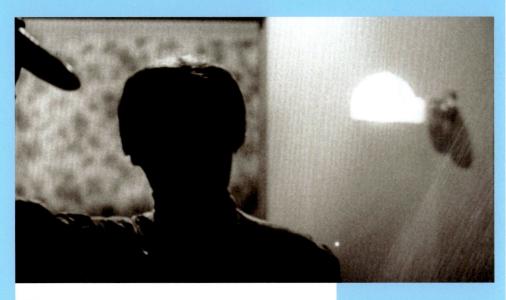

7.7

We return to this angle several times, closer each time, as the attack becomes more frenzied. Just before we see the attacked for the first time, the long shot is on-screen for an uncomfortable length of time, filled with empty space on one side of the screen—we know something is going to fill it.

Tip

Look for ways that patterns develop in editing. Try to think about why editors have chosen shots that don't always conform to what we'd expect. This is deeply embedded into the storytelling. We're been shown things by the formal choices that otherwise go unspoken. We're initially lured into a false sense of security like Marion. The first few shots feel safe, although we're there voyeuristically in the shower with her—not outside looking in. We've already seen Norman peeping at her (and shared the POV), and now we're with this naked woman in the shower. Just before the attack, we have a very long take in which Marion is framed tight to the right of screen—there's too much space on the left, as the composition is unbalanced. It's into this space the shadowy figure emerges behind the shower curtain. It builds tension and suspense, before it's all released by the aggressive editing of the next 20 or so seconds.

The sequence is a textbook use of montage to create specific effects, manage pacing, create tension and release it, and to place the viewer in specific positions. *Psycho* is an essential text to study for student editors. As the opening scene showed us, even a simple dialogue sequence can be enhanced by thoughtful editing and significant shot choices, while the shower scene is a lesson in montage effects.

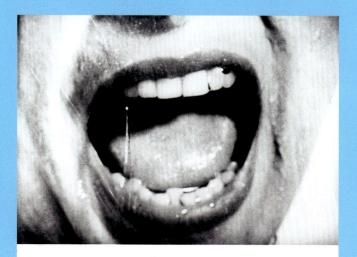

7.8

Hitchcock cuts three times closer and closer into Marion's mouth when she's first attacked. It's a sudden and disorienting pair of jump cuts, motivated by her scream.

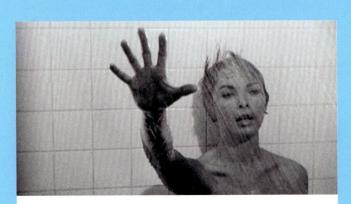

7.9

Finally, Marion reaches out toward the camera, toward us, but no help is coming. At this point in the sequence, the shots have returned to a normal duration. The final shots, tilted down the plug hole and tracking back from Marion's eye are of much longer duration as the tension subsides, and we're left to contemplate the horror.

DISCUSSION QUESTIONS

Why do you think *Psycho* has been such a fascination for filmmakers and critics? In what ways do you feel you're being played with by Hitchcock in *Psycho*? Where do you sit in the debate between the formalists and realists? What do you think is the most distinctive part of cinema's overall artistry?

Tip

Watching any film, try to pay attention to how editing constructs performances from parts, concentrating on the most significant details, such as eyes, hands, and mouths. Editing is the actor's friend (and it wasn't just Janet Leigh in the shower). In this chapter, we've seen just why many filmmakers consider film to be an editor's art. Film comes alive in editing. We can think about how shots fit together and how cinema isn't just about the things that we can see. In most films, the editor constructs the film space (knowledgeable direction will help) from fragments, and turns individual shots into a narrative the audience can understand and a space that appears coherent. This doesn't always need to be the case though—filmmakers can subvert rules and produce forceful statements about politics and the medium itself by breaking rules. Like the shots we see, as film-goers we must consider what editing means and how it shapes our experience of film. Only then will we understand how film produces its powerful effect on us.

It's never been easier to practice film editing than it is now. With many editing software packages intended for home use, like iMovie, Adobe Premiere Elements, Corel VideoStudio, Sony Movie Studio, you can practice your editing skills (provided you've got stock footage—this can be found on many websites and on DVDs), and apply the critical terms you've read and thought about here. Many professional editors are highly invested in the theory of their practice, and it's the best way to learn a craft.

EXERCISE: PACING AND SHOT DURATION

Take any short sequence from a feature film or the whole of a short film such as *Persistence* (which is freely available on Vimeo at vimeo.com/56307615) and consider how the editing affects the pace of the film.

You can think about the pacing of editing in really minute ways. If you download the measurement tool from www.cinemetrics.lv, you can use it to measure how sequences are cut, noting the length of shots and the types of framing used. It's a good way to get into an editor's frame of mind, thinking about frames and the length of shots, but also what motivates cuts, on-screen and in the context of the narrative. The tool will also let you know the average shot length of a sequence you've measured, and it's interesting to compare different types of films and scenes.

Take any film with which you are familiar and look at the transitions between shots. We often discuss meaning as implied, but it is often implied by how images within and across scenes are edited together. How does this work with the examples you have selected?

EXERCISE: PUTTING IT ALL TOGETHER

Now, using all of the knowledge of film aesthetics from the previous three chapters, take a piece of text, a stage play or short story, and create a cinematic sequence. Try to pay attention to how you will tell the story, which shots will work best, how the sequence will cut together, and how it will sound. Think about what you are trying to achieve overall: realism? non-realism? expressionism? emotion?

Recommended Reading

Introductory Reading

Crittenden, R. Fine Cuts: The Art of European Film Editing. Abingdon: Focal, 2013.

Dancyger, K. The Technique of Film and Video Editing: History, Theory and Practice. Abingdon: Focal, 2013.

Oldham, G. *First Cut: Conversations with Film Editors*. New York: Columbia University Press, 1995. Oldham, G. *First Cut 2: More Conversations with Film Editors*. New York: Columbia University Press, 2012. Orpen, V. *Film Editing: The Art of the Expressive*. London: Wallflower, 2003.

Advanced Reading

Eisenstein, S. *Film Form: Essays in Film Theory.* New York: Harcourt, 1969. Murch, W. *In the Blink of an Eye: A Perspective on Film Editing.* Los Angeles: Silman-James, 2001. You have now covered all the basics in understanding the language of film. This is the starting point of knowledge rather than the end of it, and the work continues. For some of you, this will mean putting these ideas into practice by starting the process of making a film. For some of you, it will mean embarking on a career as a theorist or critic. For some of you it will be both. What has been covered here deals with form and content and importantly the relationship between the two. Thus the language of film is not just about how film communicates but what film communicates.

You will doubtless have seen the list of further reading at the end of each chapter. You now know which areas interest you the most and which you will find the most useful for your own ends. This is your opportunity to continue your own education and further your knowledge in addition to the instruction provided by any course you might be undertaking. Don't see the recommended reading in this book as the only information that is available to you; look in libraries, bookshops, and on the Internet. You will discover that there is no shortage of material around. The lists are broken into introductory and advanced for a reason. There is nothing to stop you starting with a text that is classed as advanced, but don't be put off by the complexity of some of the ideas—you will get it, even if it isn't straightaway.

This book has introduced the core theories and ideas that film studies are based on. The ideas contained in this text intertwine and inform other theories, some of which are specifically about film and others, like ideological analysis, which are broader but which film has adopted and made specific to the medium. These include gender theory, psychoanalytic theory, feminism, and apparatus theory.

There are lots of ideas out there and, after all, at root, cinema is about ideas. Happy thinking.

Film Language Glossary 209

180° rule	Editing rule intended to preserve spatial continuity in a sequence, creating an imaginary line of action that the camera must not cross.
30° rule	Shooting/editing rule; if shot angles differ by less than 30 degrees when cut together the cut will produce a noticeable jump as the angles are too similar to be cut together.
Abstract	To remove (like a dental abstraction) for scrutiny; a concern with form rather than content (as in abstract art).
Acousmatic sound	Sound in which the originating source is unseen offscreen. The opposite of visualized sound.
ADR (Automated or Additional Dialogue Replacement, Looping)	The process of re-recording dialogue, usually because it hasn't been cleanly recorded on set.
Aristotle (384–322 BCE)	Philosopher and the founding father of textual analysis.
Asynchronous sound	Sound that does not match the image. It might be dubbed dialogue that doesn't match the on-screen lip movements-for example, a dog might meow.
Auteur	A director whose individual "vision" is the sole or dominant driving force behind an entire body of work.
Back light	Located behind the subject in three-point lighting to give that subject the appearance of depth by creating a haloing effect around the subject, ensuring the figure won't appear as a flat part of the background.
Barthes, Roland (1915–1980)	Critic responsible for the development of semiotic analysis. His major work, published 1950–1970, sought to locate the universal structure and narrative conventions from which the impression of "meaning" is created in "realist" texts.
Bullet-time	A digital special effects technique used to slow action, named for the effect in <i>The Matrix</i> (1999).
Camera angle	The angle of the camera from the scene being filmed.
Camera distance	The distance of the shot in relation to the actor or object being filmed.
Camera height	The physical height of the camera in relation to the actor or object being filmed.
Camera movement	Using a number of methods; from tilting the camera to moving it physically on tracks or a crane, moving the camera adds dramatic effect or simply avoids the need to cut.
Canted (or Dutch) (angled) frame	The level of the camera slanted, often to show us a world out of kilter, uncertainty, and drama.
Cliché	Overused, stale, and outworn expression-mostly to be avoided, but they are overused for a reason-they tend to <i>work</i> , especially when given a slight "tweak."
Close-up (CU)	A tightly framed shot that emphasizes individual details—faces, hands, feet, small objects—regularly used to give us an insight into significant narrative details.
Continuity editing	The dominant economical style of editing, used to create coherent space and narrative, avoiding unnecessary content and repetition.
Crane (also helicopter or airplane) shot	Mounting the camera to a crane can produce stunning shots from great height, either to look down on diminished characters or to show scenery.
Cross-cutting	An editing effect that intertwines narrative threads that are separate in space and/or time, often for the effect of building pace or tension toward a climax.
Crossing the line	A violation of the 180° rule.
Cutaway	Shots of a character reacting to a line of dialogue.
Depth of field (focus)	Focal depth, either shallow, with the background indistinct and out of focus (shot with a long lens) or with everything in focus (deep focus with a short or wide-angle lens).
Dialectic	The opposition between two conflicting forces or elements.
Dialectical (or intellectual) montage	An editing technique that creates a symbolic or thematic association between two unrelated shots.
Dialogic	That what we say always carries something of what has been said in the past, and anticipates something of what will be said in the future.
Diegesis	The fictional story world within the film, the sum of on-screen and offscreen space.
Diegetic (or actual) sound	Sound that emanates from characters or objects within the narrative's fictional space, e.g., dialogue, music from jukeboxes, etc.
Diegetic	Any object within the fictional world is referred to as diegetic.
Direct sound	Sound recorded on set, which can often combine dialogue, sound effects, and music. Common in realist films.
Discontinuity editing	The opposite of continuity editing, unconcerned with the narrative experience of cinema; the use of editing devices that subvert or disrupt the coherence of space and time in the film, such as unmatched lines of action or symbolic graphic matches.

1

Dissolve	A smooth transition from one shot to another.
DoP (Director of Photography)	Head of the camera/lighting department on a film set. In American, DP; alternatively cinematographer.
Exposition	The means by which narrative information is relayed to viewers. This can be done visually, but is often conveyed in dialogue, an "information dump" or a super-villain "monologuing."
Expressionism	A style of filmmaking that uses overt manipulation of image, color, camera style, or mise en scène to express inner states of mind of a character or filmmaker.
Extreme close-up (XCU)	A very tightly framed shot that isolates very small details—eyes, lips, or details of small objects.
Extreme long shot (XLS)	A very long, wide shot that shows us massive backgrounds and tiny, often insignificant people.
Eyeline match	An editing technique that preserves spatial coherence by matching characters' eyelines between shots.
Fade	A transition from one shot to another with a fade to black (or other color) and fade into the second.
Fill light	Used in three-point lighting; usually positioned on the other side from the key, this light is softer and less bright, which lessens the effect of shadowing on the face.
Film noir	A largely American film genre often based around crime fiction. It has its roots in German Expressionism.
Foley	The technique of creating sound effects in post-production, on a Foley stage, filled with props.
Freeze frame	The frame that stops still before a transition or that stops time for emphasis. Often an arty technique.
Frontality	Action is performed straight-on for the audience, as though on a stage.
Genette, Gérard (1930–)	French literary theorist and developer of Narratology.
Genre	A French word simply meaning "type."
Giallo	A genre of Italian thrillers and horror films made throughout the 1960s, 1970s, and 1980s. Key <i>gialli</i> include the films of Dario Argento.
Graphic matches	An edit that creates a visual relationship between shots; often emphasizes thematic or spatial relationship between objects/subjects.
Hand-held camera	Similar type of moving shot to the tracking shot, but with a shaky effect that is often associated with a documentary-style realism or with the subjective POV of a character.
High-angle shot	The camera position above the subject, looking down on them. High angles are often used to make the audience feel superior to whatever they are watching.
High-key (low-contrast) lighting	Lighting technique that uses a limited contrast range, producing soft, bright images. The most common form of lighting.
Ideology	A set of ideas, shared or individual, and the means by which these are communicated.
Impact aesthetics (King)	The aggressive stylization of editing and/or camera movement to physically shake the viewer.
Intensified continuity (Bordwell)	A commonly used modern style of continuity editing that uses tighter and shorter shots compared to earlier uses of continuity editing.
Intertextuality	The shaping of one text by other texts-the interrelationship between texts.
Iris	A circular frame on the shot, often isolating an important detail. Irises were commonly used in silent cinema for emphasis. A closing iris can also be used as a transition from one shot to another.
Jump cut	(1) A shot that is arrhythmic or disjunctive and produces a noticeable skip between two shots, either because action isn't matched or shots break the 30° rule. (2) A cut that interrupts a single shot, literally producing a jump and an ellipsis in the action.
Key light	The brightest of three lights used in three-point lighting, this highlights details on the face by casting shadow on the unlit portion.
Kristeva, Julia	A French theorist of intertextuality, among other things.
Kuleshov effect	Named after Soviet filmmaker Lev Kuleshov, an editing effect that creates an emotional effect by placing unrelated shots side by side.
Long shot (LS)	A shot in which human figures are just distinct, but background is still very visible.
Long take	A shot of long duration. One of cinema's most impressive techniques.
Looping	See ADR.
Low-angle shot	The camera is positioned below the subject, looking up. Low angles can often suggest a powerful subject who looms over us.

Low-key (high-contrast) lighting	Lighting technique that creates dark pockets with little light on-screen (common in horror films and film noir).
Master (or establishing) shot	Often the first shot of a scene, the master, usually a long shot, shows us the whole scene, the setting, spatial relationships between characters, and important action. Sometimes, whole scenes are shot in masters.
Match-on-action	Editing technique that matches line and movement of action from one shot to another.
Medium close-up (MCU)	A shot which shows individuals framed from the waist upward; one of the most typical shots in television.
Medium long shot (MLS)	The human figure framed from around the knees upward.
Metric montage (Eisenstein)	A montage effect in which the length of shots is determined arbitrarily and independently of the content of the images, by music or such.
Mise en scène	A critical term used of the organization of objects within the camera's frame.
Montage	A general term for editing. Often associated with a montage sequence that condenses a lot of narrative information into a short space of time, or one that uses editing for a particular effect. Also a term for the kind of dialectical editing developed by Sergei Eisenstein.
Motif	A dominant idea or concept, a recurring formal element, color, or design feature. Repeated use of a particular shot distance can be developed into a motif through repetition and variation.
Narratology	A branch of Structuralism that examines narrative structure and narrative communication.
Noddy	Another name for a cutaway.
Non-diegetic (or commentary) sound	Sound that does not emanate from objects or characters within the narrative fictional space, for example voice-over narration, soundtrack, and so on.
Non-diegetic	Anything in the film but not in its fictional world is referred to as non-diegetic (the score, credits, etc.).
Objective camera	Shots that allow the viewer a God-like perspective of the action without intruding on it.
Offscreen space	Space unseen by the camera, but implied by characters'/objects' movements, in dialogue or by sound.
On-screen space	The space seen by the camera.
Over-cranking	The camera is run at more than 24 frames per second (fps) to produce smooth slow motion, sometimes up to around 2,000 fps.
Overtonal montage (Eisenstein)	A montage effect that creates resonances in the conflict between dominant metric, rhythmic, and tonal montage techniques used within a sequence.
Pan (panorama) shot	The camera turns left and right, as though turning its head on a horizontal plane.
Plan Américain ("American shot")	A French critical term for the medium long shot frequently used by Hollywood in the 1930s and 1940s.
Plot (Bordwell/Thompson)	The sum of story and non-diegetic elements, such as camera angles, editing, sound, titles, etc.
Point of view (POV) shot	Shots taken from the subjective perspective of a character or object in the film.
Point-of-audition sound	Sound whose intensity, pitch, and space imply hearing from a subjective point in the diegesis, where the hearing/hearer of the sound is seen rather than its point of origin.
Pro-filmic event	The action filmed in front of the camera on location or in a studio before it is encoded into film language.
Propaganda	The tools used to deliberately influence the population.
Propp, Vladimir (1895–1970)	Russian critic and literary theorist.
Proscenium	A theater stage or space that has a frame or arch as its main feature. Cinema still has very close links with theater, and the camera frame was initially conceived as like a proscenium arch, as a window on the world.
Realism	A style of filmmaking that attempts to mimic material reality as closely as possible.
Reverse zoom	A special technique achieved by tracking toward a character while simultaneously zooming out, changing focal length and making the background stretch into the distance.
Rhythmic montage (Eisenstein)	A montage effect in which the length of shots is determined by the content of the images.
Semiotics	The study of signs. It has its origins in the work of Ferdinand de Saussure, a Swiss linguist who was the first to identify some of the basic principles that apply to any sign- based system.
Sequence shot (Bazin)	A sequence filmed in a single take in extreme depth of field.

212 Film Language Glossary

Shot distance	The distance of the shot in relation to the actor or object being filmed.
Shot-reverse-shot editing	Pattern of shooting and editing often used for conversations, which cuts back and forth between shots following 180° and 30° rules with corresponding eyeline matches.
Sign	Something which "stands for" something else.
Sound bridge	A type of sound edit that bridges one scene into another either by introducing sound from one scene, or extending sounds from the previous one.
Sound perspective	A sound's quality relative to the camera's position. Perspective can be suggested by manipulating volume, echo, and the balance in relation to other sounds in the diegesis.
Sound qualities (Bordwell/Thompson)	The properties exhibited by on-screen and offscreen sound; includes acoustic properties (such as loudness, pitch, and timbre) and dimensions (including rhythm, fidelity, space, and time).
Spotting	The process of determining where music cues need to go in a film.
Steadicam	The camera is strapped to the camera operator using a special mount, which produces smooth, floating shots that are more flexible than tracking shots.
Story (Bordwell/Thompson)	The linear construction of both represented and inferred narrative events.
Straight-on shot	The camera pointed straight at its subject.
Structuralism	A term applied to a body of thought that examines patterns of communication and meaning.
Sub-genre	Category within an overarching genre that is defined by specific characteristics. For example the slasher film as a sub-genre of horror, or post-apocalyptic films as a sub- genre of science fiction.
Subjective camera	Shots that show us the world from the perspective of a character or object in the film.
Surrealism	An artistic movement that explores subjective states of mind in dream states and was concerned with fragmentation.
Synchronous sound	That which is heard at the same time that it is produced in the diegesis, for example dialogue or gun shots. Synchronized sound can be on-screen or offscreen and is in time with the image.
Synecdoche	Where some portion of a thing stands for the whole.
Text	A verbal, written, or visual artifact.
Three-point lighting	The most common lighting technique, which uses three lights to ensure good exposure and give the illusion of a three-dimensional image.
Tight close-up	Frames the face very closely, rather than the individual features of an extreme close- up.
Tilting shot	The camera tilts up and down on a vertical line.
Tonal montage (Eisenstein)	A montage effect that creates associations between the dominant emotional content of each shot.
Tracking (dolly or trucking) shot	The camera moves on a fixed track, which can be laid in any direction.
Under-cranking	The camera is run at slower than 24 frames per second (fps) to produce faster motion on playback.
Urtext	An original or the earliest version of a text, to which later versions can be compared.
Vococentrism (Chion)	The prioritizing of the voice over all other sounds, in the hierarchy of perception, and in the sound mix.
Wipe	A transition in which a line wipes one shot from the screen, which is replaced by the next.
Worldized sound	Sounds that are re-recorded in their space of audition to capture the acoustics of the space in which they are heard in the diegesis.
Zoom	A lens fitted to the camera that allows the operator to change the focal length and alter the dimension of the image; produces moving shots without requiring the camera to move physically.

Entries in italics indicate titles of works. Page numbers in italics refer to illustrations.

28 Days Later 110 30° rule 186 180° rule 185 300 145 2001: A Space Odyssey 132, 189, 195 abstract 128 Achilles 87, 94 acousmêtre 170 Acting in Film: An Actor's Take on Movie Making 170 action code 27, 33 ADR (Automated/Additional Dialogue Replacement) 177 aesthetic categories 89 Alice's Adventures in Wonderland 85 Alison, Joan 86 Allen, Woody 60, 62, 78, 93 allusion 82-83 Althusser, Louis 117 Altman, Rick 169 Altman, Robert 143, 168, 169 Ambition 52 Amelie 136 American Graffiti 168 Anderson, Lindsay 111 Anderson, Michael 84 Anderson, Wes 194 angle (camera) 128, 130 antitheses 28, 34 Antonioni, Michelangelo 111 anxiety 14 Apartment, The 53, 54-55 Apocalypse Now 196 appropriation 78-79 Argento, Dario 174 Aristotle 42, 52, 53 Arnheim, Rudolf 108 Arnold, Andrea 110, 167 Aronofsky, Darren 197 assembly 32 association 83 asynchronous sound 164 Attenborough, Richard 86 audience analysis 43, 88 Audio-Vision: Sound on Screen 159 Avildsen, John G. 87 Babenco, Hector 83 Bach, J. S. 80 back light 137 Bakhtin, Mikhail 74 Barreda, Alonso Alvarez 63 Barrymore, Drew 81 Barthes, Roland 13, 26-28, 42, 44 base 117 Battleship Potemkin 82, 196, 197 Baudrillard, Jean 85 Bay, Michael 190 Bazin, André 108, 144, 145. 183 Beckett-King, Alasdair 63 Bed Sitting Room, The 133 Belmondo, Jean-Paul 143 Berberian Sound Studio 174-179

Bergman, Ingmar 60 Birth of a Nation 23, 24, 25, 25 Black, Paul 63 Black Narcissus 140 Blade Runner 84, 86, 90, 164 Blade Runner: The Final Cut 177 Blair Witch Project 142 Blow-Up 157 Boorman, John 39 Bordwell, David 129, 144, 160 Boudu, sauvé des eaux 53 Bourne Supremacy 143 Boy in the Striped Pajamas Boyle, Danny 110 Branagh, Kenneth 73 branding 88 Brando, Marlon 12 Brave New World 85 Brazil 78, 82, 83, 91 Breathless 143, 191 Bresson, Robert 106 bullet-time 145 Bunuel, Luis 52 Burch, Noël 131 Burnett, Murray 86 Burton, Richard 99 Burtt, Ben 163 Cabinet of Dr. Caligari 140 Cahiers du Cinéma 144 Caine, Michael 170 California Suite 63 camera properties 128; angle 128, 130; duration 144-146; level 133; lighting 137; movement 142-143; shot distance 132-134 Cameron, James 86, 87 Campbell, Joseph 84 Carpenter, John 188 Carrey, Jim 141 Casablanca 78, 79, 86, 90 case studies: Berberian Sound Studio 174-179: Citizen Kane 92-97; Dead Man's Shoes 118-123; Hero 148-153; Psycho 200–205; Secret Life of Walter Mitty 64-69; Seven 30-35 causality 45, 47 Cavalcanti, Alberto 63 characterization 59, 67 characters 57 Chion, Michel 159, 167, 170 Cinderella 87 Citizen Kane 92-97, 130 Classic Hollywood Narrative Structure 52-55 clichés 13 close-up 132 Cloverfield 142 codes 26-28 Coffee and Cigarettes 63 collaborative working 8 collective authorship 104-105 confrontation 53

Connery, Sean 38 connotation 24 connotative code 27; Falling Down 27; Seven 31 Conrad, Steven 64 Considine, Paddy 118 context 41, 103 continuity editing 183, 184-189 Conversation, The 131, 163, 170 Coppola, Francis Ford 62, 131 Coppola, Roman 183 Course in General Linguistics 42 CQ 183 crane shot 142 Craven, Wes 80, 81 Creepshow 63 Crichton, Charles 63 Cuarón, Alfonso 89, 167 cult films 84-87 cultural code 28; Seven 34 Curtiz, Michael 78 cutaways 187 Dam Busters 84 Dancyger, Ken 186 Daring Daylight Burglary 40 Dark Knight, The 198 Day the Earth Stood Still 137 De Niro, Robert 135 De Palma, Brian 157 De Sica, Vittorio 111 de-acousmatization 171 Dead Man's Shoes 118-123 Dead of Night 63 Dearden, Basil 63 Deep Red 174 denotation 24 depersonalization 20 dialecticism 117, 196 dialogue 80 Diamond, Izzy 55 Diary of the Dead 142 Dick, Philip K. 86 Dickens, Charles 111 Die Hard 77, 91 diegetic sound 131, 164 digital technology 41 Dirty Harry 106, 107 dirty realism 110 discontinuity editing 190-193 distance 128 Divine Comedy 80, 85 Do Androids Dream of Electric Sheep? 86 Dogme 95 114-115 Donen, Stanley 133, 164 Donnelly, K. J. 173 Donner, Richard 89 donors 50 Don't Look Now 138, 139 Douglas, Michael 27, 29 Down and Out in Beverley Hills 53 Doyle, Christopher 148 Eagleton, Terry 102

Eagleton, Terry 102 Eastwood, Clint 106, 107 Eco, Umberto 90 editing: continuity 184-189; discontinuity 190-193; formalism vs realism 183; intensified continuity 199; montage 194-197, 204; pacing 198 Edwards, Gareth 172 Eisenstein, Sergei 82, 111, 128, 183, 196–197 enigma code 27, 33 Ephron, Nora 87 equilibrium 52, 55, 63, 66 Eternal Sunshine of the Spotless Mind 140, 141 events 57 Everybody Comes to Rick's 86 exercises: adaptation 71; analyzing propaganda 104; annotate a sequence 155; the audience 41; audience profile 91; changing the image 37; changing the soundtrack 181; character and ideology 125; combining shots 134; considering cultural and contextual ideologies 125; considering film style 140; finding ideology 103; the iconography of stardom 99; interpreting signs 20; listening to the soundtrack 165; the long take 146; narrative 71; pacing and shot duration 207; plot and originality 99; putting it all together 207; reading fairy tales 49; reading mise en scène 140; reading personal ideology 109; reading signs 28; reading the edit 189; refashioning 83; refreshing clichés 37; sound qualities 161; understanding motivation 199; understanding the audience 43; using Propp 51 exposition 134 expressionism 140 external ocularization 59 extradiegetic narration 57, 58 extreme close-up 132 extreme long shot 132 eveline matches 186 fairy tales 48-51 Falling Down 27, 28, 29, 29 Fatal Attraction 87 Faust 87 fear 14 Fellini, Federico 111 Festen 114 Field, Syd 48, 53

Film, A Sound Art 159 Film Art: An Introduction 129, 160

Film Music: Critical Approaches 173

film noir 57, 96, 116 film theory 8, 40-41 films: cult 84-87; portmanteau 63; short 62-63 Fincher, David 30, 75 Fish Tank 167 Flapwing and the Last Work of Ezekiel Crumb 63 Fleming, Victor 171 Flirt 145 focalization 59, 60, 68 focus 128 folk tales 48-51 For Whom the Bell Tolls 80 form 106 formalism 48-51, 183 Forman, Milos 83 Forrest Gump 58 Forster, E.M. 45 'fourth wall' 131 frames: duration 144-146: long take 144-146; mise en scène 136-141. 148-152; movement and 142-143; objective vs subjective shots 128; overview 125; perspective 128, 129; on-screen/offscreen space 131; shot distance 34, 132-134 Frankenstein 72, 84 Freeman, Morgan 30-35 French Nouvelle Vague 144 Gandhi 86 Gellar, Sarah Michelle 81 Genette, Gérard 56 genre 88-91; ideology and 116 - 117giallo 174 Gilliam, Terry 78, 82, 91 Godard, Jean Luc 49, 128, 143, 191 Godzilla 172 Goldfinger 185 Gondry, Michel 141 Good, the Bad and the Ugly 127, 132 Gosford Park 168 Gramsci, Antonio 117 Grauman, Walter 84 Gravity 167 Grease 10, 11, 12, 13 Greenaway, Peter 19, 20, 21 Greengrass, Paul 143 Griffith, D. W. 23, 25, 183 gritty realism 110 Halloween 188 Hamer, Robert 63 Hamilton, Guy 185 Harry Potter and the Prisoner of Azkaban 89 Hartley, Hal 52, 145 Heart of the World 63 hegemony 117 height 128 Hemingway, Ernest 80 Herbert, Mark 118 Herman, Mark 7, 111 Hero 148-153 Hero With a Thousand Faces 84

heroes 50–51, 117 heroic realism 110

Herrmann, Bernard 60, 172 Hidden Fortress 84 high angle 130 high key light 137 Hill, The 109, 113 Hitchcock, Alfred 14, 15, 27, 60, 92, 127, 129, 143, 172, 195, 200–205 Hollywood Narrative Structure, Classic see Classic Hollywood Narrative Structure homodiegetic narration 57, 58 How I Won the War 101 Huxley, Aldous 85 ideology: collective authorship 104-105; Dead Man's Shoes 118–123; defined 102; form 104; genre and 116-117; production flow and 104-105; realism 108-115; text and context 103; time and place 103

102 images: fragmentation 6; memorable 14; precision 13; visual culture 12 see also frames impact aesthetics 143 In the Mood for Love 147 industry branding 88 intensified continuity 199 internal ocularization 59 interpellation 117 intertextuality: allusion 82-83; appropriation 78-79; Citizen Kane 92-97; cult films 84-87; defined 73, 74; dialogue 80; evolution of ideas 75-76; genre 88-91; primary plots 86-87; quotation 78-80 intradiegetic narration 57, 58 Introduction to the Structural Analysis of Narrative 44 Italian neo-realism 111

Ideology: An Introduction

Jackson, Peter 87 Jarmusch, Jim 63 Jason 87 Jaws 143 Jeunet, Jean-Pierre 136 Jewison, Norman 87 Jost, François 59 jump cuts 184

Kael, Pauline 86 Kar-Wai, Wong 147 Kebbell, Tony 118 Kelly, Gene 133, 164 key light 137 Kiarostami, Abbas 165 King, Geoff 142, 143 *Kiss of the Spider Woman* 83 Kleiser, Randal 11 knowledge, articulating 8 Kobayashi, Masaki 63 Kracauer, Siegfried 108 Kristeva, Julia 74 Kubrick, Stanley 132, 189, 195 Kuleshov, Lev 194 Kurosawa, Akira 84 *Kwaidan* 63

La ronde 63 Lacy, Jerry 78 Lang, Fritz 169 Laughton, Charles 110 Lee, Bruce 85 Leigh, Mike 111 leitmotif 173 Lemmon, Jack 55 Leone, Sergio 99, 127, 132 Les Cahiers du Cinéma 144 Lester, Richard 101, 133 Lévi-Strauss, Claude 45 Li, Jet 148, 149 Life Lessons 62, 63 Life Without Zoe 62 lighting 137 Loach, Ken 110, 111 Lone Ranger 77 long shot 132 long take 144-146 Look Back in Anger 111 looping 177 Lord of the Rings 87 **Joss 87** love 87 low angle 130 low key light 137 Lucas, George 84, 168 Lumet, Sidney 83, 109, 112, 113 Lynch, David 159, 161 Lyne, Adrian 87 M 169 MacLaine, Shirley 55 MacMurray, Fred 55 Maddin, Guy 63 magic realism 110 magnetization 167 Manhunter 61 Mann, Michael 61 Marshall, Garry 87 Marxism 116–117 **MASH 168** master shot 185 match-on-action 185 Matrix, The 85, 90, 145 Mazursky, Paul 53 McCabe and Mrs. Miller 169 McTiernan, John 76, 77 Meadows, Louise 118 Meadows, Shane 111 Mean Streets 196 meaning: constructing see editingfive systems of 26-28; fluctuation 24; units of 16 medium close-up 132 medium long shot 132 Memento 47, 87, 164 memory 14 metaphor 23 metonymy 23 Metz, Christian 8 Meyer, Nicholas 144 mise en scène 136-141, 148-152 missing reverse shot 188 mobile camera frame 142 montage 82, 128, 194-197, 204

Moonstruck 87 Morphology of the Folk Tale 48 motif 34, 173 Mottershaw, Frank S. 40 movement 128 Mulholland Drive 161 multilayered sound 168 Murch, Walter 163, 169 Murder on the Orient Express 83 music 60-61, 172-173 My Name is Joe 110 Myrick, Daniel 142 Mythologies 13, 42 Nakata, Hideo 161 narration 57, 58 narrative: Classic Hollywood Narrative Structure 52-55; context 41; defined 39; formalism 48-51; genre and 89; music 60-61; narrative analysis 43; narrative discourse 56-57: narrative elements 49-51; narratology 45, 116; plot 45, 65-66, 86-87, 129; 'Seven Spheres of Action' 48, 49; short films 62-63; story 45, 57, 65, 129; structural analysis 44; structural theories 48-63; structuralism 42; surrealism 52; text 42, 56-57, 59, 67-68; theory 40-41; visual devices 146 Narrative Discourse: An Essay in Method 56 narratology 45, 116 naturalism 110 New Vocabularies in Film Semiotics 78 New York Stories 62 Newton-John, Olivia 12 Nichols, Mike 87, 99 Night of the Hunter 110 Nolan, Christopher 47, 87, 164, 198 non-diegetic material 129 non-diegetic sound 164 non-narrative form 52 non-simultaneous sound 164-165 Now, Voyager 87 objective shots 129 ocularization 59 Oedipus Wrecks 62 Once Upon a Time in the West 99 One Flew Over the Cuckoo's Nest 83 on-screen/offscreen space 131 Ophüls, Max 63 Orpheus 87, 94 overcoming 87 Ozu, Yasujirô 130 pacing 198 panning 142 Pan's Labyrinth 3, 3, 110 Paradise Lost 80 Peckinpah, Sam 85, 145,

146

Peeping Tom 15, 15 Penn, Sean 64 Perkins, Anthony 83 Persistence 63, 187 perspective 128, 129 physical signs 22 Pillow Book 18, 19, 19, 20, 21 Pinkaew, Prachya 145 Play It Again, Sam 78, 79 Please! 63 plot 45, 65-66, 86-87, 129 Poetics 42, 53 point of view (POV) shots 129 point-of-audition sound 179 pop music 173 PopcornMaker 155 portmanteau films 63 post-structuralist Marxists 117 Powell, Michael 15, 140 precision 13, 36 Pretty Woman 87 primary plots 86-87 proairetic code see action code Producers, The 130 production flow 104-105 propaganda 104 Propp, Vladimir 48-51 proscenium 130 Psycho 14, 27, 83, 129, 172, 200-205 psychological signs 22 Pulp Fiction 89 pursuit 87 quotation 78-80 Rapper, Irving 87 realism 108–115, 183 Rear Window 14, 195 Rebecca 92 Red Road 110 Red Shoes, The 140 Reeves, Matt 142 reference 82 referential code see cultural code Reframing Screen Performance 170 **Regarding Henry 87** Renoir, Jean 53, 109, 110 Requiem for a Dream 197 resolution 53 reverse zoom 143 Richardson, Tony 111 Riefenstahl, Leni 104 Ringu 161 Rocky 87, 194 Roeg, Nicolas 139 Rome, Open City 111

Romeo and Juliet 87 Romero, George A. 63, 142 Ross, Herbert 63, 79 Rossellini, Roberto 111 Royal Tenenbaums 194 Rushmore 194 Russian Ark 144 Russian formalists 48–51

Sanchez, Eduardo 142 Saussure, Ferdinand de 42, 45 Saving Private Ryan 86, 165 Schindler's List 33, 49 Schumacher, Joel 29 Scorsese, Martin 62, 134, 135 Scott, Ridley 84, 87, 164 Scream 2 80-81 Screenwriter's Workbook 48 Seberg, Jean 143 Secret Life of Walter Mitty 64-69 self-reference 82 semiotics: codes 26-28; compound of signs 20; defined 9, 11; denotation and connotation 24; flow of signs 21; genre and 91; memorable images 14-15; metaphor and metonymy 23; physical and psychological signs 22; precision 13; Seven 30-35; structuralism 42; units of meaning 16; visual abbreviation 17; visual culture 12 sequels 82 sequence shots 144 setting 57 setup 53 Seven 30-35, 75, 80 Seven Spheres of Action' 48.49 Shelley, Mary 84 Shoot the Pianist 186 short films 62-63 shot distance 34, 132-134 shot-reverse-shot editing 187, 188 signs see semiotics Simulacra and Simulation 85 simultaneous sound 164 Singer, Bryan 82 Singin' in the Rain 133, 164 Sixguns and Society: A Structural Study of the Western 49 Sleepless in Seattle 87 Snyder, Zach 145 social realism 111 Sokurov, Alexander 144 sonic nostalgia 175 Sonnenschein, David 160, 161 sound 155; acousmêtre 170; Berberian Sound Studio 174-179; deacousmatization 171; diegetic and nondiegetic 131, 164, 177; motif and leitmotif 173; multilayered 168; music 172-173; offscreen and audio 166-168; overview 157; perspective 163, 175; point-of-audition 179; properties 160-162; simultaneous and nonsimultaneous sound 164-165; synchronous 158; voice 170-171 sound bridge 177 Sound Design: The Expressive Power of Music, Voice, and Sound Effects in Cinema 161 Sound Practice, Sound

Theory 169

Soviet social realism 111 Spectacular Narratives: Hollywood in the Age of the Blockbuster 142 speech 57 Spielberg, Steven 33, 49, 86, 143, 165 spotting 172 Squadron 84 Stam, Robert 78 Stanton, Andrew 163 Star Trek 85 Star Trek II: The Wrath of Khan 144 Star Wars 49, 84, 90, 189 steadicam 142 stereotypes 12 Stiller, Ben 64 Stone, Oliver 87 story 45, 57, 65, 129 Story of a Sign 63 straight-on angle 130 Stretch, Gary 118 Strickland, Peter 174 Strike 196 Stroman, Susan 130 structural analysis 44 structural theories 48-63 structuralism 42 structuralist Marxists 117 sub-genre 88 subjective shots 129 Sundström, Joakim 167, 174 Superman 89 superstructure 117 surrealism 52 surround sound 166-168 Suspiria 174 symbolic code 28; Falling Down 27; Seven 34 synchronous sound 158 synecdoche 23 Synowiec, Sebastian 63, 187 Tarantino, Quentin 89 Taxi Driver 134, 135 Taylor, Elizabeth 99

Team America: World Police 194 tears 22 Technique of Film and Video Editing 186 temptation 87 Ten 165 Terminator 87 text 42, 56-57, 59, 67-68, 103 Thelma & Louise 87 Thompson, Kristin 129, 160 three-point lighting 137 tilting 142 time 59, 67, 144-146 Titanic 86 Todorov, Tzvetan 52, 63, 66 Toni 109 Toro, Guillermo del 3, 110 transformation 87 Transformers 190 transitions 189 Travolta, John 12 Tristan and Isolde 87 Triumph of the Will 104 Truffaut, François 127, 186 Twin Peaks: Fire Walk with Me 159

Un Chien Andalou 52, 190–193 under-cranking 145 Untouchables, The 196 urtext 94 Usual Suspects 82 Vertigo 143 victims 50

villains 50, 51 Vinterberg, Thomas 114, 115 visual abbreviation 17 visual culture 12 visual devices 146 vococentrism 171 voice 170–171 *Voice in Cinema*, *The* 159 Von rrier, Lars 114, 115 Vow of Chastity (Dogme 95) 115

Wachowski, Andy 85 Wachowski, Lana 85 Wall Street 76, 87 Wall-E 163 Warrior King 145 Watchmen 145 Week End 49 Welles, Orson 92-97, 130 What is Cinema? 145 Who's Afraid of Virginia Woolf? 99 Wiene, Robert 140 Wiig, Kirsten 64 *Wild Bunch, The* 145, 146 Wilder, Billy 53, 54–55 Willis, Bruce 77 Wise, Robert 137 Wizard of Oz 39, 171 Wonderful Wizard of Oz 85 worldized sound 168 Wright, Will 49

Xanadu 93

Yimou, Zhang 148

Zardoz 38, 39 *Zelig* 78, 93 Zemeckis, Robert 58 zoom 143 Cover image: The Wizard of Oz (1939) courtesy of MGM/The Kobal Collection

Pages 2–3: Pan's Labyrinth (2006) courtesy of Tequila Gang/WB/The Kobal Collection

Page 7: The Boy in the Striped Pajamas (2008) courtesy of Heyday Films/The Kobal Collection

Pages 10–11: Grease (1978) courtesy of Paramount/The Kobal Collection

Page 15: Peeping Tom (1960) courtesy of Anglo Amalgamated/ The Kobal Collection

Pages 18–19: The Pillow Book (1995) courtesy of Kasander & Wigman/Alpha Films/The Kobal Collection/ Mark Guillamot

Page 25: The Birth of a Nation (1915) courtesy of Epoch/The Kobal Collection

Page 29: Falling Down (1993) courtesy of Warner Bros/The Kobal Collection

Page 30: Seven (1995) courtesy of New Line/The Kobal Collection/Peter Sorel

Page 35: Seven (1995) courtesy of New Line/The Kobal Collection

Pages 38–39: Zardoz (1973) courtesy of 20th Century Fox/The Kobal Collection

Pages 46–47: Memento (2000) courtesy of Summit Entertainment/ The Kobal Collection/Danny Rothenberg

Page 54: The Apartment (1960) courtesy of United Artists/The Kobal Collection

Page 58: Forrest Gump (1994) courtesy of Paramount/The Kobal Collection

Page 61: Manhunter (1986) courtesy of De Laurentiis Group/ The Kobal Collection

Page 62: New York Stories (1989) courtesy of Touchstone/The Kobal Collection/Hamill, Brian

Pages 64–69: The Secret Life Of Walter Mitty (2013) courtesv of Red House Entertainment/

The Kobal Collection

Pages 72–73: Frankenstein (1994) courtesy of Tri-Star/American Zoetrope/ The Kobal Collection

Pages 76–77: Die Hard (1988) courtesy of 20th Century Fox/The Kobal Collection/Peter Sorel

Page 79: Play It Again, Sam (1972) courtesy of Paramount/The Kobal Collection

Page 81: Scream 2 (1997) courtesy of Dimension Films/The Kobal Collection

Page 85 The Matrix (1999) courtesy of Warner Bros/The Kobal Collection/Jasin Boland

Page 94 Citizen Kane (1941) courtesy of RKO/The Kobal Collection

Page 97: Citizen Kane (1941) courtesy of RKO/The Kobal Collection/ Alex Kahle

Pages 100–101: How I Won the War (1967) courtesy of United Artists/ The Kobal Collection

Page 107: Dirty Harry (1971) courtesy of Warner Bros/The Kobal Collection

Pages 112–113: The Hill (1965) courtesy of MGM/7 Arts/The Kobal Collection

Page 114: Festen (1998) courtesy of Nimbus Film/The Kobal Collection

Pages 118–123:Dead Man's Shoes (2004) courtesy of Warp Films/Big Arty Productions/The Kobal Collection

Pages 126–127: The Good, the Bad and the Ugly (1966)

courtesy of P.E.A./The Kobal Collection Page 133: Singin' in the Rain (1952)

courtesy of MGM/The Kobal Collection Page 135: Taxi Driver (1976)

courtesy of Columbia/The Kobal Collection

Page 136: Amelie (2001) courtesy of UGC/Studio Canal +/ The Kobal Collection

Pages 138–139: Don't Look Now (1973) courtesy of Casey Prods-Eldorado Films/The Kobal Collection Page 141: Eternal Sunshine of the Spotless Mind (2004) courtesy of Focus Features/The Kobal Collection/David Lee

Page 147: In the Mood for Love (2000) courtesy of Block 2 Pics/Jet Tone/ The Kobal Collection

Pages 148–153: Hero (2002) courtesy of Beijing New Picture/ Elite Group/The Kobal Collection

Pages 156–157: Blow Out (1981) courtesy of Columbia/The Kobal Collection

Pages 158–159: Twin Peaks: Fire Walk With Me (1992) courtesy of Lynch-Frost/CiBy 2000/

The Kobal Collection

Page 162: The Conversation (1974) courtesy of Paramount/The Kobal Collection

Pages 168–169: McCabe and Mrs Miller (1971)

courtesy of Warner Bros/The Kobal Collection

Page 171: The Wizard of Oz (1939) courtesy of MGM/The Kobal Collection

Pages 176–178: Berberian Sound Studio (2012) courtesy of Illuminations Films/ Warp X/The Kobal Collection

Pages 182–183: CQ (2001) courtesy of Zoetrope/UA/The Kobal Collection/Jean-Paul Kieffer

Page 187: Persistence (2012) courtesy of York St John University

Pages 192–193: Un Chien Andalou (1929) courtesy of Bunuel-Dali/The Kobal Collection

Page 195: 2001: A Space Odyssey (1968)

courtesy of MGM/The Kobal Collection

Page 195: Rear Window (1954) courtesy of Paramount/The Kobal Collection

Page 197: Battleship Potemkin (1925) courtesy of Goskino/The Kobal Collection

Pages 203–205: Psycho (1960) courtesy of Paramount/The Kobal Collection

For their contribution and help:

Thanks to the students and staff of BA Film and TV Production, BA English Literature, BA Creative Writing, and MA Film Production at York St John University, UK. Also thanks to the students of the University of Kent at Canterbury, UK; University of Aberdeen, UK; Hull University, UK; and the Open University, UK, for years of inspiration (and frustration).

Special thanks go to Lynsey Brough and Georgia Kennedy at Bloomsbury Publishing.

 This book is dedicated to:

 Rob:
 Julia, Evan, Agatha, and Meredith

 John:
 John and Marian

 Steve:
 Murray